TITANIC UNSEEN

IN MEMORY OF MY FATHER

TITANIC UNSEEN

TITANIC AND HER CONTEMPORARIES
IMAGES FROM THE BELL AND KEMPSTER ALBUMS

SENAN MOLONY
WITH STEVE RAFFIELD

The
History
Press

About the Authors

Senan Molony is political editor of the *Irish Daily Mail* and an award-winning national journalist. Born in 1963, he has over thirty years' experience in his craft. He lectured on both memorial voyages to mark the centenaries of the *Titanic* and *Lusitania,* held in 2012 and 2015 respectively, and has addressed British Titanic Society and Titanic International Society conventions. He also owns an extensive collection of original liner memorabilia from the golden age of steam. He lives in Dublin with wife Brigid and children Pippa, Millie and Mossie. Email: senanmol@gmail.com

Also by this author:

The Irish Aboard Titanic
Lusitania: An Irish Tragedy
Titanic and the Mystery Ship
The Phoenix Park Murders
Titanic: Victims and Villains
Titanic Scandal: The Trial of the Mount Temple

Steve Raffield is a lawyer and *Titanic* collector and lives in London.

First published 2016

The History Press
The Mill, Brimscombe Port
Stroud, Gloucestershire, GL5 2QG
www.thehistorypress.co.uk

© Senan Molony & Steve Raffield, 2016

The right of Senan Molony & Steve Raffield to be identified
as the Authors of this work has been asserted in accordance with
the Copyright, Designs and Patents Act 1988.

British Library Cataloguing in Publication Data.
A catalogue record for this book is available from the British Library.

ISBN 978 0 7509 6717 4

Typesetting and origination by The History Press
Printed and bound in Malta by Melita Press

CONTENTS

INTRODUCTION

PARALLEL LIVES

Two men, both with a passionate interest in photography, whose lives and pictures overlap. Philip Bell and John Kempster present us with layered insights into what it meant to build, deploy and operate the great ships of the White Star Line in the era of the RMS *Titanic*.

From the surging spectacle and excitement of a launch to the lazy days of a long homeward haul from Australia, we see intimate details of life on shipboard or are asked to confront stark illustrations of the ever-present dangers of an industrial shipyard.

The *Titanic* represented one superlative stage in a proud heritage. She was a great ship that was nonetheless genetically generated from an ever-strengthening fleet of vessels that eventually extended to a globe-girdling enterprise. These pictures, from a pair of extraordinary albums, help to provide her context.

The engineers who built her are inextricably linked to the staff who would animate her innards. An army of riveters and caulkers gave way to a no smaller legion of stewards and waiters, who were similarly unsung but just as vital to the fulfilment of an ultimate ambition.

Likewise, the officials of Harland & Wolff passed the torch to the navigational officers of the White Star Line. They in turn took this latest achievement of naval architecture and directed her, and ships like her, on the blue concourse of the world. What were their lives like, before and afterwards?

Sadly *Titanic*'s seagoing service was numbered to a few days, a fact that has naturally contributed to her immortality. There are no extant photographs of her after she dropped the pilot at Queenstown on Thursday 11 April 1912, until her gutted remains swam into remote view on the sea floor in the early hours of Sunday 1 September 1985. Much had been forgotten in the intervening 26,806 days, and much has indeed eroded since. Our collective perception of the nature of that time, over a century ago now, has crumbled from memory. For a generation that cannot imagine a time before computers, the idea that gigantic steel ships could spring solely from brainpower, toil and the draughtsman's hand must seem incomprehensible. Yet it happened.

Impossible dreams were magnificently made manifest, and it was done by individuals, albeit yoked to a common vision. At Harland & Wolff some 15,000 workers bent their intelligence to the collective will, day after day, to give birth to wonders of the deep that had been designed in drawing offices and given substance in the shipyard.

The navigational officers who took charge of completed vessels like the *Athenic*, *Adriatic* or *Olympic* were highly educated, vastly competent men who knew not just practical seamanship and all that went with it, but who were soundly versed in geometry, trigonometry, physics, meteorology and even astronomy. Their minds were arguably far more honed and nimble that many of those of modernity ... yet they were human too, as shown in a succession of glimpses enclosed within these covers, from a picture of a snoozing stewardess to the glint of young men about to go to town when ashore on long-awaited leave.

It is Philip Bell and John Kempster, very different personalities, who have preserved their pressurised present day for posterity, bequeathing it timelessly to us, though they themselves and all their peers and

quotidian concerns have long since disappeared into the wake of history. Bell was about to turn 32 in April 1912, while Kempster was 47. The former was single, the latter married with children. One was ocean-going, the other largely a landlubber. Their contrasts counterbalance.

The White Star officer and the Harland & Wolff executive were born just 50 miles apart, but almost a generation removed from each other, though they shared a social class. What they also had in common was an obsession with the emerging wizardry of cameras – and a delight in capturing the sheer glory of shipping in all its variety.

Their albums automatically complement and cross-reference the famed Fr Browne photographs from the truncated maiden voyage of the RMS *Titanic*. They strengthen that canon and expand its scope, from fleshing out the birth of a leviathan in superb launch photographs to graphically representing the aftermath of her unhappy resolution, whether it be the tide of additional lifeboats overrunning the top deck of the *Majestic* a few months later, or the endurance-etched face of senior surviving officer Charles Herbert Lightoller as he begins to overcome his arduous ordeal.

Not only offering a new overture and finale to that well-known symphony of icy slaughter, this book also brings us the faces and brief stories of other personalities who worked on water in those short days of industry and optimism prior to the First World War. It is a visual *souvenir de visite* to a lost moment, through an anthology of unseen images. It is hoped to thus encourage a fuller understanding of what was an eyeblink amid the epochs, an interlude both ephemeral and yet eternal, the tantalising but almost tangible timeframe of *Titanic*.

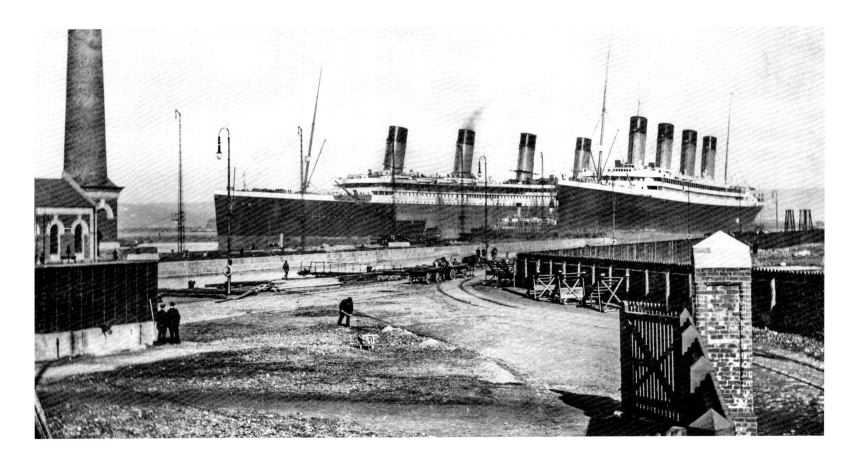

BIOGRAPHIES OF BELL AND KEMPSTER

Philip Agathos Bell (1880–1934)

It was likely his early service on the famed White Star liner RMS *Baltic* that convinced young Bell to get himself a camera.

He served as a junior officer under Captain Joseph Barlow Ranson in the rescue of the passengers and crew of another White Star liner, the *Republic*, following collision with the *Florida* in late January 1909. No lives had been lost, although the *Republic* subsequently sank, and the episode made a hero of her wireless operator, Jack Binns. In summoning the assistance of other liners Binns appeared to have at once banished the great dread of a lonely sinking, far from the succour of civilisation.

The *Nottingham Evening Post* of the 25th of the month proudly reported on its sixth page: 'Mr Philip A. Bell, son of Mr James Bell, of Edwalton, a Nottingham High School old boy, is one of the officers of the RMS *Baltic*, of the White Star Line, and was engaged in rescuing the passengers from the *Republic* after the collision with the *Florida*.'

Just one grainy picture of the sinking *Republic* was published, and it is probable that the budding photographer Bell resolved never to let such an opportunity ever slip again.

He had only been with White Star since Halloween 1908, having served his apprenticeship with William Thomas & Co. of Liverpool, yet already he held a Master's Certificate, gained at the early age of 27.

Bell's very first ship had been a 1,000-ton barque called the *County of Merioneth*, which he signed aboard as third mate on 15 April 1902

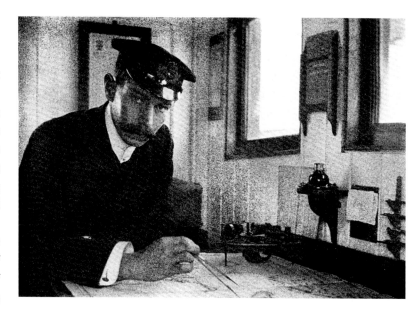

— exactly ten years before the *Titanic* sinking. Other small vessels on which he sailed included *Cranford*, *Florence* and *Rainton*, and his apprenticeship took him from the Baltic to the River Plate.

Bell's next White Star vessel was the *Oceanic* in April 1909. The 29-year-old, whose curious middle name is a form of 'Augustus', cited his *Baltic* experience while signing on as sixth officer. He replaced Harold Mostyn Watkins, who had resigned from White Star the previous day and who would eventually switch from sea to air, becoming a wing

commander in the RAF. The crew agreement shows that Bell stood 5ft 8½in tall, was of fair complexion and had brown hair and blue eyes. He had been born on 1 May 1880, at Nottingham, and his family resided at Edwalton House, near the city.

He served on the New Zealand run on the *Athenic* under Captain Charles Howard Kempson as fourth officer, from 26 February 1910 to 7 April 1911.

Just before the launch of the *Titanic*, Bell switched to the Australian service, serving on the *Medic* under Captain Vere Hickson. He went aboard as third officer from 1 May to 9 September 1911. In a different hemisphere, the RMS *Olympic* was making her maiden voyage that June for the same shipping line, with a former *Medic* officer aboard in the shape of William McMaster Murdoch, who was fated to lose his life just months later on *Titanic*.

Bell next stood duty on the *Runic* as third officer under Captain James Kearney and was aboard when the cataclysm in the North Atlantic reverberated through the company.

He married that September 1912 one Elizabeth Ursula Johnson and was back at sea the same month aboard the *Majestic*, where he was reunited with an old shipmate from the *Oceanic*. This was Charles Lightoller, the senior surviving officer from the April disaster, who allowed his harrowed countenance to be photographed, providing a stark contrast with earlier portraits of him by Bell from prior joint service.

Bell resigned from the White Star Line on 1 March 1914, but returned to sea with the Royal Navy Reserve for the duration of the conflict that broke out in August that year. His health had begun to deteriorate and he next took a succession of shore appointments before going on early pension.

Philip Agathos Bell, of Somerdale Avenue, Milton, Somerset, died on 11 August 1934. He was aged just 54.

John Westbeech Kempster (1864–1947)

(Prof. Nigel Harris)

John W. Kempster was described as very charming and a fluent speaker; he delivered an entertaining oration at a special guest lunch at the Grand Central Hotel in Belfast following the launch of the *Titanic* on 31 May 1911. He said that when he saw the first *Oceanic*, he had felt immensely proud. But he had since seen many bigger vessels, and now they had brought about the largest ships yet launched. His photographs of them both, *Olympic* and *Titanic*, grace this volume.

An engineer and eventual head of the electrical department at Harland & Wolff, Kempster was born in Birmingham in 1864. John Westbeech was the namesake son of a noted temperance campaigner who was also the founder and first editor of the *Police Review*.

Approaching his half-century at the time of *Titanic*'s maiden voyage, he was married to Eleanor and the couple had been blessed with two daughters, Margaret Meredith, 11, and Sheila Elizabeth, 6. They lived in a desirable detached house at 18 Adelaide Park in leafy south Belfast.

Attention to detail ran in the family. John was a descendant of Christopher Kempster, who served as Sir Christopher Wren's master builder in the construction of St Paul's Cathedral in the heart of London.

He was educated in Dulwich College (where *Titanic* second-class passenger Lawrence Beesley worked as a science teacher), but also studied at Neuwied-on-the-Rhine and Finsbury Technical College. In his early career, Kempster was works manager with W.H. Allen & Sons and largely responsible for the transfer of that company's entire undertakings from London to Bedford.

He joined Harland & Wolff in Belfast in 1900, being appointed a managing director in 1906, in charge of the electrical plant. In due course he would become chairman of the managing directors at the yard.

The electricity supply in Harland & Wolff at the time of his appointment consisted of two small steam sets running in an open shed, and under Kempster a large generating station was built within the works. Some ten years later he purchased for that station the largest Diesel-driven generator that had been built at that time, a Sulzer set of 3,500hp with both AC and DC capability, each of 2,500kW capacity.

It was said of Kempster, in his obituary, that he 'probably did more for the early development of marine electrical engineering than anyone else'. At the time when he became interested in it, electrical equipment generally was quite primitive in design, but soon special precautions were being taken to meet the rigorous conditions of marine service. 'His insistence on high quality and a high factor of safety, his remarkable vision and judgment, and his meticulous care of detail were outstanding qualities in his work,' it was said, and many of the same qualities were brought to his photography.

In May 1907 he made his second crossing of the Atlantic (the first being in 1897) on the maiden voyage of the RMS *Adriatic* from Liverpool. By 1911 he held £10,000 worth of shares in Harland & Wolff and was 'closely involved' in the construction and launch of the *Titanic*. Kempster had been due to sail on her maiden voyage (having done so with *Olympic*), but shortly before the sea trials he was asked to go to Glasgow on urgent company business. Internal Harland & Wolff documents show Kempster was prominent in organising the company's charitable aid to the widows and orphans of the Guarantee Group from the shipyard, a specialist team to spot snags and provide advice, who went down to a man with the *Titanic*.

In 1915 he left Belfast to take charge of Harland & Wolff interests at Greenock in Scotland, and he became president of the Clyde Shipbuilders Association. He was later president of Greenock Chamber of Commerce and even chairman of Greenock Provident Bank.

Kempster retired from Harland & Wolff's service in 1928, by which time he had penned numerous works on financial, industrial and economic subjects. After his retirement he wrote another textbook, this time about his hobby and lifelong sport. It was entitled simply *Fishing*.

John Westbeech Kempster died in Guildford, Surrey, on 24 January 1947 at the age of 82.

1

QUEEN OF THE SEAS

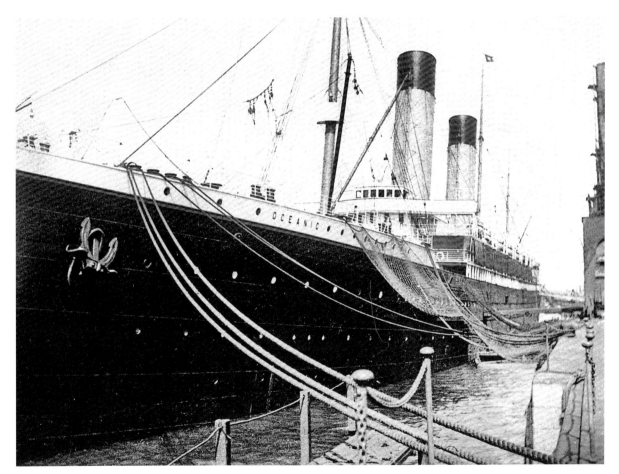

Oceanic alongside Test Quay, Southampton, on 23 May 1909. She was also tied up at Test Quay on Wednesday 10 April 1912 when the *Titanic* began her maiden voyage. *Oceanic* was then moored inside of the American Line's *New York*, whose berthing lines famously snapped as the new White Star liner passed, causing the American Line vessel to drift dangerously near the new leviathan, delaying her departure.

The *Oceanic* was built at Harland & Wolff over two years, debuting in 1899 as the largest vessel ever wrought, at over 700ft and 30,000 tons displacement (17,000grt). She had a speed of 21 knots, assisted by her sleek design, and quickly became a passenger favourite between Liverpool and New York. She was once commanded by Captain E.J. Smith of the *Titanic*. A former officer of both, Charles Herbert Lightoller always claimed she would have survived the iceberg impact that sank her successor, so sturdily was she constructed. Commissioned as a merchant cruiser on the outbreak of the First World War, *Oceanic* ran aground on Foula in the Shetland Islands in September 1914, becoming a total loss.

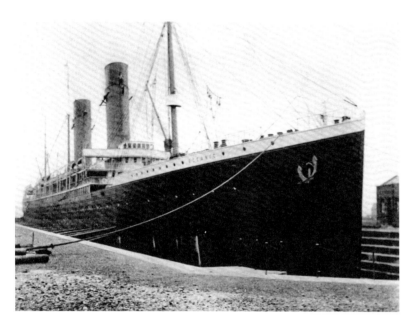

In dry dock at Southampton, 17 June 1909.

Oceanic does the 'Corkscrew Twist' at sea

When Propeller Blade Broke, Liner Acted Like a Dog Wagging His Tail

Adventure in the Fog

Imagine, if you can, a great ocean liner making motions like a dog wagging its tail.

That is what the *Oceanic*, of the White Star Line, did in mid-ocean last Sunday evening, according to the passengers who spoke of the incident when the vessel docked here today.

The *Oceanic*, which left Southampton on Dec. 30, was steaming at top speed through boisterous seas Sunday evening at 7.30 o'clock, when one of the blades of her port propeller snapped off, and dropped to the bottom of the sea. Of course this destroyed the continuity of the propulsive pressure and the *Oceanic* proceeded to cut up the most amazing antics.

To the passengers, who were just finishing dinner, it appeared as though the long, towering hull of the ship had become flexible and was doing a corkscrew twist. The peculiar motion lasted for only a few moments, until the engineers shut off steam and stopped the engines.

Their trained senses had already told them what had happened. After twenty minutes of work they so regulated the engines that the full-bladed starboard propeller and the short-bladed port propeller exercised equal power in the water. After that the *Oceanic* moved smoothly and evenly, but with slightly diminished speed.

Late yesterday afternoon the *Oceanic* off Nantucket ran into the thick fog which the cold wave from the northwest drove away from these parts in the morning. The mist was so heavy that the engines were slowed down. Suddenly the sound of a fog horn and a bell was heard.

The sounds grew louder and louder, but no one on board, from the officers on the bridge to the passengers grouped along the rails, could tell from what direction it proceeded. Finally, when the unseen horn and bell sounded so clearly that they seemed to be almost on the *Oceanic*'s deck, the engines were stopped entirely and the gigantic steamship stood motionless, blanketed in impenetrable fog.

There was not a sound on the liner between the regular signals from the siren whistle. When all was still and the mysterious bell and foghorn were silent, the sound of men's voices sifted through the fog. It was uncanny – as though men were walking about on the sea close by the vessel.

Then the passengers felt an icy breeze come over the bows. The fog was dissipated as if by magic. Two ships' length away and dead ahead was the Nantucket lightship. As speed was made and the *Oceanic* passed, the liner and the lightship were so close together that the proverbial biscuit could have been tossed from one craft to the other.

(*Evening World*, New York, Thursday 7 January 1909, p.6)

This description of the *Oceanic*'s 'adventure', complete with taking the biscuit, is an example of the light-hearted, derring-do spirit of the coverage during the period – a folly that was exposed for all time by the *Titanic* disaster.

It was not as if the *Oceanic* did not have form. In August 1901, in a dense fog off the Tuskar rock, she collided with the Waterford Steamship Company's *Kincora*, of 453 tons. *Kincora* sank in seven minutes, taking with her seven lives. Fourteen others were rescued by the *Oceanic* and landed at Queenstown.

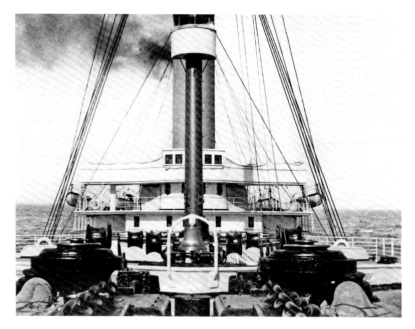

Eastbound for England: *Oceanic* at sea, mid May 1909; bridge view and forward view. *Titanic* lookouts Fred Fleet and George Symons were aboard and would later testify that they had binoculars 'every trip' when in the crow's nest of the *Oceanic*.

17380. The rank of lookout, how long you have held that position? [Fred Fleet] – About four years. All the time I was in the *Oceanic*.
17381. The only boats on which you have been a look-out man are the *Oceanic* and the *Titanic*? – Yes, that is all.
...
17401. Do you think if you had had glasses you could have seen the iceberg sooner? – Certainly.
17402. How much sooner? – In time for the ship to get out of the way.
17403. So it's your view that if you had had glasses it would have made all the difference between safety and disaster? – Yes.

On 15 May 1912, *Oceanic* found Collapsible A from *Titanic* in Latitude 39° 56' N, Longitude 47° 01' W:

The Finding of a *Titanic* Life Raft

Bodies Recovered by the *Oceanic*

A letter has been received in Birmingham, from Mr Harry C. Church of Moseley, who was on board the *Oceanic* on May 15, in which he describes the finding of one of the *Titanic*'s rafts with three bodies in it. He writes:-

About 12.30 on Tuesday we were playing shuffleboard on deck when we noticed our boat making a sharp turning movement. We could not make it out, and thought at first a derelict was in front, but after a few minutes we sighted the lifeboat in the water on our starboard.

We passed within 50 yards of it. By then our engines had been stopped, so we could plainly see the three men in it. It was the most pathetic sight I have ever witnessed. One man was lying under the bows and the other two in the stern.

Their legs were under the thwarts, and this no doubt held them in the boat. They all had lifebelts on, and we could see their faces were almost black.

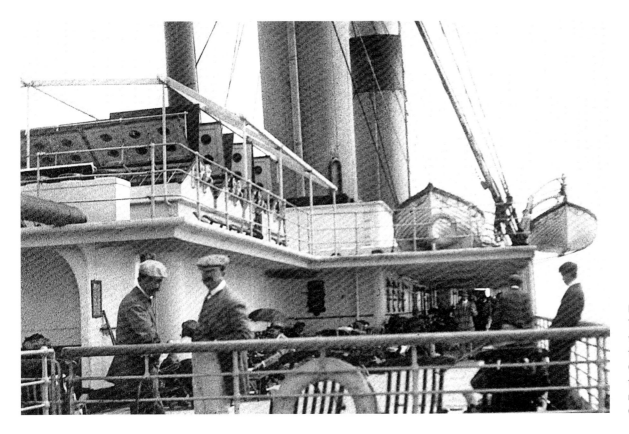

Promenade deck, *Oceanic* at sea, 1909. Three years after this photograph was taken, the *Oceanic* came across the abandoned *Titanic* lifeboat Collapsible A, in which were found three bodies. Coincidentally her master at the time was another Captain Smith, first name Harry.

As quickly as possible a boat was lowered. They rowed out, and then after a few minutes came back to report. They then took tarpaulins and big iron weights, and the doctor also went out and read the burial service over them, and they were then buried in the sea.

I have never seen anything so impressive in my life, and there was hardly a dry eye on the ship whilst this was taking place. I sat next to the doctor at table, and he told me the three men consisted of a seaman, a fireman, and a first-class passenger. They found the latter's name in a pocket book.

He was in evening dress. His name was Thomas [Thomson] Beattie, of Chicago. They also found a fur overcoat, some hairpins, a comb, and some ladies' rings, so it proves there were some other people in it, including ladies. His theory is that the boat was never launched, but floated off the *Titanic* just before she sank, and no doubt the oars floated off at the same time, leaving them absolutely helpless.

The boat was very flat-bottomed and is called a raft. It has collapsible sides, which they had tried to pull up, but evidently they were unable to do so, and only the front part was up, so that you can imagine the suffering, as the seats were almost level with the water, and no doubt many were washed overboard.

The marvellous thing about it is that they were never picked up, as they must have drifted right in the tracks of the liners, and you can imagine the terrible scenes when they could not attract attention. The first officer told me the boat must have drifted about 330 miles before we picked her up, as she would drift due south and then get into the Gulf Stream and drift eastward. The doctor thinks the fireman died first, and the others had not sufficient strength to throw him overboard, so they crawled to the other end of the boat and died there.

There was no water, and evidently no food, as the doctor told me he saw some small bits of cork, which had been chewed. Fancy, it was

just a month before this boat was picked up. It seems incredible on such a busy route as the North Atlantic. I got one or two snapshots of the lifeboat as they were towing her to the ship, but I was so upset I do not know how they will turn out.

I had a good look at the boat. She had copper airtight compartments all over the bottom, and is practically unsinkable in any sea, as water washes out as fast as it rushes over her. When the sides are pulled up properly, she would give protection for 47 people and they would be all right if picked up pretty soon.

(*The Times*, 31 May 1912, p.4)

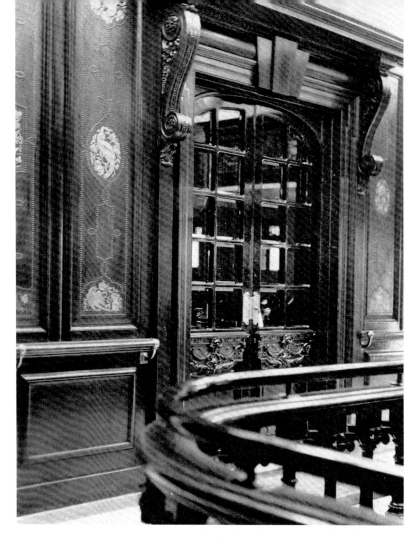

Oceanic's library door, Sunday 9 May 1909: 'The library is over the saloon ... the carving of the doors, which are of mahogany, and of the panelling, which is of oak, is very fine', declared the *Marine Engineer*. The panels left and right of the entrance were 'of brilliant Turkey red with gilt designs'.

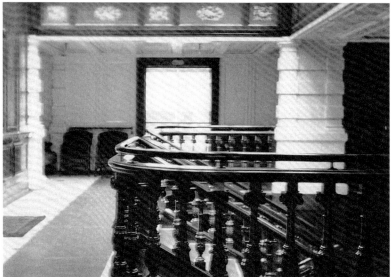

The entrance hall of the first-class saloon: 'The main companion is very fine, well lit from above and roomy. There are striking and massive carved door posts, coloured plain and white, which lead to the passages at the side of the ship.'

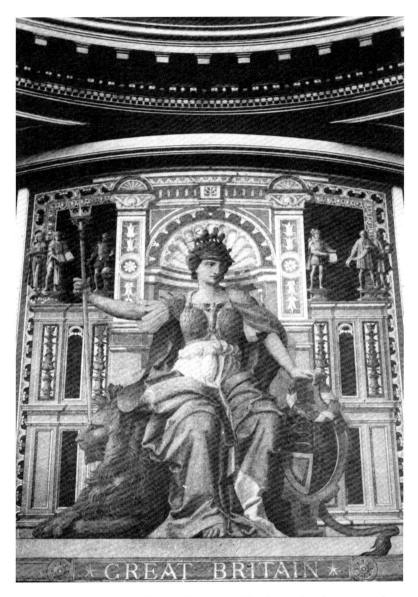
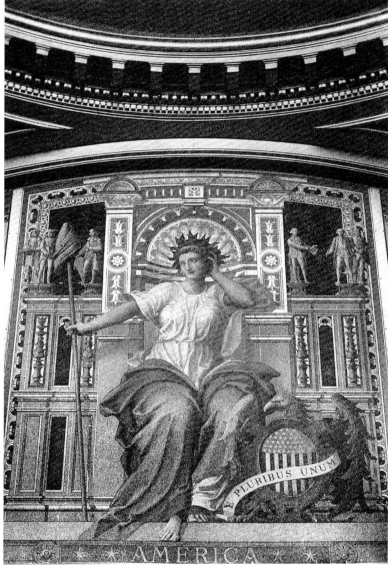

Representations of Great Britain and America, with a lion and eagle respectively, around the dome in the first-class dining room amidships on the *Oceanic*. Britannia grips Neptune's trident, while Columbia makes do with a republican staff and French revolutionary cap.

The *Marine Engineer* of 1899 said: 'The room is remarkable for its decoration. It is panelled in oak washed with gold, while its saloon dome, designed by a Royal Academician, decorated with allegorical figures representing Great Britain and the United States, and Liverpool and New York, is very beautiful and striking.'

The *Oceanic*'s bridge, seen here at New York on Thursday 5 May 1909, was covered with expensive white rubber, laid to mimic planks but to provide 'secure foothold'. If doused with salt water it became 'abominably slippery', senior surviving *Titanic* officer Charles Lightoller recalled. He occasionally slalomed from one side to another when the ship rolled in wet weather.

This picture was taken the morning after the *Oceanic* docked. She was then commanded by Herbert James Haddock, first captain of the *Titanic* while that vessel was at Belfast.

Later in 1909 the *Oceanic* carried suffragette leader Emmeline Pankhurst, who sat at Captain Haddock's table and announced on arrival in New York that she would also return on the *Oceanic* because she had only half-converted the veteran skipper to the cause of votes for women.

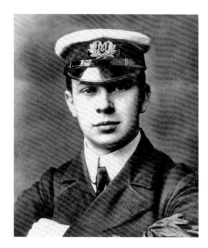

The Marconi cabin of the *Oceanic* at New York, pictured on 6 June 1909, as verified by the calendar. John Stapleton was the 'telegraphist' on this voyage, but Jack Phillips (*above*) later sat at this wireless set. Phillips was transferred directly from the *Oceanic* to the *Titanic* for the latter's maiden voyage, only to find posthumous fame for his devotion to duty in sending out CQD and SOS messages during the sinking.

Celtic Interlude

The *Oceanic* was surpassed in 1901 by the *Celtic* (20,900grt), the first ship larger than the *Great Eastern* and the first of the famed 'big four' of the White Star Line, the others being *Cedric* (1903), *Baltic* (1904) and *Adriatic* (1906), a quartet only excelled in turn by the Olympic class.

In April 1912, many of the *Titanic* crew survivors were herded aboard the *Celtic* for return home. A *New York Times* reporter who got aboard managed to speak to Fred Fleet, the lookout who first spotted the iceberg. Fleet referred to 'sitting tight and waiting for the boss's word'. He added that he 'had been drilled, and so when Mr Ismay said not to talk it meant as far as he was concerned that there was nothing to be said'.

The *Celtic* went aground on the Cow and Calf Rocks at the entrance to Queenstown (by then called Cobh) in December 1928, directly underneath the lighthouse at Roche's Point. Despite efforts to refloat her, she became a total loss.

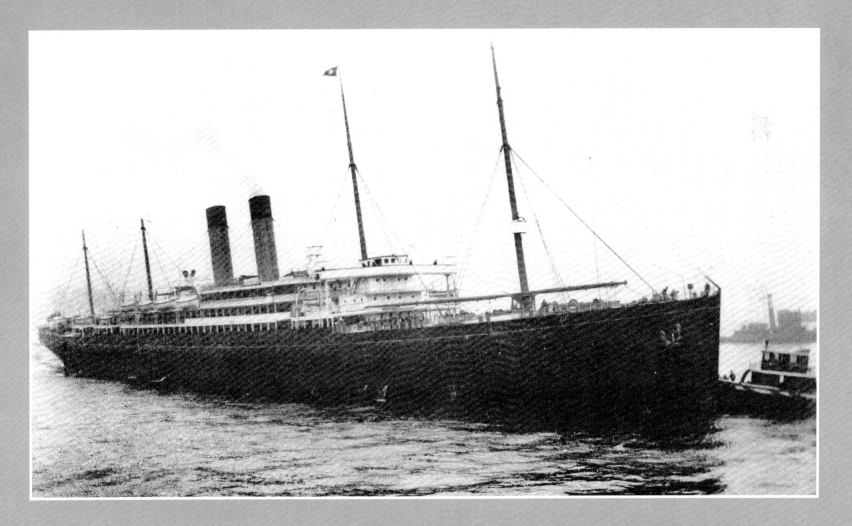

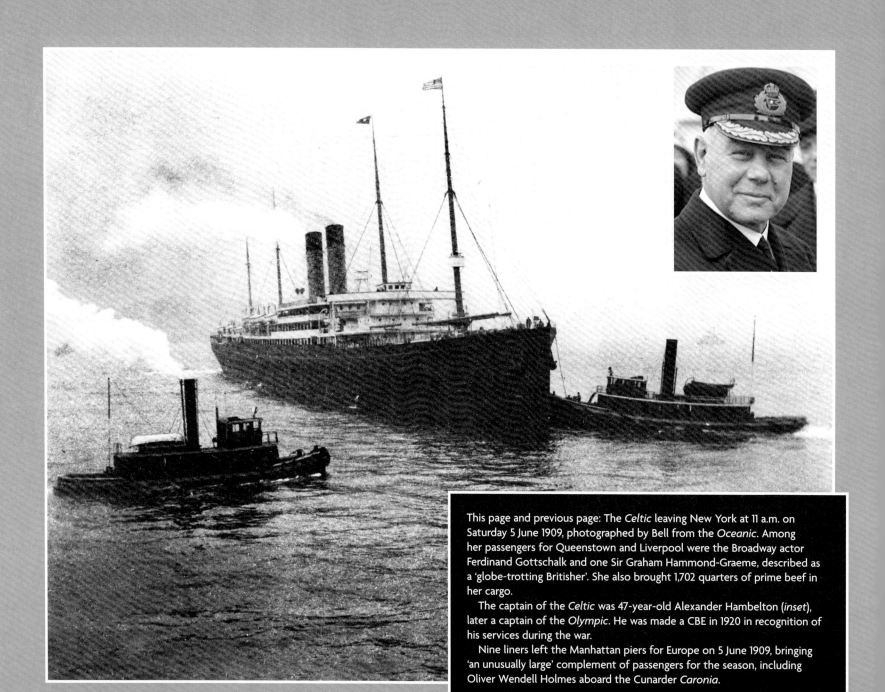

This page and previous page: The *Celtic* leaving New York at 11 a.m. on Saturday 5 June 1909, photographed by Bell from the *Oceanic*. Among her passengers for Queenstown and Liverpool were the Broadway actor Ferdinand Gottschalk and one Sir Graham Hammond-Graeme, described as a 'globe-trotting Britisher'. She also brought 1,702 quarters of prime beef in her cargo.

The captain of the *Celtic* was 47-year-old Alexander Hambelton (*inset*), later a captain of the *Olympic*. He was made a CBE in 1920 in recognition of his services during the war.

Nine liners left the Manhattan piers for Europe on 5 June 1909, bringing 'an unusually large' complement of passengers for the season, including Oliver Wendell Holmes aboard the Cunarder *Caronia*.

2

OCEANIC OFFICERS

'Work on an ocean steamship never ends, for no sooner does she reach her moorings in New York, Liverpool or Hamburg than preparations begin for the next voyage,' wrote Rufus Wilson in 1906. The officers were the cream of their profession at a time when a career at sea in any capacity was seen as exciting and even glamorous for a young man.

Hard graft provided 'the shadow of a dream', as Rudyard Kipling understood in his 1894 poem 'McAndrew's Hymn', inspired by the White Star liner *Doric*. Long, arduous hours filled the men's lives, but officers found fulfilment and *esprit de corps* through habitual excellence and dedication in the performance of their duties. Their free time was meagre, meaning candid moments were all the more unusual.

Charles Lightoller, second officer of the *Titanic*, observed:

I got my severest mail boat training during the seven hard though happy years I spent in the Queen of the Seas, as the *Oceanic* was then called. A wonderful ship, built in a class of her own, and by herself ... in lone and stately majesty came the *Oceanic*.

She was an experiment, and a wonderfully successful one; built by Harland and Wolff, regardless of cost, elaborate to a degree, money lavished where it was necessary, but never gaudily as is so common nowadays.

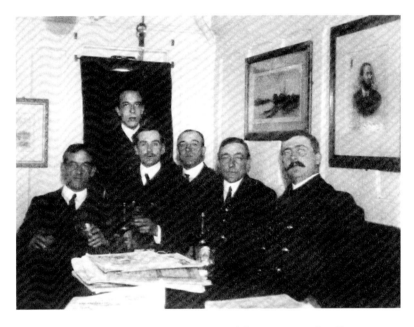

Celebrating in the ward room (officers' mess) of the *Oceanic* with colleagues from the *Celtic* prior to her leaving New York. The beers consist of Guinness and Bass, and there is a pile of magazines, such as the *Illustrated London News*, in the centre of the table. On the bulkhead wall is a youthful portrait of Thomas Henry Ismay, founder of White Star Line.

Left to right: Alfred Brocklebank, third officer, and Mr Denis, assistant Marconi officer (both *Celtic*); Joseph Groves Boxhall – later on *Titanic* – fifth officer; James Symons, fourth officer; William Oldershaw, second officer; and Marconi operator James Stapleton (all *Oceanic*).

[Mr Alexander, pictured right] senior chief engineer in the White Star Company's service, who has just retired, has what must be a nearly unique record.

The whole of his seafaring career of 38½ years has been spent in the White Star service. During that time he has crossed the Atlantic 912 times, travelling about 3,000,000 miles, and has never missed a voyage. By a curious coincidence Mr Alexander began and finished his career in vessels named *Oceanic*. He was chief engineer of the *Britannic* when that vessel took out the Imperial contingent of troops to Australia when the present King opened the Commonwealth Parliament. Mr Alexander, who is a native of Dundee, has just completed his 59th year.

(*Marlborough Express*, 31 May 1911)

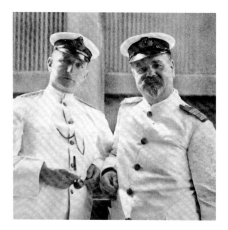

Pictured on 29 August 1909 are Charles Herbert Greame, first officer, and J.W. Alexander, chief engineer of the *Oceanic*.

Henry Freeman received an award for submarine evasion on 25 April 1918 when he was second officer aboard the RMS *Olympic* under Commander Bertram Fox Hayes. The latter wrote:

Mr Freeman, who was keeping a lookout, shouted: 'Submarine on the port bow', and our course was again altered to bring him astern at the same time as our guns opened fire ... if we had continued for another minute or so on the course we were on when he was first sighted, we would have run across his line of fire.

(Bertram Fox Hayes, *Hull Down: Reminiscences of Windjammers, Troops and Travellers*, Cassell, London, 1925)

Olympic thus avoided going to the bottom like her sister ships *Titanic* and *Britannic*, and the next month she would ram and sink another predator, U-103.

On board *Oceanic* at New York, 27 August 1909. More fraternising with officers of the *Celtic*. Charles Lightoller, second officer (same rank as on *Titanic*), makes a merry centrepiece, along with a man named Henchman, left, Fourth Officer Henry Freeman, top position, and an unidentified sixth officer.

To the right is the only known picture of a White Star Line stewardess in uniform aboard ship, much less relaxing in a deckchair. The red company burgee is visible on both shoulders. The form of attire meant stewardesses were commonly called 'nurses' by passengers. Martin identified herself as a nurse in the 1901 census and the two occupations were closely linked.

Born in Guernsey and 36 years old in this picture (she would sign aboard *Titanic* as 33), Annie had escaped to sea from a disastrous marriage to a soldier.

Little is known of her experience on *Titanic*, except that she escaped in Lifeboat 11 from the aft starboard side. A number of stewardesses, including Sarah Stap and Annie Robinson, also escaped in Lifeboat 11.

Robinson was aboard the *Devonian* in heavy fog in October 1914 when 'the continual sounding of the whistle so worked upon her nerves that she feared another disaster'. She jumped overboard and was lost. Annie Martin died in November 1936.

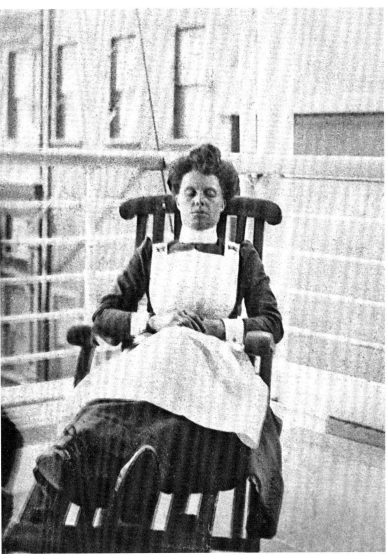

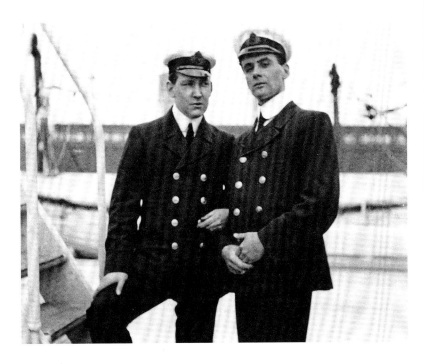

Titanic stewardess Annie Martin asleep on the second-class deck of the *Oceanic* at New York on the day after the US Independence holiday in 1909.

A seafarer with the highly appropriate name of Francis Drake is pictured alongside Joseph Groves Boxhall, fifth officer, right, on the *Oceanic* at New York on 9 May 1909. Drake, a 23-year-old Londoner, was assistant fourth engineer. The log of HMS *Orbita* shows that eight years later, while docked in Valparaiso, Chile, 'Eng. Lt Francis B Drake returned on board from shore in uniform, at 1.35 p.m., drunk and incapable of performing his duty.'

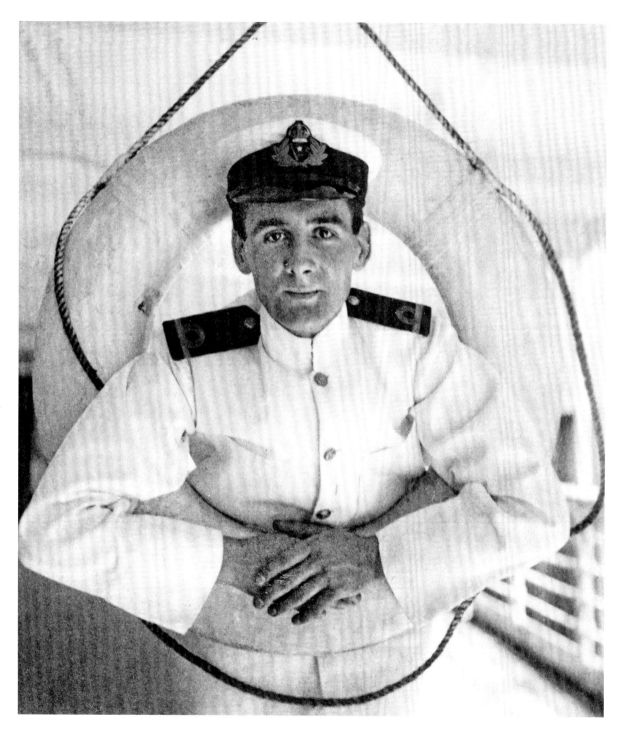

Boxhall in an *Oceanic* lifebuoy at New York, 29 May 1909. A poignant picture considering the disaster that befell *Titanic* just under three years later, when he would be sent away in charge of Lifeboat 2 by Captain Smith. Boxhall was in pain when landed by the *Carpathia* and soon developed pleurisy, causing him to be temporarily excused from giving evidence to the Senate *Titanic* inquiry.

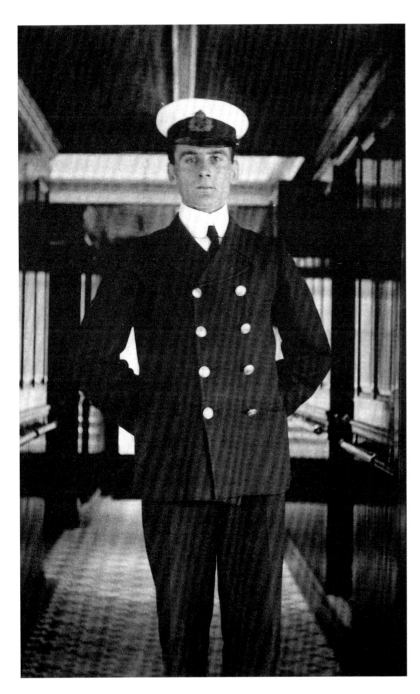

Fifth Mate Boxhall in the *Oceanic* officers' corridor on Sunday 6 June 1909. The image is redolent of his later evidence to the British Inquiry.

15344. Where were you at that time? [Joseph Boxhall] – Just coming out of the officers' quarters.

15345. How soon after the [lookout iceberg warning] did you feel the shock? – Only a moment or two after that.

15346. – I heard the first officer give the order, 'Hard-a-starboard', and I heard the engine room telegraph bells ringing.

15347. Was that before you felt the shock, or afterwards? – Just a moment before.

15349. Did you go on to the bridge immediately after the impact? – I was almost on the bridge when she struck.

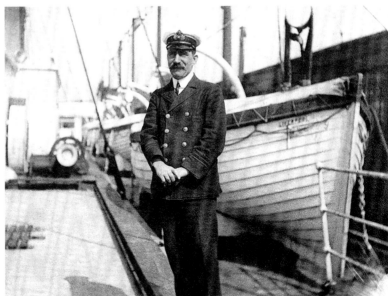

Chief Officer William Henry Cookson at Lifeboat 9 on the starboard side. He resigned from White Star Line four months later, in November 1909, but stayed at sea as a commander with other concerns, dying at the age of 80 in New York in 1937. Note the Liverpool plaque, White Star burgee and lifeboat number. Other attachments included a loading capacity disc and a nameplate. Such details were stripped from recovered *Titanic* boats by avid souvenir hunters.

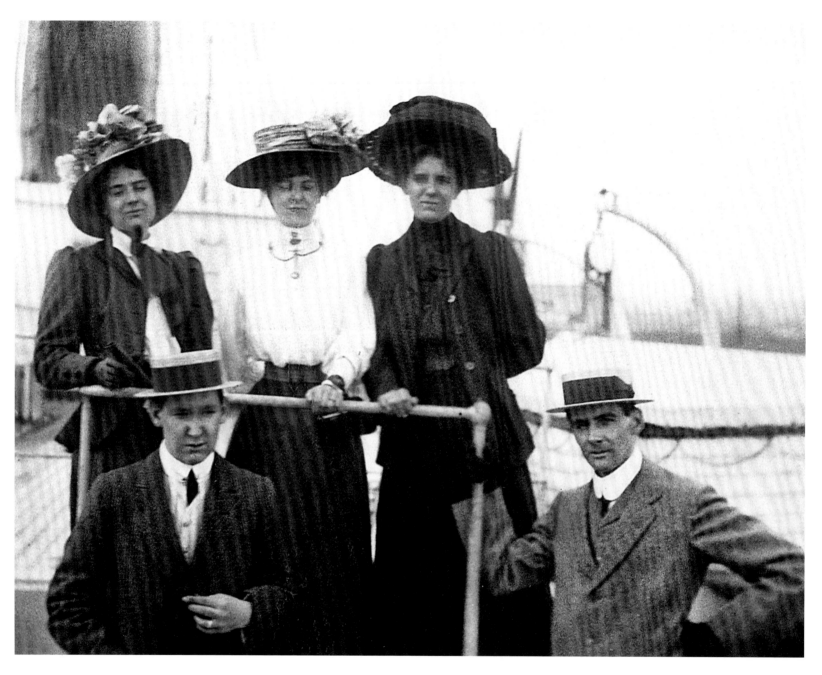

Oceanic at Southampton, as Engineer Drake and Fifth Officer Boxhall prepare to go out on the town with the latter's sister Mabel, left, along with a Boxhall cousin, centre, and an unidentified woman. Behind the camera, officer Bell completes the triple date. Married in 1915, the new Mrs Mabel Cranswick settled in Bradford with husband Henry, becoming a Post Office telephonist.

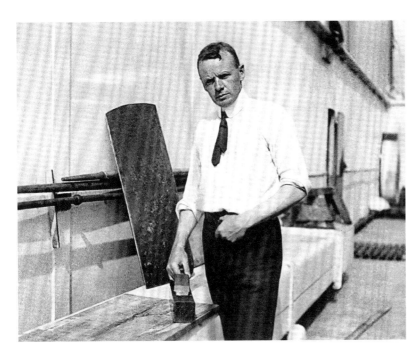

This scene is captioned 'Mr Lightoller, 2nd Officer, making a boat', and he has sizeable pieces of wood. The *Oceanic* is at Southampton on a slack Saturday (8 May 1909) and he has worked up a sweat.

First Officer Charles Greame at New York, 26 August 1909. He was aboard the *Olympic* in 1912 when news came through of calamity to her sister ship.

In his autobiography, *Titanic and Other Ships*, Lightoller tells of hurrying to the two remaining lifeboats hanging in their davits when the junior surgeon, John Simpson:

> even in the face of tragedy, couldn't resist his last mild joke: 'Hello, Lights, are you warm?' The idea of anyone being warm in that temperature was a joke in itself ... even in pants and sweater over pyjamas alone I was in a bath of perspiration ... The thing was to get these boats away at all costs. Eventually, and to my great relief, they were all loaded and safely lowered into the water.

Charles Greame's is a tragic story. He was commander of the White Star liner *Bardic* when she went aground on the Lizard in late August 1924. Within ten days he was suspended on half pay.

Less than two months later, on 3 November, Greame was returning to his home in Lincoln Road, Blackpool, aboard a train from Liverpool, when it dramatically derailed at Warton, outside Lytham. The engine and two coaches were overturned, with the train smashing into a signal box and setting it on fire. The blaze spread to the carriages. Five were killed instantly. A witness named Tarbuck later told *The Times*: 'If ever there was a brave man it was Commander Greame, for he never made the slightest complaint. Both legs were severed, and all he asked for was a cup of tea, and to be remembered to his people.' Greame died at midnight in the local hospital, 'whither he had been taken, after urging that others should be attended to before himself'.

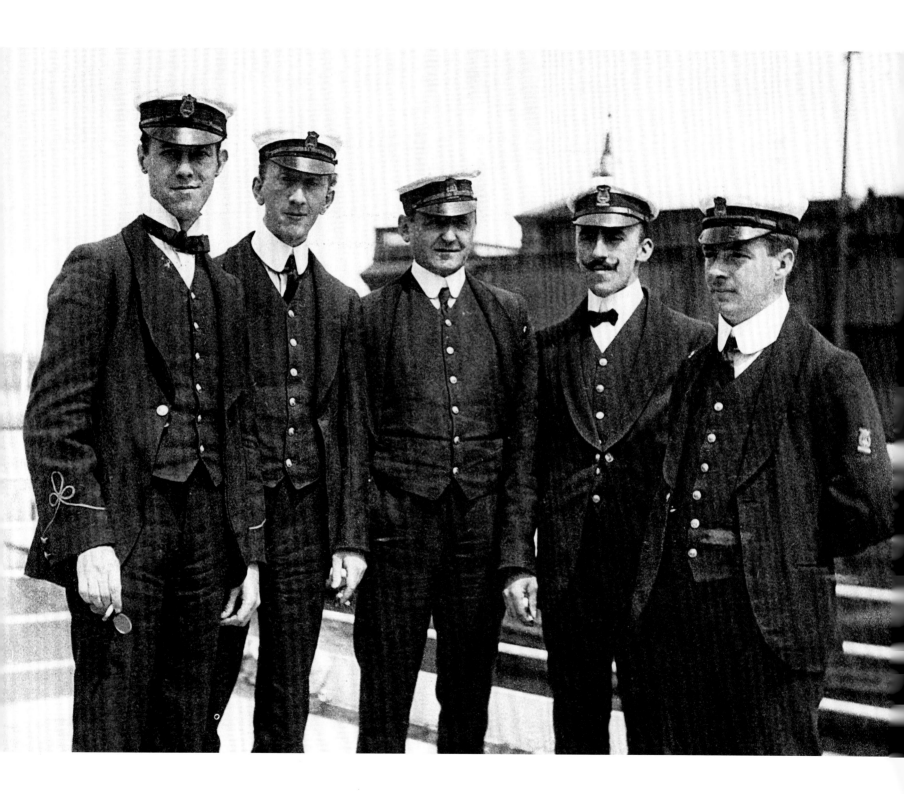

Bardic aground. (Gibson & Co., real photo series postcard, 1924)

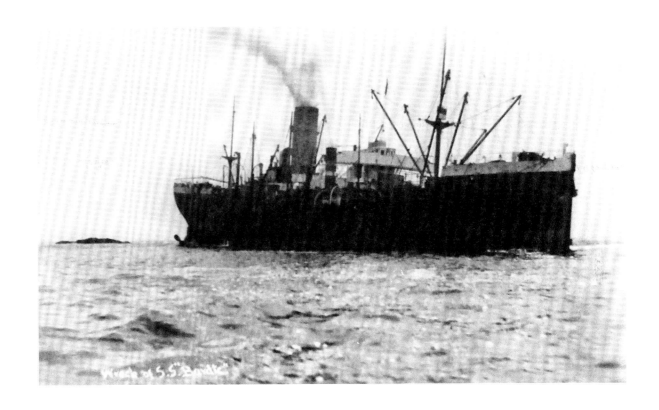

Opposite page: A unique image of a White Star Line travelling ship's orchestra, taken aboard the *Oceanic* in New York on Sunday 6 June 1909. The musicians are Sydney Bennett (24), born in Devon; Alec Turner (29), London; S.M. Parker (38), Wiltshire; Albano De Lucia (31), Venice; and Rupert Borowski (29), Blackpool. They wear lyre cap badges and sleeve patches, and their tunics have green trim. The *Titanic* orchestra would have had a similar appearance.

The crew agreement for this voyage shows members of the ship's orchestra were paid just 1 shilling per month, being reliant on tips from passengers.

This line-up, too, was touched by tragedy. Horn player Bennett died in 1913; two of his brothers died in war at sea in separate ships in 1916, and a third was killed at Ypres a year later. Pianist and violinist Borowski died in May 1918 of pulmonary TB 'contracted on army service'.

De Lucia played aboard the *Olympic* in early 1914 until the outbreak of the First World War, whereupon he immigrated to the United States.

Later in 1912 the *Oceanic* returned the 'Titanic waifs', Lolo and Momon Navratil, to Europe, in the grateful company of their mother Marcelle. They had been abducted by their father, Michel, a tailor from Nice, who perished in the sinking. Marcelle Navratil had also journeyed outward on the *Oceanic* from Cherbourg, arriving in New York on 16 May. She later tried unsuccessfully to sue the White Star Line, seeking £6,000 damages for the loss of her estranged husband.

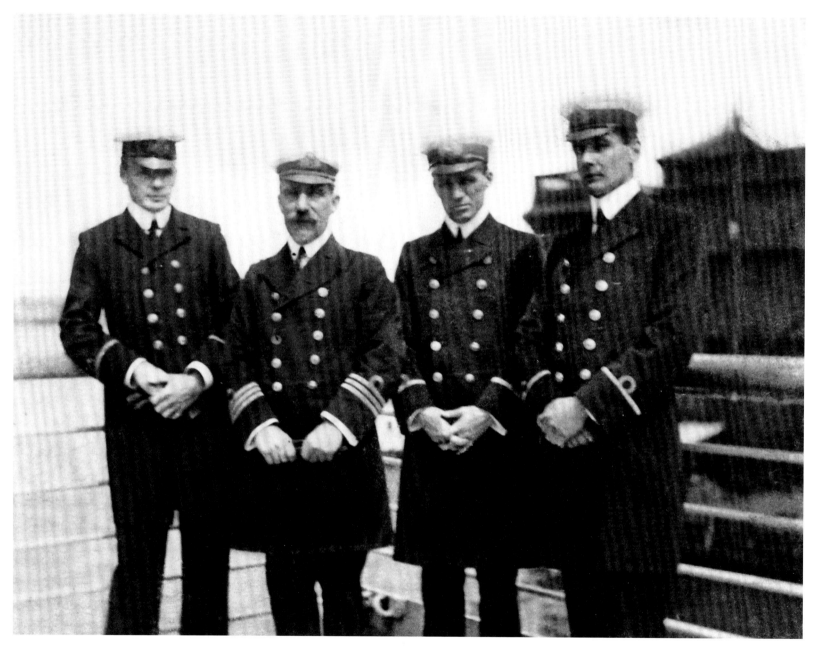

Second Officer Lightoller, left, Chief Officer Cookson, Fourth Officer Brown, and Fifth Officer Boxhall. This is exactly how Lightoller and Boxhall would have looked aboard the RMS *Titanic*.

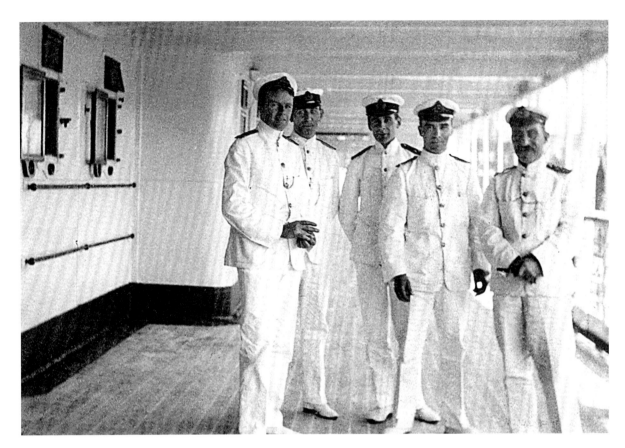

A light-hearted line-up in summer whites. Between Lightoller, left, and Boxhall stands the famed purser Claude Lancaster. Assistant Purser J.H.M. Smith and Chief Officer Cookson stand to the right.

Dr J.C.H. Beaumont, senior surgeon on the *Olympic*, later wrote:

All went smoothly till the Sunday night, on the voyage from New York. Around midnight, Lancaster and I were in his room, having a pipe together, when the door opened, and in walked Bob Fleming, chief engineer. 'Boys,' said he, 'there is awful trouble. The *Titanic* has been struck by an iceberg, is badly damaged and we are going up north to her assistance.'

(J.C.H. Beaumont, *Ships and People*, Frederick A. Stokes Company, 1928)

Lancaster kept a copy of all Marconigrams received as the disaster unfolded. He had served aboard *Olympic* with Captain Smith and other *Titanic* officers, such as Henry Wilde, chief officer, and William McMaster Murdoch, first mate.

First made purser on the *Majestic* in 1901, Lancaster retired at Christmas 1936, just shy of 60. He was aboard the *Britannic* when it hit a mine in November 1916, and he was torpedoed in the *Justicia* off the north coast of Donegal in July 1918.

Another social occasion is in the offing. Fifth Officer Boxhall, centre, and Sixth Officer Philip Bell, below, with Miss May Smyth and friend. They are gathered below the compass platform of the *Oceanic* at New York on Sunday 29 August 1909. This may be a time-release shutter snap.

This must rank as the finest portrait ever taken of Charles Lightoller in White Star uniform. It was generated on the same day as that of his making a model boat, perhaps prefiguring the dramatic change in his appearance on the day and night *Titanic* struck. 'I was never so fond of any ship as the *Oceanic*, either before or since,' wrote Lightoller in his memoirs.

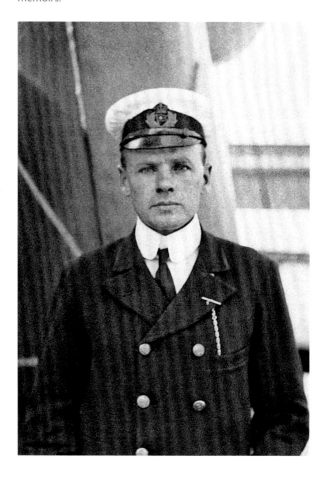

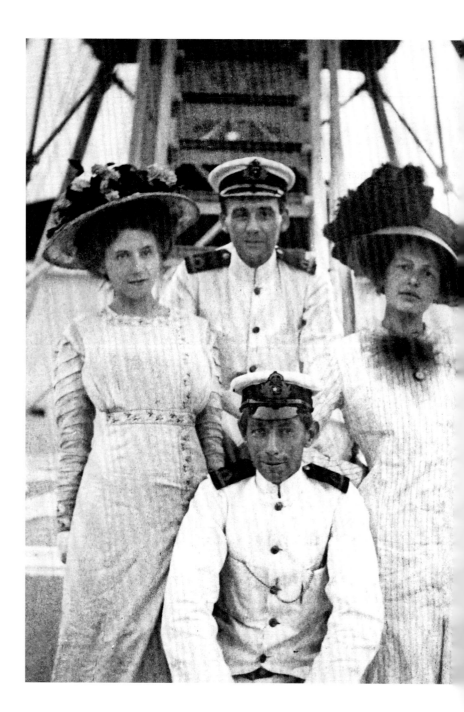

3

THE UNSUNG *ATHENIC*

The *Athenic* was considered a perfect vessel by her owners, the White Star Line. She was unobtrusive, economical to run, steadily productive of profit and blithely accident-free despite a working life that exceeded a quarter-century.

In fact the *Athenic* would soldier on in various guises for over sixty years, a service record more than double that of the *Olympic*, dubbed the 'Old Reliable' for her own durability.

Yet much of that work was for other masters. She was sold in 1928 to a Norwegian whaling company that renamed her *Pelagos*. She was captured by the Nazis in 1941 and turned into a high seas refuelling ship for the U-boat fleet. Torpedoed by one of her clients in late 1944 so that she would not fall into Allied hands, she was later raised from Kirkenes Harbour, cleaned up, and pressed back into commercial service, to be finally broken up in Hamburg half a century after the *Titanic* disaster.

On her debut in 1902, however, the *Athenic*, at over 12,000 tons, was the last word in the New Zealand trade. She was followed by similarly proportioned sisters in the *Corinthic* and *Ionic*.

Captain Charles Howard Kempson, then in command of the *Runic* on the Australian run, was appointed commander of the new flagship. He had once served on the *Coptic* in the China trade with a fellow junior officer by the name of E.J. Smith.

Athenic at sea, steaming from London to New Zealand on 8 March 1910.

The *Athenic* at Lyttelton, New Zealand, 24 April 1911. Bell went aboard her as fourth officer.

The bridge of the *Athenic* on 2 April 1910, exactly two years before *Titanic* departed Belfast on her delivery voyage. The crow's nest is just visible, and the ghostly panorama is emblematic of the vast empty seas she ploughed. On her next outward voyage, stopping at Cape Town in August, she picked up Robert Falcon Scott, who had stayed nearly a fortnight in South Africa after the departure of the *Terra Nova* for New Zealand. Scott of the Antarctic had been taking a last holiday with his wife Katherine, a sculptor, who would later execute a bronze statue of *Titanic* captain E.J. Smith that stands in Lichfield.

Scott made rendezvous with the *Terra Nova* at Lyttelton. He would never return from his own ice encounter.

At the time of Bell's first *Athenic* photographs it was elsewhere reported:

> The work on the *Titanic* is also proceeding apace, the stern frame being now in position ... which speaks volumes for the industry of the White Star Line. It also affords evidence of the development of commerce and intercourse between the two hemispheres.
>
> Rudyard Kipling's latest speculations on the conquest of the air may or may not be realised wholly or in part next century. There is no need to speculate with regard to the doings of the White Star Line. Their enterprise has ensured the continued supremacy of British shipping'.
>
> (*Cork Examiner*, 15 March 1910, p.2)

C.H. Kempson retired at the conclusion of the twenty-seventh voyage, bemoaning in valedictory interviews with the New Zealand press that he had little to relate from his forty years at sea: 'When pressed by the reporter to recount any exciting or notable incidents in his long career, Captain Kempson confessed that he had no story to tell.'

Captain Kempson retired to Paignton, Devon, where he died at the age of 81 on 23 January 1934.

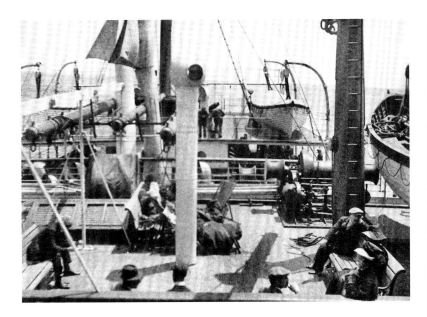

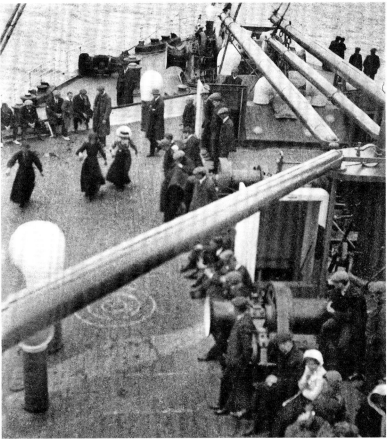

Long lazy days aboard the *Athenic*. The outward trip took a month and a half, and ditto the return. She made twenty-six round voyages from London to New Zealand in twelve years, all with the same commander, representing over 650,000 monotonous miles.

To break the tedium. This is the ladies' glass-of-water walking race along the port side, whose victor would be decided by a few drops, all buoyed on what seemed a perpetual planet of water. Nonetheless the excitement is such that some young men are standing on a hatch cover for a better view.

Officers watch as *Athenic* leaves Wellington during a dockers' strike in 1913 (contemporary postcard).

Left: Frederick John Burd, second officer of the *Athenic*. Four years after this portrait, the giant officer earned a pair of inscribed marine binoculars from the United States government.

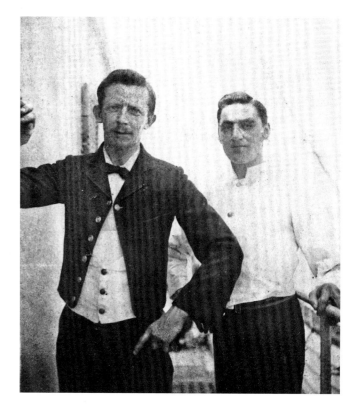

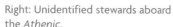

Right: Unidentified stewards aboard the *Athenic*.

Burd was aboard the *Megantic* in the mid Atlantic when she received a wireless distress call from the sinking steamer *Denver*. When the wallowing vessel came into view, Chief Officer Burd took a boat of volunteers to the rescue 'despite dangerous seas and heavy winds'. He saved the captain, his wife, several crew, 'and another Captain whose vessel had been sunk by a mine'.

Inevitably known as 'Big Burd', this officer went on to survive the torpedoing of the *Justicia* in 1918 when her first officer. He rose to command the *Calgaric* and *Laurentic* in peacetime, finishing as assistant commander of the *Olympic* shortly before her scrapping.

Burd died in 1952 at the age of 75.

On Tuesday 3 January 1911, a letter from Captain Kempson, written at Tenerife, appeared in a Sydney newspaper. *Athenic*'s master opined:

I notice that one of your correspondents has a strong prejudice against British crews as compared with foreigners. For over 20 years I have carried wholly British crews and have only occasionally shipped a foreigner, when no Britisher was available.

British crews – properly treated – are as good, and probably better, than any others. The seamen are certainly not as good at reefing topsails and sailor work generally as they used to be, but their manners have improved very much, and there is not a quarter the drunkenness there was 15 or even two years ago.

(*Daily Commercial News and Shipping List*, Tuesday 3 January 1911, p.12)

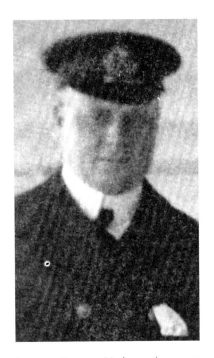

Seymour Freeman-Mathews, the purser of the *Athenic*, perhaps personified the quiet life.

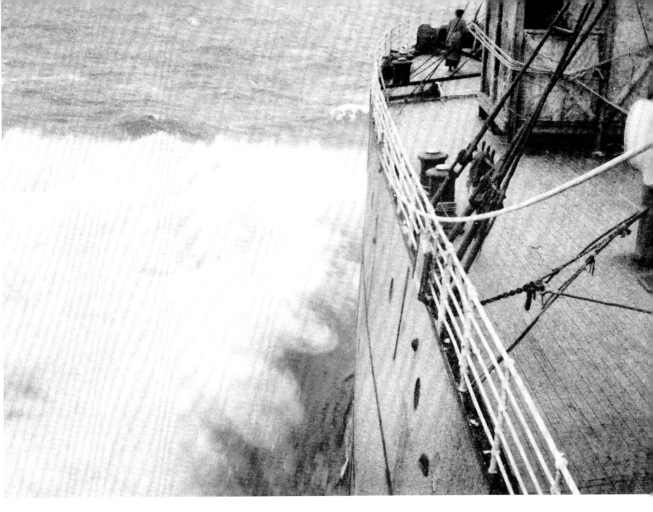

Taken on 6 January 1911 from a risky position in a rough sea, during the journey from Cape Town to New Zealand via Hobart, Tasmania. Photographer Bell captures a hardy woman passenger persevering in her promenade to the bows. A horse box is on deck, and barely visible is an equine head poking from the opening, perhaps suffering from mal-de-*mare*?

Mr. S.C.J. Freeman-Matthews, purser on the White Star liner *Athenic*, at present in Lyttelton, is the possessor of a very large and highly interesting collection of autographs. These number about 4,000 and include those of celebrities in nearly every walk of life.

(*Otago Daily Times*, 25 January 1906, p.6)

His autographs included Queen Victoria, King Edward VII, King George and Queen Mary, US Presidents William McKinley and Theodore Roosevelt, President Kruger, Lords Palmerston, Milner and Roberts, and Admiral Togo – eventually filling seventeen 'monster' volumes by the time he retired from his position as purser of the *Celtic*.

By then he had been thirty-eight years at sea and had travelled 3 million miles. He circumnavigated the globe thirty-seven times. Freeman-Matthews died in England in 1955, aged 85.

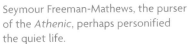

The *Hobart Mercury* reported in January 1911:

Experiment with Boys

Aboard the R.M.S. *Athenic*, which arrived at this port yesterday from London, were 50 sturdy youths, ranging from 16 to 20 years of age, who have been selected by Mr Sedgwick for agricultural work in New Zealand.

As fully 250 applications were received from farmers for the services of the boys, the Labour Department, to which the work was entrusted, has been able to place the lads in situations where they are likely to secure the greatest possible benefit and instruction. The boys in equal numbers are from Liverpool and London. On their arrival in New Zealand they will scatter over a wide area.

The New Zealand Government gave assisted passages to the youths. There were, Mr Sedgwick said, 100,000 boys in England unemployed or prospectless.

The Premier (Sir Elliott Lewis) and the Minister for Lands (Hon. Alec Hean) paid a visit to the *Athenic* yesterday, had a chat with Mr Sedgwick, and saw the boys. They expressed themselves as pleased with the type of lads, and said they would like to see a number of them settled in Tasmania.

(*Hobart Mercury*, Saturday 21 January 1911)

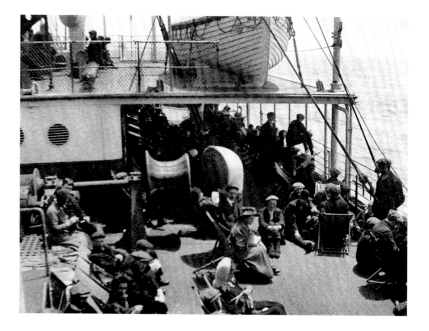

A scene of mass indolence as the *Athenic* nears New Zealand. One adventurous youth is perched on a windlass, his feet on the rail. Many young men were on board.

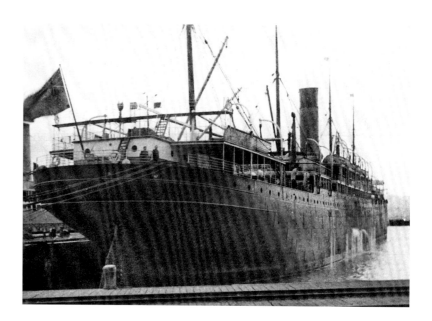

Athenic lying at Glasgow Wharf in Wellington, New Zealand, on 7 May 1911, in the same month as the launch, half a world away, of the RMS *Titanic*. A couple of crew stand idly at the stern, close to a red noticeboard placed on the outer rail which reads in white letters: 'This vessel has triple screws. Keep clear of blades.'

4

READYING *OLYMPIC*

Harland & Wolff yard project 400 had her keel laid on 16 December 1908. The following February it was announced that the trial success of a new combination of reciprocating and turbine engines in the *Laurentic* would lead to their adoption for the triple-screw propulsion of both the *Olympic* and her successor, yard number 401, *Titanic*.

By December 1909, the last frame of *Olympic* had been laid. Beside her, the skeleton of another vessel was slowly taking shape. Both had been originally intended to have only a foremast, but Bruce Ismay decided on a mainmast too after seeing the *Lusitania* leaving New York.

They were also equipped with new Welin davits, described in the press as a 'life-saving device', being the 'quickest, simplest and most efficient means of lowering a boat into the water that has ever been invented'. It was reported in February 1910 that each vessel would have thirty-two lifeboats.

Olympic had her hull painted white for her launch on 20 October that year, sliding into the Lagan at a steady 12 knots. Her 24,600 launch tons were then brought to a new deepwater wharf for initial fitting out, including the installation of boilers and propellers.

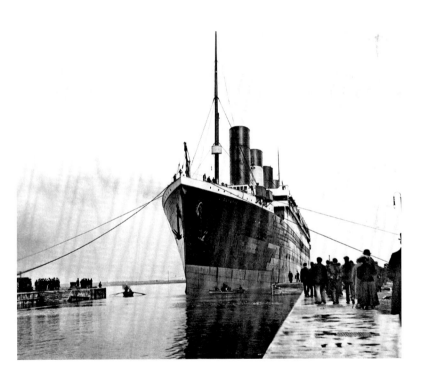

New Graving Dock Opened at Belfast

Belfast, April 1 — The new graving dock, which is the property of the Harbour Trust, and has taken seven years to construct, was opened today to receive the new White Star liner *Olympic*. The event was remarkable in view of the fact that both the ship and dock are the largest in the world.

The operation of docking the liner, which occupied 47 minutes, was witnessed by a vast crowd. The width of the dock entrance is 96ft, and the beam of the vessel from outside to outside of the plating 92ft 8in, but the docking was completed without a hitch.

The cost of constructing the new dock has been £350,000.

(*The Times*, Monday 3 April 1911, p.7)

Less than five and a half months since launch, rapid progress has been made on the *Olympic*, now with two masts and fully engined with all funnels, even if only the second one has been painted, the others described as a dull red on this occasion.

The Harbour Commissioners had planned a year before to invite King Edward VII to formally inaugurate the new dock, but he died in May 1910. It is not known if the request was ever made of his successor, George V, who would have his coronation in June.

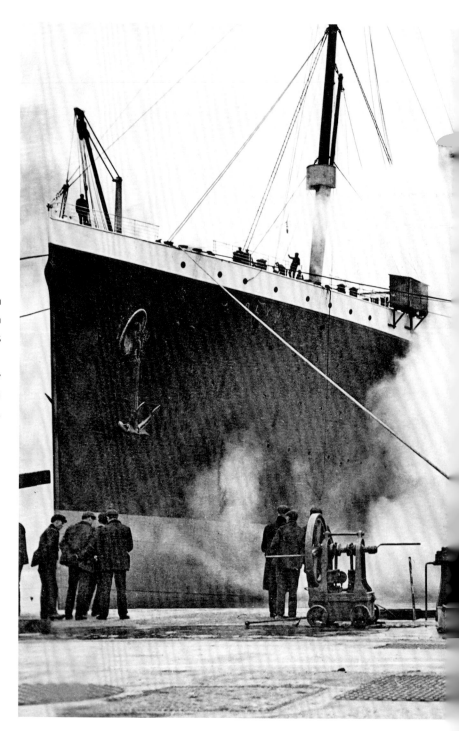

The *Olympic* is wreathed in steam from her deck winches as warping lines are made tight. The previous night, Friday 31 March, some 23 million tons of water were flowed into the dry dock to allow it to receive the vast vessel.

Collapsible B lifeboat (which overturned in *Titanic*'s case, but on which Officer Lightoller and others stood for hours before rescue) can be discerned between the first and second funnels.

The men in the rowboat from the previous picture have now withdrawn to relative safety. In the background is the twin-funnelled tug *Jackal*, built at Newcastle, which was bought by Harland & Wolff in 1905.

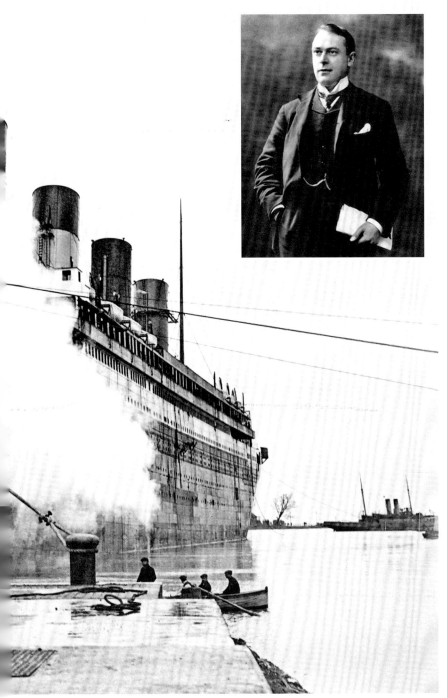

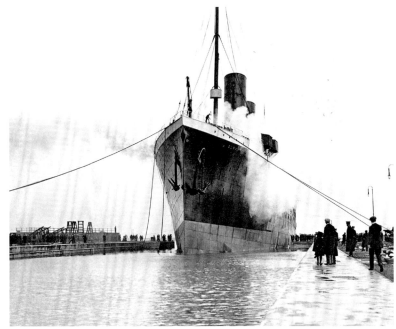

The *Olympic* begins her slow progress, crossing the bar of the dock with less than 2ft to spare at either side. It is noticeable that the wooden poppets from the launch are still attached at the bow, just above the waterline. A propeller is visible on the land to extreme right.

The Harbour Commissioners have come to watch, with admittance to the new dock by ticket only, although thousands of people lined both banks of the Lagan to admire the morning's work. Lord Pirrie is to the left, wearing a top hat, while aboard the *Olympic* is his nephew, Thomas Andrews (*inset*), fated to die on the *Titanic*.

The dock could have been emptied by pumps and engines within 100 minutes, but the work was done in phases from noon to allow the vessel to be propped from the sides of the dock. Finally, nine hours later, the *Olympic* was resting on her shore supports and the deck was dry.

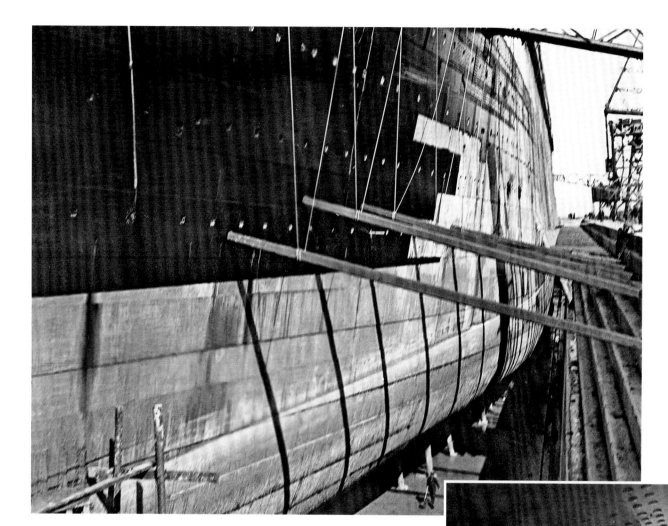

The *Olympic*, half-painted in her service livery, in the new graving dock, which will later be named after the Harbour Commissioners' chairman Robert Thompson MP. Her immensity can be gauged by the workman walking with a brush on the floor of the dock, 44ft below. The furry appearance of the lower plates above him derives from deliberate anti-fouling roughage. Rail tracks underneath the vessel enabled flat cars laden with material to run from stem to stern. An image of same, published in the *New York Tribune* in July 1910 was captioned: 'This is not a photograph of a subway.' At top right, an access gangway connects with a door on E Deck. There are figures using another gangway further aft.

This picture was probably taken in mid April. On the 13th, a labourer named Peter Ward, 31, of Trafalgar Street, was helping to lower a steel beam on the *Olympic*. He was sitting across the beam when lift wires snapped and he fell. Ward suffered compound fractures to both legs and died of shock.

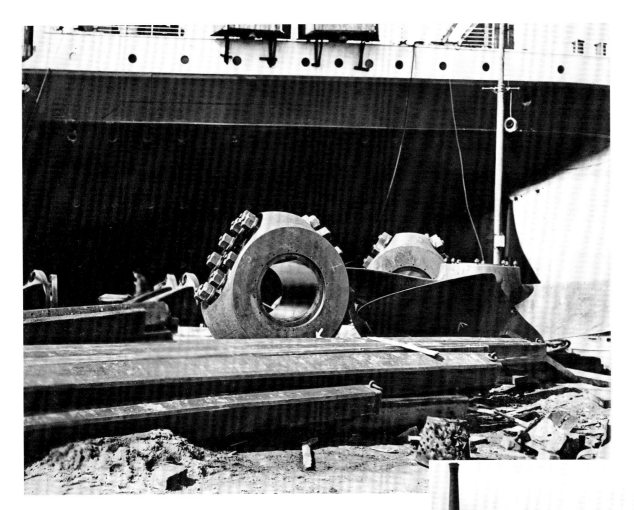

The poop deck of the *Olympic* with two temporary toilet sheds fitted. Between the white and black of the hull is a gold band, while the *Olympic*'s aft docking bridge, seen here, was of shorter extension than on her sister ship.

In the foreground are huge propeller bosses, single propeller blades (behind which a workman is seen), and a four-bladed propeller, which weighed 38 tons. At the time of the *Titanic*'s maiden voyage it was reported that she was 'expected by experts on navigation to make faster time than the *Olympic* because of a slight difference in the curvature of the propeller blades'. The punctured bucket in the foreground may have been used as a brazier for brewing tea.

This postcard gives some orientation. The caisson gate to the dry dock is holding back the Lagan and the location of the pump-house chimney is obvious, while behind it is the Arrol gantry over the two slipways where *Olympic* and *Titanic* were built and launched.

Swinging the *Olympic*

Yesterday morning the *Olympic* was turned, the operation being successfully carried out, thanks largely to the satisfactory manner in which Messrs Kelly, Zwoon, & Co. have dredged the river at this point, notwithstanding the difficulties of the work.

(Belfast *Newsletter*, Monday 29 May 1911, p.7)

Dredger No. 4 had been sunk in collision at the mouth of the Lough the previous year, but was speedily replaced with a dredger of the 'latest type'.

After the *Olympic* was launched, she was nudged by tugs within the hour to the fitting-out wharf, her bows still pointing towards the city. She would have to be swung around in preparation for leaving Belfast, and such an operation was carried out seven months later on Sunday 28 May 1911. Her prow looms high over the onlookers, a gangway door open on her starboard side.

This group of admirers consists of the bearded David Campbell Kemp, a shipowner; Lady Margaret Pirrie, wife of Lord Pirrie; and John W. Kempster himself, which suggests that this photo was taken by his spouse, Eleanor.

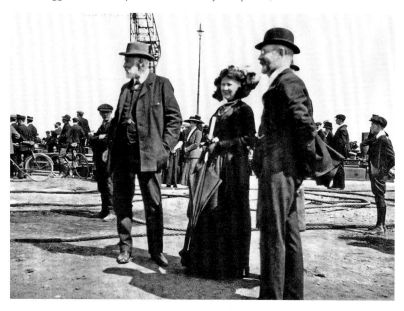

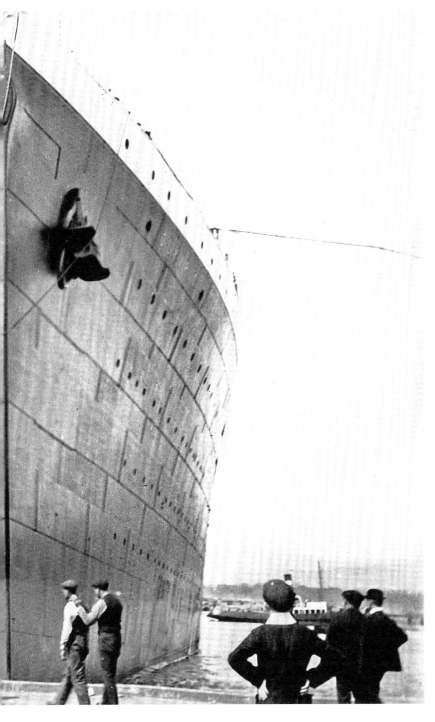

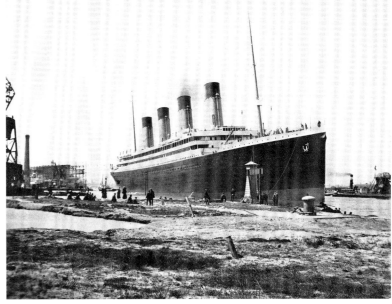

A good establishing shot, the physical features being (from extreme left): the floating crane, the chimney of the pump house at the graving dock and the great gantry designed by Sir William Arrol – where the stern of the *Titanic* is visible on slipway number 3, awaiting her baptism in three days' time.

A couple of bicycles are propped against the base of the light tower on East Twin Island, at the starboard bow, which marks the entrance to the harbour proper. Contemporary maps establish that this elegant tower had a fixed green light and may also have been painted green. The *Olympic* has by now largely completed her Sunday exercise.

The ship has been swung and is blowing off surplus steam at her forward funnel. The E Deck door on the starboard side is open, and crew are using the aft access gangway, which has been connected by the floating crane.

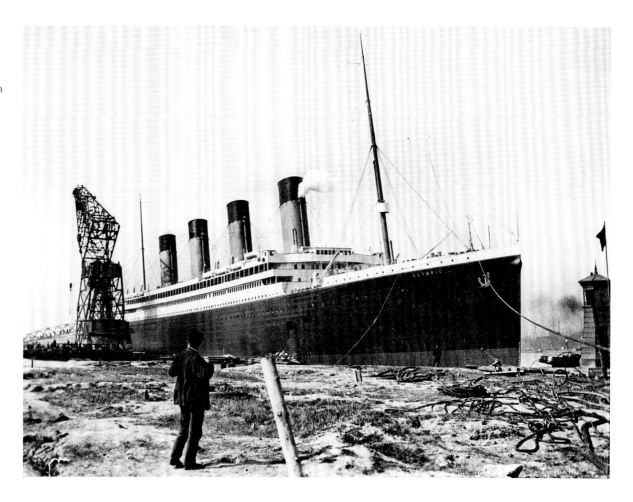

The task of 'swinging' the biggest ship in the world had been successfully achieved on Sunday, the operation being complicated by the fact that the basin is not yet completed, and the work of dredging had been an exceptionally severe one. The whole operation was carried out without a hitch.

(*Belfast Evening Telegraph*, Tuesday 30 May 1911)

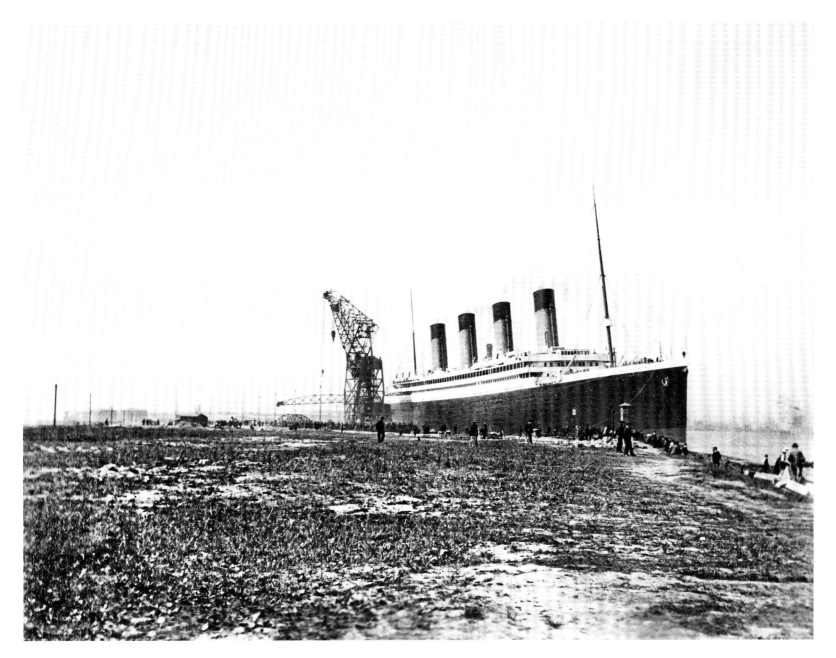

It is the morning of Monday 29 May 1911 and the vessel is about to leave on her sea trials. She is due to make her maiden voyage to New York on 14 June.

On Saturday 27 May she had been specially opened to the public:

Olympic Inspection

A Wonderful Ship

Departure Arrangements

The people of Ulster had, on Saturday, their first and only opportunity of inspecting the great White Star liner *Olympic*, ere she leaves to take up her sailings between Southampton, Cherbourg and New York.

For close on two and a half years they had watched the progress of the great liner with an interest which began on 16th December, 1908, when her keel was laid underneath the huge gantry, which towers high above the North Yard at the Queen's Island.

Eleven months later, or to be exact, on 20th November, 1909, they were privileged for the first time to behold from a distance the monster in complete frame; eleven months later, on 20th October, 1910, they turned out in tens of thousands to witness the launch of the mighty hull, plated and painted, and giving an idea of the tremendous size of a 45,000 ton ship, the largest the world has ever seen.

On Saturday, seven months later still, the helpless hull of 1910 is a living, throbbing machine, equipped with a wonderful combination of engines, and manned by a crew larger than any hitherto seen on a merchant ship; in short the wonder of the world, and one of the most striking triumphs of mind over matter that has ever been.

It was not surprising that notwithstanding the somewhat stiff prices charged for admission [2 shillings and 6 pence] and the limitation of the inspection to a few hours, a great many people should embrace the opportunity of going over the vessel from stem to stern. To have made the charge nominal would have been to invite overcrowding and inconvenience, while the exigencies of the work on board and the White Star line's traffic arrangements were such that an extension of the inspection over several days was impossible. The *Olympic* must sail from Southampton on 14th prox.,

and as the intervening time will be occupied with her trials and a public inspection of one day in the Mersey, it will be seen Belfast's claims have not been overlooked in the matter of obligement to the public.

It has been a mighty effort to get the vessel ready for Saturday; the amount of overtime worked has been prodigious, and there are few, if any, firms which would have finished the ship in the time.

Queen's weather was proverbial in the days of Victoria the Good for Royal functions. *Olympic* weather bids fair to pass into tradition also. The launch took place on a glorious Autumn day, the dry-docking was carried out on an exhilarating spring day, and the inspection was made in brilliant summer sunshine, which showed off the vessel to the best possible effect as she lay moored to the wharf northward of the new graving dock, where practically her entire fitting-out has been done.

A noble sight truly, and as one gazed from the wharf at her magnificent proportions it was impossible to keep the mind from dwelling on the marvellous advance which a quarter of a century has witnessed in shipbuilding. Little over twenty years ago, the world wondered when the 10,000-tonners *Teutonic* and *Majestic* came into being; now they seem ridiculously small contrasted with the huge 45,000-ton vessel before us and her sister ship, the *Titanic*, on the stocks in the neighbouring shipyard, ready to leave the ways at 12.15pm on Wednesday next at Lord Pirrie's command.

A Floating Palace

Through the courtesy of Messrs. Harland & Wolff a number of Press representatives were shown over the vessel prior to the public inspection. The party assembled at the forward gangway, and under the guidance of Mr Saxon J. Payne and other officials, made a tour of the gigantic liner.

To attempt to adequately describe all that was seen in the hour the Pressmen were on board would be to attempt the impossible. Nothing more gorgeous in the way of fitting out a ship has ever been seen, and while the *Olympic* may and will be eclipsed in size, she can never be eclipsed in beauty.

One hardly knew what to admire most – the magnificent promenades on the various decks, the luxurious suites of rooms furnished in styles of different periods, the great dining saloon with its chaste appointments, the beautiful lounge, and the hundred and one other things to be seen on every hand. It was all a revelation even to Atlantic travellers, who were struck with the capacious apartments stretching the entire breadth of the ship, a distance of 94ft.

The party descended at first to the third-class open steerage, and finished up on the boat deck, on which are the gymnasium and the officers' quarters.

Then there were the elevators all through the vessel, the squash racquet court, the swimming baths, and many other conveniences for travellers. It was, in fact, just as if one were in the Hotel Cecil, so perfectly furnished is everything.

The first-class reception room, a noble apartment, beautifully done in white, with exquisite panelling and carvings, attracted an admiration which was eclipsed as one stepped into the first-class dining-room, splendidly decorated, and giving accommodation to 532 passengers. It is 150ft long by 92ft broad, with ceilings 10ft 6in high, while the lighting is remarkably fine, the arrangement of electric lights being exceedingly handsome.

The pantries and galleys already in possession of cooks were wonderful to behold, but there was so much to be seen one could not linger. The second-class dining saloon and the library both claimed attention, and as one wandered along great passages and corridors or ascended to deck after deck, one could not but be almost overpowered by the thought of the brains which had designed that ship, the hands who had built it, and the organisation which had everything in readiness to the hour.

A novel feature was the restaurant à la carte, where the most critical connoisseur in the culinary arts could have everything his heart desired. The longer on the promenade deck and the first-class smoking room were veritable treats. In the latter room the windows were well worth a visit alone, so handsome have they been done. The windows in the saloons are all in most perfect taste, and as some indication of the accommodation in the vessel we may mention that there are over 2,000 sidelights and windows in her, but, needless to say, all the appointments are of the most sumptuous.

Full advantage has been taken of the enormous size and spaciousness of the vessel to excel anything hitherto attempted, both in the public rooms and private cabins. The entrances, the magnificent staircases, and other features are on a scale of unrivalled magnitude and excellence. One could spend hours in writing rooms, reading rooms, the palm court, and the verandahs, but time pressed and the party had to be content with a glimpse of everything, there was so much ground to be covered.

A Small Town

In all, 3,346 passengers, officers and crew will be accommodated. For first-class passengers there are thirty suite rooms on the bridge deck and thirty more on the shelter deck. Including these, there are 330 rooms for first-class passengers, 100 having single berths, 100 double berths, and 130 three berths, with provision in some cases for an additional pullman berth.

For second-class passengers there are 168 rooms, arranged with single, double, or four berths. The boat deck, from which there was a magnificent view of the lough, is 97ft above the keel, and has a length overall of about 492ft. The only public room on this boat deck is a gymnasium, which has a length of about 46ft and a width of 17ft 6in.

The next, the promenade deck, extends over a length of 510ft. The reading and writing room has a length of about 41ft, and a width of about 41ft. The lounge is on this deck, as is the first-class smoking room, which has a length of over 65ft.

On the bridge deck, for nearly 365ft amidships, the shell-plating has been carried to the deck above, but is provided with large square windows, raised by mechanical means at will. Within these is thus a bright sheltered promenade for first class passengers; the walking space abaft this is reserved for the second-class passenger.

In the after end of this deck is a restaurant for first-class passengers. This, as already indicated, is supplementary to the dining room, and is provided so that first-class passengers may dine à la carte.

The dining-saloon for first-class passengers is nearly 120ft long, with a reception room occupying about 50ft of the length of the ship, independently of the stairway and elevators. An interesting

development in merchant ship equipment is introduced on the middle deck and the deck below, in the form of a squash racquet court, which is some 30ft long by 20ft wide, with a gallery, while further aft are Turkish and electric baths, with all the usual appliances.

The swimming bath is 33ft long and over 17ft wide. These two additions, in association with the gymnasium, and the à la carte restaurant, introduce acceptable variations in that cast-iron rule of line on board ship, which in the past has proved so monotonous to many passengers.

The complete length of the vessel is 882ft 6in, 440ft of which is taken up with the machinery; this is equal to 50 per cent of the the total length, while in the case of the express liners it is about 70 per cent.

During the tour the press party met Lord and Lady Pirrie, who exchanged greetings with them and welcomed them on board. His Lordship and Lady Pirrie remain in Belfast until after the launch of the *Titanic* on Wednesday.

Public Inspection

Public concern in the historic interest and importance of the occasion was indicated by the large crowd which has assembled quite half an hour before the period fixed for the public inspection, which was 3 o'clock.

The arrangement was that the public should board the ship by the huge gangway at the bow, and leave by a similar exit at the stern. At the bow gangway a barrier had been erected behind which was a pay-box. Just prior to 2 o'clock a long queue had been formed, which was perpetually being augmented as an unending stream of motor-cars and other vehicles brought fresh contingents every minute to take the places of those who had passed through the barriers.

A special and frequent tramcar service from Castle Junction also helped to swell the complement of sightseers, and incidentally to add to the receipts available for disbursement amongst the hospitals which are to benefit. This fresh evidence of the deep and abiding interest of Lord and Lady Pirrie in philanthropic work, and especially the hospital side of it was the subject of much appreciative comment by the crowd of sightseers.

An army of officials was stationed throughout the huge ship, distributed over the various decks, so as to facilitate inspection by the public, and prevent the bewilderment and confusion that would inevitably have resulted in passing along the various corridors, and proceeding from one deck to another, as well as through the almost bewildering maze of staircase after staircase.

The lounge and the saloon, with their rich furnishings and highly ornate decorative themes, excited continuous exclamations of surprise and delight. Experienced travellers declared that all the efforts of the great competing liners had been completely out-distanced in this direction, and that we seemed to have reached the very last effort in the direction of luxury and comfort that skill and art was capable of accomplishing.

The sleeping rooms in particular evoked expressions of astonishment at the enormous advance that had been made in this direction. One delightful suite of apartments after another presented itself for consideration and admiration, all furnished and equipped with due regard to a particular period in the age of art – Louis XIV, Louis XVI, the Georgian, the Italian, the Renaissance, the Empire – were all represented, and represented at their very highest stage of excellence.

Lord Pirrie declared that it represented his last effort in this direction, and if that be so, his crowning effort is well worthy of the supremely splendid history in shipbuilding which he has written. Surely the *ne plus ultra* in the matter of comfort and decoration has been attained in the *Olympic* and all that is connoted by the expression 'a floating palace' has been adequately realised. As a 'world beater' in other directions the positive luxury and splendour of the ship are upon a par with her record as the greatest thing in ships upon earth.

The inspection at the cheaper rate began at 4 o'clock, and again a great human avalanche passed along the gangways to realise the same surprise, delight and bewilderment of their predecessors. Huge as the *Olympic* looks at the wharf, her true proportions and magnitude are only realised when one has traversed deck after deck and corridor after corridor to finally reached the top deck.

Looked at from the stern, the vista stretching away is enormous, and the *Viper* slipping out to sea, though a really good type of cross-Channel boat, looked little more than a big type of coasting

steamer by comparison. In fact, it almost seemed as if she might be tucked away in the *Olympic*'s engine-room without inconvenience.

The inspection should net a handsome sum for the several hospitals that are to benefit, and the builders of the mammoth liner and the city whose men gave her 'local habitation and a name' have just cause for pride in a ship that will immortalise the name and fame of Belfast for ever.

During Sunday thousands of people viewed the liner from the wharf. A special tram service was run from Castle Junction, and throughout the entire day Queen's Road presented an animated appearance. On ordinary occasions there is no tram service on the Queen's Road on Sunday.

Arrangements For Departure

The *Olympic* leaves the Lough for Liverpool on Wednesday evening, and sails from the Mersey on Thursday evening for Southampton.

(*Belfast Evening Telegraph*, Monday 29 May 1911, p.5)

The *Irish News* of 30 May reported:

The gangway between the vessel and the shore was raised about nine o'clock and the spectators, looking up on to the towering decks, could see the figures of the members of the crew as they moved from one part of the ship to the other, each of them having previously had his duty assigned to him.

The weather was gloriously fine, the sun falling in scorching rays from an azure sky, and large crowds of people assembled in the vicinity of the Twin Islands for the purpose of witnessing the operations.

(*Irish News*, 30 May 1911, p.8)

When the channel had been cleared, the *Olympic* dropped the tugs, and proceeded under her own steam. She presented a magnificent spectacle as she ploughed her way through the water, the beauty of her lines and the vastness of her dimensions being made more impressive and imposing under these new conditions.

The trials are taking place over the measured mile outside the lough on the County Antrim side near the Gobbins Cliffs. The *Olympic* will not return to her berth in Belfast, but she will remain in the lough until after the launch of the *Titanic* tomorrow, when she is to journey to Liverpool, having on board a distinguished party of guests.

(*Irish News*, 30 May 1911, p.8)

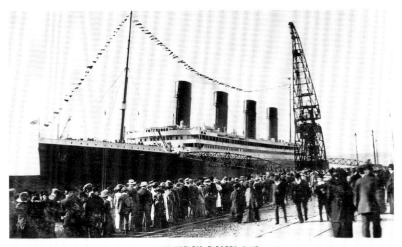

THE WORLD'S BIGGEST SHIP.
PUBLIC INSPECTION OF THE "OLYMPIC" BEFORE LEAVING BELFAST 27TH MAY 1911

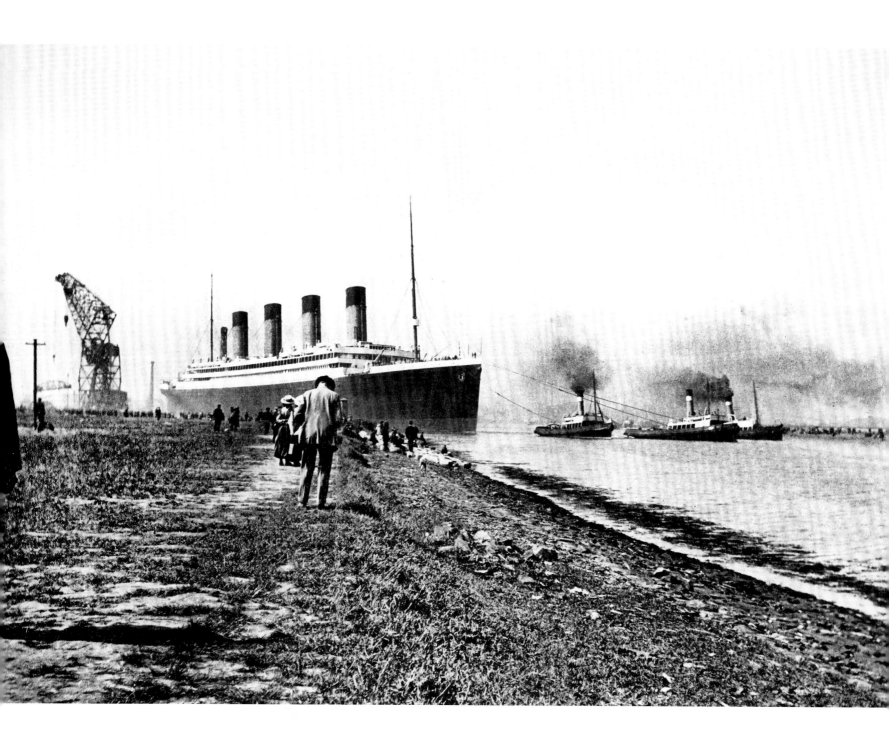

Opposite page: To the left is seen a giant floating crane (designed by Bertha Krupp, after whom the First World War artillery 'Big Bertha' was named), made by Benrather Maschinenfabrik in Germany and sent in stages for assembly at Belfast.

It is capable of lifting a load of 150 tons to a height of 149ft. 'In fitting out big ships like the *Olympic*, it lifts the boilers complete from the wharf and lowers them into the interior of the vessel,' the *Irish Times* declared, adding, 'Fifty years ago Harland and Wolff's only employed about 100 men and boys, and the wages bill just touched £100. The first ship built for them, *Kitty of Coleraine*, could comfortably be accommodated in one of the *Olympic*'s four funnels.'

The crane is removing the aft access gangway. In the picture on p.47 the gangway wheels, which enable it to rise and fall with the tide, are dangling in mid-air. The chimney of the graving dock pump house was between the second and third funnels, but now the *Olympic* has come under the strain of three tugs as she leaves the wharf, and it instead looms between the fourth funnel and the mainmast.

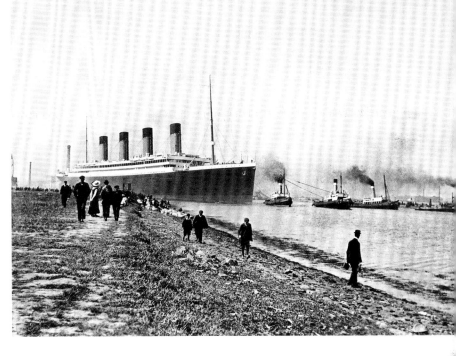

The *Belfast Evening Telegraph* reported:

> The progress of the immense craft down the Lough was watched by huge crowds of people at various points of vantage along the coast at Holywood, Bangor and Whitehead, and those who saw the majestic liner as it dwarfed the proportions of every ship it passed, will not readily forget the spectacle.

The *Olympic* is entering the Victoria Channel, bound for Belfast Lough and her sea trials.

'In the removal of the steamer, five tugs were used – namely the *Herculaneum*, *Wallasey*, *Alexandra*, *Hornby* and *Hercules*. Three of the tugs were at the bow of the vessel, while the other two went astern,' the *Irish News reported*. 'As soon as the signal was given, the tugs got under way, and cheers were raised by the crowds assembled on the shore as the liner gradually left her berthing-place behind.'

A tiny rowboat can be glimpsed on the starboard bow, conveying the new liner's colossal proportions. Just aft of the stern is the pump house of the graving dock which could barely contain her. Crew numbering 250 are now aboard the vessel and she will practise manoeuvres and have her compasses adjusted over several hours before paperwork is signed and she officially becomes part of the White Star Line.

The closest figure, on the shoreline, carries a Kodak folding camera in his right hand and may be an accredited photographer with Harland & Wolff.

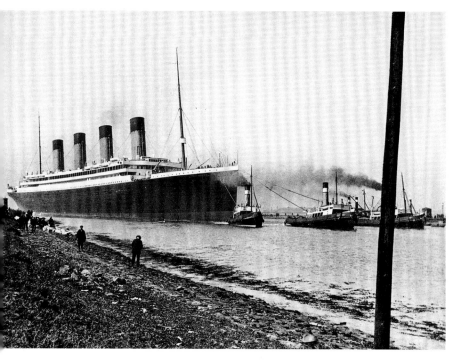

Shipwrecks Lose Jobs of Captains

Navigation Companies Generally Dismiss Officer Whether Guilty or Not

In the case of shipwreck or collision at sea, the general rule of the big steamship companies has been that the captain who is at fault not only loses his place in the service, but frequently has his certificate suspended by the licensing authority. This is one reason why captains prefer to go down with their ships.

A few companies, the North German Lloyd among them, are lenient, giving commanders and other officers another chance if their previous record is good and if the ship does not become a total loss. On the other hand, the White Star Line and others have a hard and fast rule that commanders who lose their vessels or are in a collision that costs the company a big sum of money are to be dismissed.

(*San Francisco Call*, Monday 22 May 1911, p.11)

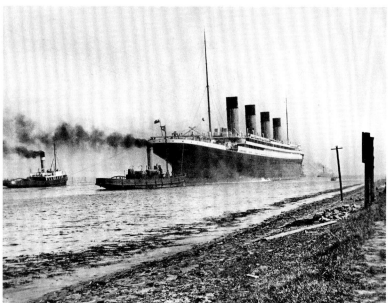

Heading for the open sea. The tug *Wallasey* is flying the White Star Line burgee, while a similar swallowtail is hoist on the aft halliard of the mainmast of the *Olympic*. The sign on the land to the right is believed to state 'Harland & Wolff'.

The *Olympic* makes a slight turn to starboard, taking her from the outfitting wharf into the Victoria Channel, the angle of the two marked by the light tower (just visible under her stern). The photographer is standing on reclaimed land known as East Twin Island. The vessel is one sixth of a mile long and will only have to run a couple of ships' lengths from the confluence of the Victoria and Musgrave Channels into Belfast Lough.

5

LAUNCH OF *TITANIC*

All the while the *Titanic* had been assembling, the second sister on slipway number 3, largely overlooked in the acclaim for *Olympic*. Mentioned in tandem at best, she had to await her baptism in Belfast waters to first claim column inches in her own right. Once more the scribes reached for superlatives, perhaps a touch dutifully, not realising that the vessel being brought to life in words and wrought metal was already fated to enter immortality.

A Marvellous Launch

Witnessed by Thousands

Brilliant Scene at Queen's Island

(From our Reporter)

The vessel launched yesterday from the yard of Harland and Wolff deserves well her name *Titanic*, for none other would more aptly apply.

This ship, the greatest that ever took the water, has been Irish built throughout, it may be said 'born on Irish soil,' and this noble specimen of engineering is so far the finest of man's creation, a testimony to the superiority of Irish brains and Irish hands.

She may visit the greatest of the world's ports, pass rival liners on the vast oceans, still will long remain the finest ship afloat until the day that her greatness will be eclipsed by a sister ship owned by the eminent firm of the White Star Line, designed, built, and engined by Harland and Wolff, just as this one and her renowned elder sisters, such as the *Olympic*, *Baltic*, *Oceanic*, *Laurentic*, have been.

Each of these colossal ships has built up the acknowledged record of the White Star Company for having fast, luxurious, safe reliable ships, but the existence and the performance of these vessels have even added in a greater degree to the lustre of the wonderful Irish firm of which Lord Pirrie is the chief.

The day was really observed as a holiday by all who could possibly leave work, some of them people joining the many of the leisured class who travelled long distances in order to witness the launch.

A glorious day fell to the lot of the public, brilliant sun and a sky unflecked by the tiniest of clouds being the fair, favoured conditions of the weather, *and it is to be hoped that it augurs such a sunny future for the noble ship that she will never know the dark shadow of disaster* [author's emphasis].

Most of the spectators went to the County Antrim side of the river, and here every vantage point, free or bought, was quickly seized on, and those who were on the Queen's Island, on which are the works where the White Star ships were built, could see a dense mass of people lining the opposite side of the river.

The Harbour Board gave up their works to the public for the day, a charge for admission was made, and the resulting sum given over to

the city hospitals. On the river were many craft from small to large, and these were full to overflowing with sightseers.

There were two sights yesterday well worth travelling a long distance to see – one was the launch, the other was the concourse that assembled to greet the entry of the leviathan to its element. The streets leading to the Queen's Bridge showed busy scenes in the forenoon, as the sightseers passed through, but the real sight was the throng that returned when the launch was over, and the torrent of vehicular traffic that poured the thousands of humanity back into the city.

The stranger saw much to interest him in the passing scenes, but it was not until within about a little less perhaps than a quarter of a mile from the works that one loses all thought of humanity and is forced to rivet his full attention on what now confronts him. Rising high over the roofs of the huge suite of offices of Harland and Wolff appears a vast network, which one can see is composed of steel girders and beams crossing one another at all possible angles.

From out of this apparent tangle there loomed the bow of the *Titanic*, just like an enormous wedge. Coming nearer to the works the wonderful picture took even more wonderful shape. On approaching the works there were apparent the complete nature of the details that were even applied to the admission of the guests.

Each door gave entry to the holder of a particular ticket, the checking being in the hands of members of the clerical staff of the firm, these gentlemen being courteous in the extreme. The moment the visitor emerged from the offices he viewed the wonder of ship construction, still it was impossible to get an idea of her gigantic dimensions, for from no part of the immense yard was it possible to see the complete ship.

Immediately beside the bow and facing that great wedge were two immense stands, one being devoted to special guests, the other being exclusively for Pressmen who numbered over a hundred – these being the invited guests of Messrs Ismay and Imrie, better known as the White Star Company.

The Press representatives were not alone from many papers but from several countries, French, German and American journals being represented, Amongst the spectators were many foreigners, notably Germans.

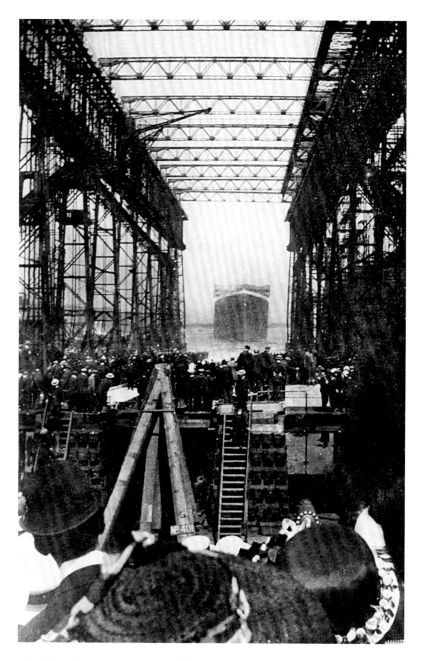

Taken from the main viewing stand (thus not a Kempster picture), this snap shows how the launch platform has been commandeered by sightseers. Just above the lady's large straw hat at bottom of picture is seen a sign reading 'No. 401', which was the *Titanic*'s yard number.

About a hundred feet down from the bow of the vessel and on the port side of the ship was a substantially built stand, almost destitute of any ornamentation, but it bore on its side one inscription that attracted to it the gaze of the public, that one word being 'Owners.' It was untenanted up to within a few minutes of the actual ceremony, for both the owners and builders had until then merged themselves with the crowd of workmen who were engaged on the finishing touches that went to ensure the perfection of launching.

Mr Bruce Ismay, the managing director, strolled unconcernedly about the enclosure, now and then being greeted by his friends, or exchanging a few words with heads of the departments of the builders. But the most interesting of all personages was Lord Pirrie. Dressed in a suit of dark navy serge, and wearing a yachting cap well down over his eyes to shade them from the intense glare of the sun, he was as active as anyone could be in superintending the final stages of the launch.

Despite the great heat, he rapidly visited places where he desired to see matters for himself. As he passed friends and acquaintances, he stopped to exchange a word or two, in most cases the reason of the hearty handshake that was accorded to him being to accentuate the wish to both himself and Lady Pirrie of many happy returns of the day, for it so came about that the birthday of each fell on yesterday – a date which could be also said to be the birthday of the *Titanic*, for it was the day on which she first touched the world of waters that she is to conquer.

Though Lord Pirrie was indeed on yesterday the busiest of men, he never for an instant disclosed the least sign of perturbation or fear of mishap – there was absolute confidence in his movements and his manner. He was the keen man of business who trusted his work to his chosen men, and these he visited at the time he thought best. To see Lord Pirrie yesterday afternoon was to observe how great minds can control and finish a task of great magnitude.

Here was this enormous mass on the ways, a ship over a quarter of a mile long, having deadweight of close on 50,000 tons, towering aloft for almost a hundred feet, worth a couple of millions of money – in the shadow that its great bulk threw as it intercepted the strong light and fierce heat of the sun, was this king of ship construction, cool and calm, awaiting the arrival of the exact second on which his creation was to be released from the fetters that yet bound her to the land.

The *Titanic* rested on a great wooden slip or platform called the ways, this being a platform that shaped at an angle of about 15 degrees towards the water, the structure being of huge beams heavily greased with tallow so as to facilitate the progress of the ship as she slid down the platform on to the water. Around this platform there was a scene of life as swarms of workmen, in the well-known brown dungaree overalls, went in and out beneath the keel of the liner.

These men were busy for some time in removing the short, thick pieces of timber that hitherto had kept the *Titanic* propped in position. In a short space of time these were cleared off, so perfect being the arrangements that they were easily taken away so as to leave an ample margin for the next operation.

Five minutes before the appointed time there boomed out a double rocket, that being the signal that all was clear. At this warning the crowd ceased to move about and took up the best points of vantage that offered. Many were to be seen, watch in hand, to check the actual time of the launch, and to chronicle the length of time it would be before the bow would be in the water, for these ships being launched stern foremost the last place to touch the water is the bow.

Suddenly there broke out from beneath her keel the clang of hundreds of hammers as they rung on metal to metal. This noise was welcome to most of the spectators, for it broke the tense feeling that many felt, for certainly the expectant feeling was but natural. On the sound of a piercing whistle the hammering ceased, and a singular stillness followed, such as one would think impossible in a place where were congregated many thousands.

By this time the 'owners,' a few friends, which included Miss Asquith, and famous American multi-millionaire Mr Pierpont Morgan, ascended to the platform, but Lord Pirrie was still below having a last look at the hydraulic rams that were now the only obstacles to the flight of the *Titanic* from terra firma. These rams were on each side of the ship, one being immediately beside the owners' stand. They are small things to look at, yet they are capable of exerting enormous pressure. In the case of yesterday each ram had a pressure of 530 tons on a trigger that held the ship from slipping down the ways; and as

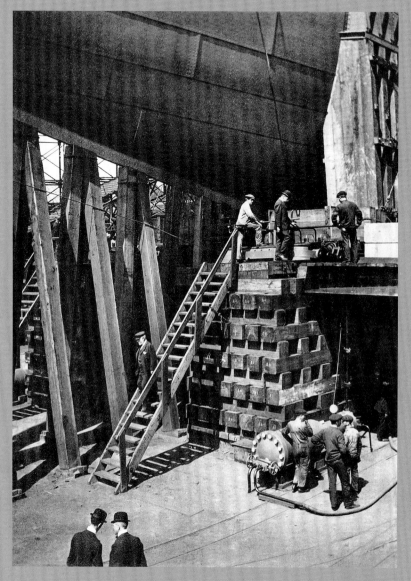

Left: White Star Line chairman J. Bruce Ismay below the hull of the ship that was to haunt him until the day he died. He takes a significant physical risk as he inspects mechanical triggers on a platform some 20ft above the shipyard floor.

Harland & Wolff chairman Lord William Pirrie has already nearly descended, having accompanied Ismay on a final inspection – see the picture taken a short while beforehand *(above, courtesy of Ulster Folk and Transport Museum)* which shows the two men passing a 'hydraulic pressure intensifier' machine.

Ismay, in a bowler hat, has now propped his walking cane in a horizontal position as he carries out his *Titanic* tyre-kicking, minutes before the launch. The stick was inscribed with the family motto 'Be Mindful', and appears to have gone down with the *Titanic*, a sinking he could never banish from his mind.

J. Bruce Ismay testified to being an entirely disinterested passenger on the maiden voyage of *Titanic*. This picture would instead suggest a keen involvement with the vessel. Personally ravaged by the disaster, he died in London in October 1937, aged 74.

Of the two men conversing at bottom of picture, the man on the right is Roland J. Shelley, White Star publicity manager, and probably the man who coined the 'practically unsinkable' phrase used in promotional material. The other man may be Harland & Wolff principal Charles Payne. At bottom right is the cylinder of the hydraulic ram that released the *Titanic* from the stocks.

Lord Dufferin said of W.J. Pirrie that he was a man who 'by his talents and indefatigable exertions had so stimulated the activity of his town that he lifted it from a comparatively inferior position to that of being the third-greatest commercial city in the Empire'.

Born in Québec in 1847, Pirrie entered Harland & Wolff in 1862 as a gentleman apprentice, becoming partner in 1874 and chairman in 1895. He was Lord Mayor of Belfast in 1896–97. He died at sea in 1924, aged 77, his body being repatriated on the *Olympic*.

the pressure was removed, these triggers were so arranged that they fell out of the notches in the ship into which they fitted, and thus the last tie was broken.

A few seconds from 12.15 not a single voice was heard. Lord Pirrie turned unconcernedly away from the hydraulic machine and slowly ascended the steps leading to his platform, leisurely took out his watch, and at the instant of 12.15 slightly, almost imperceptibly, moved his hand.

Once more the whistle rang out, and then signal rockets boomed, the mountain of metal commenced to move, and there burst forth from the throats of the thousands of men, women and children that were assembled at the yard, from those that filled the boats on the river, and from the great human host that fringed the opposite shore, a cheer that seemed like tumult – it was a wild roar. Hats flew high; persons dressed in the height of fashion forgot the menace to fine feathers and beautiful costumes that lie thick in a shipyard, for several hundred tons of tallow went to making smooth the progress to the sea of the great liner – these people were caught in the vortex of the excitement born in the wonder of seeing great things, evidently easily done, and very many hundreds ran as hard as possible in order to see the *Titanic* take the water. She beat most of her admirers, for the entire quarter of a mile of ship, displacing sixty thousand tons, was completely in the water in sixty-three seconds from the time she first moved.

The spectacle was one never to be forgotten. First her slow motion as she was loosed from her thraldom, then the speed accelerated, and became quicker and quicker as she neared the water that was to be her future foe, as if she was eager to take on the battle with the element that has waged war on her kin ever since man first pitted the structure of his creation against the mightiest force of nature.

She took the water just as would a swan, her beautiful lines of displacement throwing even a much lesser wave that would the paddles of the big tugs that took her in tow immediately after. There are always fears of a wave caused by the sudden displacement of such a huge body of water, and at English yards there have been bad accidents from the wave breaking on the quays near to the launch and enveloping spectators. In the case of the *Titanic*, though she ran into what was a comparatively narrow space, her lines are so fine that the resulting wave

only sent the water to a height of nine inches, certainly not quite a foot, so that the spectators were never once in the least danger.

It was only when the *Titanic* was in the water that her magnificent lines were apparent. She looked the perfection of symmetry, truly a ship, sitting as vertical in the water as if she had previously been tested and balanced to the ounce. To the writer the launch was a most fascinating spectacle, but what chiefly absorbed his attention was the giant personality of the head of the wonderful firm of Harland and Wolff, Belfast, the builders of the largest and best ships that the world has ever seen, a reputation that they will preserve as long as there will exist such a firm as the White Star Company, [which] believes in having built for them by the best people the best of ships.

(*Cork Examiner*, Thursday 1 June 1911, p.8)

—··—

New White Star Liner

Titanic Launched

Largest Afloat

—··—

(From our Reporter)
Belfast, Wednesday Night.
There was nothing in the appearance of the streets of Belfast this forenoon to inform a stranger that such a momentous event as the launching of the second of the two largest ships the world has ever yet seen was to happen.

Belfast is used to great undertakings, and did not consider it necessary to pay general public attention to the ceremony to be gone through at mid-day, having regard to the fact that a similar function was brought off only as far back as last October, when the sister ship *Olympic* was consigned to the waters of the Lagan, and eminently successful as that launch was, it was eclipsed, if anything, by the ease and total absence of uncertainty as to eventualities evinced on the present occasion.

It was characterised by the extreme coolness of all the officials of the building yard, from Lord Pirrie down to the labourer who wielded a sledgehammer under the ways on which the ship was cradled.

Although a general holiday was not observed, enormous throngs wended their way both to the yard where the gigantic ship loomed up largely, and to all vantage points on both sides of the Lagan.

The yard itself was densely packed by a huge crowd of visitors, and as the hour approached, every available spot wherefrom a good view could be obtained, was occupied.

Ten minutes before the liberating of the ship on the ways, two guns were fired notifying to the public that all was in readiness. At five minutes to the hour the second signal was given.

Lord Pirrie seemed ubiquitous, and left no point of the ship uninspected, and now the hour had approached, appointed for despatching to her native element a huge mass of naval construction such as the world has never seen except in the days of her twin sister, and it was moved from the place which she occupied on land to the waters of the Lagan under the shadow of Cave Hill with much apparently ease and absence of trouble as a step in walking is taken by a pedestrian. Sixty-three seconds were occupied in transferring a bulk of 45,000 tons from land to water, and it was done without a hitch.

As the ship began to move on the ways, the pent-up feeling was loosened and tumultuous cheering filled the air, and Irishmen naturally felt proud that their country should have played such a conspicuous part in what has been aptly described as an historic event, and one that redounds to the credit of our country. 'Bravo, Belfast,' exclaimed an enthusiastic onlooker, 'you still lead the world in the manufacture of ships and shirts.'

At a luncheon subsequently given at the Grand Central Hotel to the guests of the White Star Company, speeches were delivered by Messrs R.J.A. Shelly, White Star Line; Mr Saxon Payne, representing the builders, Messrs Harland and Wolff; and Mr Frank Bullen, journalist [*Harmsworth* magazine; maritime author].

Mr Shelly drew attention to the fact that his company, in conjunction with the builders, were making history, and in the Lagan that day had actually floating 90,000 tons of marine architecture in its highest form of development at a round cost of three millions of money, and claimed for his company no mean share in the cementing of the two great English-speaking peoples of the United Kingdom and America, and thereby helping to secure the peace of the world.

Mr Saxon Payne said that in the *Titanic* just launched, and in the *Olympic* which has just undergone most satisfactory trials in Belfast Lough, they had absolute proof that the Anglo-Saxon and Celtic races were not effete. As a remarkable coincidence and as a moment of good augury he mentioned the fact that the launch of the *Titanic*, the

Financial titan J.P. Morgan at the launch of the *Titanic*. He might have taken the maiden voyage, but instead decided to holiday at Aix-les-Bains where he opened a sanatorium built in memory of his old doctor Leon Blanc.. 'A great part of the ceremony which had been arranged was omitted owing to the loss of the *Titanic*,' reported *The Times* on 20 April 1912.

departure of the *Olympic* on her maiden trip, and the joint birthday of Lord Pirrie, who superintended the designing and construction of both ships from truck to keel, and that of his wife, Lady Pirrie, should all have occurred on the same day.

Amongst the prominent visitors present with Lord Pirrie at the launch were: Mr Bruce Ismay, Mr Pierpont Morgan [tycoon J.P. Morgan], Messrs Harold A. Sanderson, C. H. Torry, E. C. Grenfell, John Lee, New York, etc.

(*Cork Examiner*, Thursday 1 June 1911, p.8)

——

(From our Reporter)
Belfast, Wednesday.
Yet another monster production of the shipbuilding industry has been consigned from the place of its creation to the waters of the Lagan.

A period of seven months has only elapsed since the news was given to the civilised world that the largest ship the world had yet seen was successfully launched from the yard of the famous shipbuilders, Messrs Harland and Wolff, of Belfast, and now a like event has been accomplished, and the twin sisters are floating on their native element, a monument to man's skill and industry, and marking a step in the onward march of science, which on reflection is calculated to take one's breath away in wonderment and consternation as to what is to come next.

It is not given to ordinary mortals to foretell with certainty what the future may bring forth or have in store, but that finer specimens of the shipbuilders' art can ever be produced it is hard to imagine.

Go into the details of these latest gigantic specimens of naval architecture as to construction, strength of material employed, efforts to secure absolute immunity from mishap or accident, the utility and beauty of design of their internal economy, the excellent engineering skill employed in the arranging of every cubic yard of their huge bulk, and it seems a fanciful stretch of the imagination to think that there is anything better beyond; yet who shall set a limit to the onward progress of science and man's ingenuity?

It is particularly gratifying to think that in the latest effort of man to set aside the dangers and discomforts of ocean travel, concomitants heretofore, Ireland, as represented by the Belfast shipyard on Queen's Island, should have played such a noble and conspicuous part.

In recent years ocean travel by each latest outcome of ship construction has gradually been robbed of its terrors and dangers, real and apparent, which it held for many, but now, judging by what Messrs Harland and Wolff were enabled to present to the view of their visitors to-day, these are bogeys which are set at rest for ever more [author's emphasis], and travelling in the future when undertaken on the latest White Star leviathans will be accomplished under ideal conditions and surroundings, such as to cause a rubbing of the eyelids and self-interrogation as to whether Utopia has been reached or not.

The foregoing may be characterised by the sceptical as exaggeration and not a statement of real fact, but a close examination of material facts will readily convince the most doubting.

Whatever conditions the modern sea voyager looks for in the vessel which he selects to bear him in safety over the ocean's vast bosom, he will here find at the acme of perfection. If spaciousness in the various compartments is what is sought for, then nowhere can it be found in that plenteousness to be met with on the *Titanic* or her sister ship. This is simply verified by the concrete fact that the gross tonnage of the *Titanic* equals that of the combined tonnage of the *Baltic* and *Adriatic*, two of the crack ships of the White Star line, and any traveller who is acquainted with either of these masterpieces can form a fair idea of what the *Titanic* is capable of affording her patrons in the matter of space.

Safety is the first consideration with all voyagers, and no excellence in other ways can compensate for the lack of it. The *Titanic* is the last word in this respect, double bottom and watertight compartments, steel decks, massive steel plates all in their way making for security, safety and strength. Nothing is left to chance, every mechanical device that could be conceived has been employed to further secure immunity from risk either by sinking or fire. Should disaster overtake her through contact with rock, instant means can be taken to avert consequences by concentrating attention on the compartment damaged, which is instantaneously ascertained by an indicator in view of the officer then in charge on the bridge, who is also enabled at the same time by the moving of a lever to close up and seal all or any of the watertight compartments into which the ship is divided.

Fire – more dreaded even at sea than on land – can with the same lightning speed be located and subdued before any headway has been made and so easily conquered. The dangers of the sea are practically non-existent on these latest magnificent vessels.

Comfort in every conceivable form is now-a-days looked for by every sea-going traveller, yet nowhere can it be met with in a greater degree of perfection than on board this last addition to the Mammoth White Star Fleet. State rooms, equipped and appointed in every respect equal to bedrooms in the best modern hotels ashore. Suites of apartments, replete with every requirement and luxury, even to a private shower bath, are supplied. Spacious, lofty, and elegantly decorated and luxuriously furnished rooms, such as dining saloons, lounges, library, smokerooms, are there found in readiness for the traveller's occupation and enjoyment. Of course the extreme steps taken to absolutely secure the safety of the ship has its resultant, in that all classes of passengers share equally in the benefits derivable, and the security of one could not be secured to the detriment of another; but in the matter of comfort there could, and often is, a glaring disparity between what is thought as being being suitable degrees in keeping with the prices of passage paid, yet here is found a new order of things, and second and third-class passengers are catered for in a manner beyond all expectation, and will certainly secure for the White Star Company a huge increase to the numbers who travel at the cheaper rates in their ships.

Everything now-a-days is worked at high pressure, and we have literally got to flying from place to place, yet speed was made subservient to safety and comfort on the *Titanic* and her twin and an average speed of 21 knots is only aimed at, and this will fulfil the average traveller's requirements, especially when accompanied by increased strength, security and lack of vibration.

Sea breezes beget healthy appetites, and the kitchen is furnished in such a manner as to satisfy the requirements of the most accomplished chef, who has here at his command all the latest appliances and devices employed in the culinary art, and he can draw on a larder stacked with all the best of edibles, wherewith to show his skill in tempting the palates of his patrons.

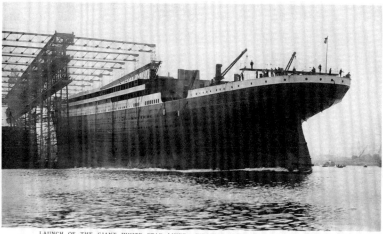

LAUNCH OF THE GIANT WHITE STAR LINER "TITANIC" 45,000 TONS, BELFAST, MAY 31st, 1911. LARGEST VESSEL IN THE WORLD.

A contemporary postcard of the launch. The flag at her stern was not a marine ensign, as the vessel was not yet in commission. Instead it was a red banner intended to warn all other traffic to stand clear.

Health giving recreation can be had in the well appointed gymnasium, swimming bath, racquet court, and music supplied by the orchestra carried will make concerts and dancing in the convertible ballroom a joyous means of social intercourse.

Whether business or pleasure caused one to be a member of the huge number of passengers – over three thousand – which the *Titanic* will carry, it is hard to conceive that a sea journey can be done under more inviting conditions, and it is hard to believe that the future has better to show posterity.

The position which the White Star Company enjoys in the world of shipping is second to none. Keenly sensible of the spirit of the age and the march of progress in everything, the White Star Company's management give evidence year after year of the gigantic strides which have made this great Company one of the leading shipping combinations of the Kingdom, and as the years roll on, so does the unlimited prosperity of the Company, which flies the solitary star as its honoured house flag, and though the magnificence of the White Star fleet as constituted at present is such that the ships of the Line continue to attract travellers from all

the countries of the world, it is safe to assume that the patronage which will be extended to the *Olympic* and *Titanic* will know no bounds, and already, wherever one turns in commercial and social circles, aye, or in the busy hives of the world's industry at home or abroad the two new giant White Star liners are discussed and the advance booking for voyages still far distant, marks how Atlantic travellers watch the advent of the two incomparable ships, the second of which rests in the Lagan this afternoon after a launching ceremony which attracted a record attendance to the riverside of the Northern capital. One of the greatest authorities on shipping present at the launch this afternoon aptly remarked as the *Titanic* slipped gracefully to the water, 'There must be finality somewhere in ship construction, and I believe the *Titanic* and *Olympic* represent such. Man's skill and ingenuity cannot produce anything greater than those two ships.'

Passenger Accommodation of the *Titanic*

The extent of the accommodation is as follows –

First-class passengers	730
Second-class passengers	560
Third-class passengers	1200
Officers and crew	63
Engine-room complement	322
Stewards and victualling department	471
Total	3346

The forward end of the boat deck constitutes the navigating bridge, and contains the accommodation for the officers, for whose use a part of the promenade space is marked off. Another portion of the promenade is allocated to the engineers, and the remainder of the space is divided between the first- and second-class passengers. The only public room on this deck is a gymnasium, measuring 46ft by 17ft 6in. On the next or promenade deck are situated all the public rooms, apart from the dining saloon and restaurant. The smoke room, which

opens into a palm court and verandah, divided into two halves by the second-class companion way, is at the extreme after end and is entered from one of the two first-class entrances.

Bridge Deck

The next or bridge deck, the midship portion of which has a length of 500ft, is mostly occupied by passenger accommodation. Round it there runs a promenade partly for first class and partly for second class, protected for a great part of its length by solid steel screens pierced with large windows. A similarly sheltered promenade for second-class passengers is provided on the shelter deck below. A large portion of the saloon deck amidships is occupied by the first-class dining saloon. It is entered from a reception room, which itself can be used for dining purposes if required.

Squash Rackets

Much of the next deck below, known as the upper deck, is given up to the accommodation of stewards, cooks and seamen, etc., but there are also state rooms for the first-, second- and third-class passengers. The middle deck, which is still well above the water-line, has accommodation for second- and third-class passengers, as well as for the engineer officers, and on it are situated a Turkish bath and a swimming bath, the latter being 33ft long and over 17ft wide. The last two decks, known as the lower deck and the orlop deck, are mainly devoted to the purposes of the ship. There are, however, rooms for second or third class, and on the lower deck a squash racket court, which rises through the middle deck.

Main Features of the *Titanic*

The advent of the *Olympic* and *Titanic*, the leviathans of the Atlantic, coincides very appropriately with the most important development of modern times – the movement of the British and American people towards the ideal of international and universal peace. Of all the forces

contributing to this great and desirable consummation, commerce has been one of the most potent, and as the growth of international trade is largely due to the progress in shipping, it is impossible to over-estimate the service rendered to the Anglo-Saxon race by the enterprise of our shipowners and shipbuilders. No better instance of this spirit of enterprise can be produced than the building of the White Star Liner *Olympic* and her sister ship *Titanic*, constructed as they have been side by side at Messrs Harland and Wolff's ship yard, Belfast. The spectacle of these two enormous vessels on adjoining slips, representing over 100,000 tons displacement, was altogether unprecedented, and naturally the public interest taken in the vessels on both sides of the Atlantic has been very keen. It has been felt that, great as the triumphs have been in the past in naval architecture and marine engineering, these two vessels represent a higher level of attainment than had hitherto been reached; that they are in fact in a class by themselves, and mark a new epoch in the conquest of the ocean, being not only much larger than any vessels previously constructed but also embodying the latest developments in modern propulsion.

The construction and general features of the *Titanic* are: Length overall, 882ft 9in; length between perpendiculars, 850ft; breadth extreme, 92ft 6in; depth, moulded, keel to top of beam, bridge deck, 73ft 6in; total height from keel to navigating bridge, 104ft; gross tonnage, about 46,000 tons; indicated horsepower of reciprocating engines, 30,000; shaft horsepower of turbine engine, 16,000; speed, 21 knots.

There are fifteen transverse water-tight bulkheads, extending from the double bottom to the upper deck, at the forward end of the ship, and to the saloon deck at the after end – in both instances far above the load water line. The room in which the reciprocating engines are placed is the largest of the water-tight compartments, being about 69ft long; while the turbine room is 57ft long. The boiler rooms are generally 57ft long, with the centre propeller, driven by the turbine works in the usual stern-frame aperture, while the wing propellers are supported in brackets.

The Arrangement of the Decks

There are ten decks in the ship, named from the bottom upwards: – Lower orlop, orlop, lower, middle, upper, saloon, shelter, bridge, promenade and boat. The passenger decks – promenade, bridge, shelter, saloon, upper, middle and lower, are named alphabetically – A, B, C, D, E, F, G. Two of the decks are above the moulded structure of the ship. The lower orlop, orlop, and lower decks do not extend for the complete length of the structure being interrupted for the machinery accommodation. The bridge deck extends for a length of 550ft amidships, the forecastle and poop on the same level being respectively 128ft and 106ft long. The promenade and boat decks are also over 500ft long.

The first-class passengers are accommodated on the five levels from the upper to the promenade decks. The second-class passengers have their accommodation on the middle, upper and saloon decks, and the third-class passengers have their accommodation on the middle, upper and saloon decks, and the third-class passengers on the lower deck, forward and aft, and on the middle, upper and saloon decks aft.

The Steering Gear

The steering gear fitted on the shelter deck is, as can readily be imagined, very massive, the diameter of the rudder-stock – 23½in. – affording some idea of the dimensions. The gear is of Harland and Wolff's wheel and pinion type, working through a spring quadrant on the rudder head, with two independent engines having triple cylinders, one on each side. Either engine suffices for the working of the gear, the other being a stand-by. The quadrant is so designed as to minimise the shocks received in a sea-way. The spire and bevel gear is of cast steel. The gear is controlled from the navigating bridge by telemotors, and from the docking-bridge aft by mechanical means. In general design the gear resembles that which has given so much satisfaction in all recent White Star ships. The steering gear of a ship is rightly regarded as of the highest importance, and Harland and Wolff's gear has long been recognised as constituting an element in the safety of the vessels in which it is fitted.

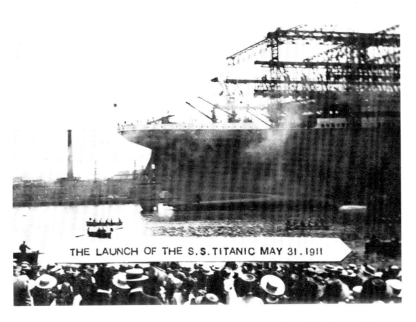

THE LAUNCH OF THE S.S. TITANIC MAY 31. 1911

A rare postcard of the launch, taken from the opposite side of the Lagan. This example sold at auction for £4,000.

A strongly-built crane is fitted at the centre line of the forecastle deck for handling the 15-ton anchor, which is placed in a well in the deck immediately abaft the stem.

The capstan gear, operated by steam engines is also by Messrs Napier, and includes on the forecastle two capstans worked by the windlass engines, two with independent engines, and on a lower level one for handling mooring ropes. Aft there are five capstans, with four steam engines, one of which actuates two capstans.

Navigating Appliances

The navigating appliances are most complete. In addition to the two compasses on the captain's bridge, and one of the docking bridge aft, there is a standard compass on an isolated brass-work platform in the centre of the ship, at a height of 12ft above all iron-work, and 78ft above the water-line. Adjacent to the bridge there are two electrically-driven sounding machines, arranged with spars to enable soundings to be taken when the ship is going at a good speed.

All observations can thus be taken under the direct control of the officer in command. The telegraphs are by Messrs J.W. Ray and Co. of Liverpool, and communicate with engine-room, capstan and other stations. As already indicated, there is also telemotor gear for the steering of the ship. The vessel is fitted with complete installation for receiving sub-marine signals.

The lifeboats, which are 30ft long, are mounted on special davits on the boat-deck.

The ship has two masts, 205ft above the average draft-line, a height necessary to take the Marconi aerial wires, and to ensure that these will be at least 50ft above the top of the funnels, and thus clear of the funnel gases. The masts are also utilised for working the cargo by means of cargo spars, and in addition there is on the foremast a derrick for lifting motor-cars, which latter will be accommodated in one of the foreholds.

Watertight Doors

The watertight doors in a vessel of this size, are, of course, a most important item. Those giving communication between the various boiler rooms and engine rooms are arranged, as is usual in White Star steamers, on the drop system. They are of Harland and Wolff's special design, of massive construction, and provided with oil cataracts governing the closing speed. Each door is held in the open position by a suitable friction clutch, which can be instantly released by means of a powerful electric magnet controlled from the captain's bridge, so that, in the event of accident, or at any time when it may be considered advisable, the captain can, by simply moving an electric switch, instantly close the doors throughout, *practically making the vessel unsinkable* [author's emphasis]. In addition to the foregoing, each door can also be immediately closed from below by operating a releasing lever fitted in connection with the friction clutch. Moreover, as a further precaution, floats are provided beneath the floor level, which, in the event of water accidentally entering any of the compartments, automatically lift and thereby close the doors opening into that compartment if they have not already been dropped by those in charge of the vessel.

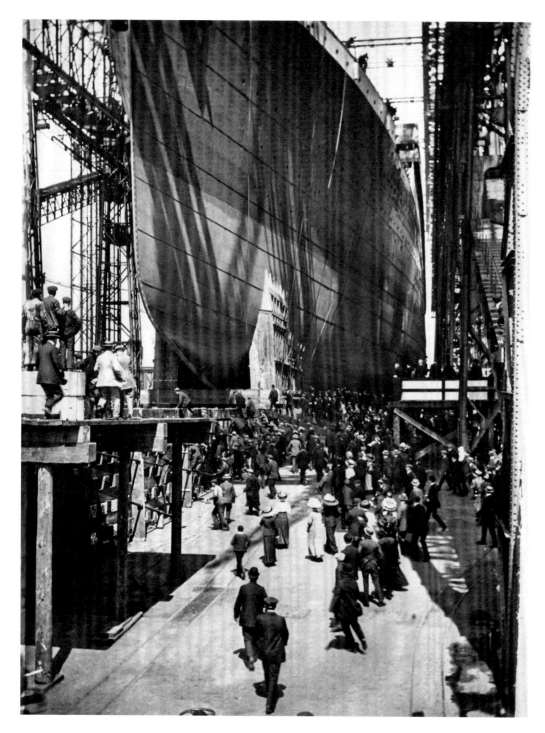

'Launch of *Titanic*, May 31st, 1911. "Going"': An irregular line of bumpy white reveals the tallow on top of slipway number 3, on which *Titanic*, still in her wooden cradle, is already relentlessly sliding to 'a roar of cheers'.

It is only about fifteen seconds into the launch. The extreme left of picture is not a viewing stand – it is instead the ram platform where Bruce Ismay stood just a short while before. To the right is the owners' stand, where business chiefs are staring at their latest success, while people below have broken from their corralled lines. Some observers are on the Arrol gantry, right.

The excitement has caused a rush of men, lower centre, who are feverishly anxious to clamber up onto the slipway in a species of launch hysteria, leaving women in their wake. It was reported next day: 'Very many hundreds ran as hard as possible in order to see the *Titanic* take the water.'

If this is what a thrill of adventure can do, what might or must have happened in the panic of a sinking? Col Archibald Gracie described the moment, just before the end, when 'a mass of humanity several lines deep' burst onto the boat deck. This was a steerage tide, overwhelmingly doomed to drown.

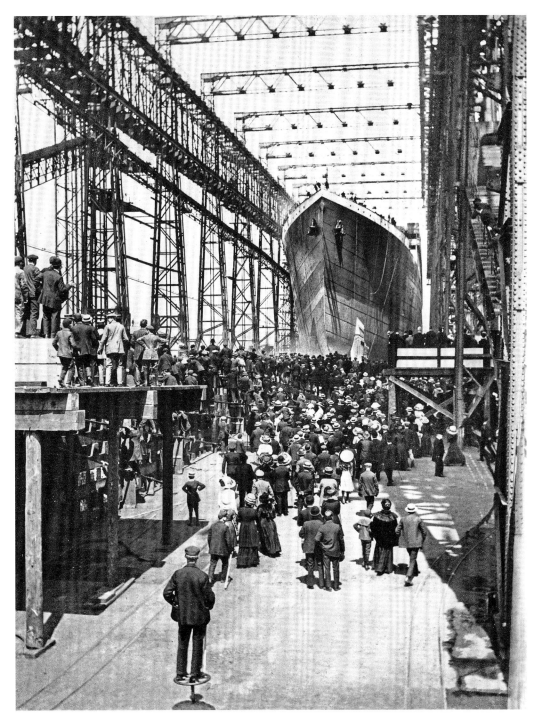

'"Going"': Half a minute in, shoals of people have shouldered their way up and on to the slipway. One intrepid soul at the bottom of picture is standing on an elevated wheel of machinery; another is standing on the roof of a building. Under the platform to the left, a gentleman in a top hat and overcoat is desperately trying to climb higher. while a youth in a boater, arms akimbo, appears to have been studying him in wonder, even if he has just turned his head towards a policeman, a few steps ahead. Note that there is not a single female in this exultant male ascent.

Workers on board the *Titanic* herself have journeyed to the stem post to behold a vast assembly swarming, yet receding steadily from them. The *Titanic*'s name has not been painted on the hull, demonstrating that all photographs of her on the stocks with a name visible have been simply touched up.

A lady's bonnet is craning out from the owner's stand; while there was no christening ceremony (it was said White Star 'builds 'em, and shoves 'em in'), the *Irish News* reported the next day that Florence Ismay, wife of Bruce, intoned as the steel cliff slid by, 'I name this ship *Titanic*, and may God bless her, and all who sail in her'.

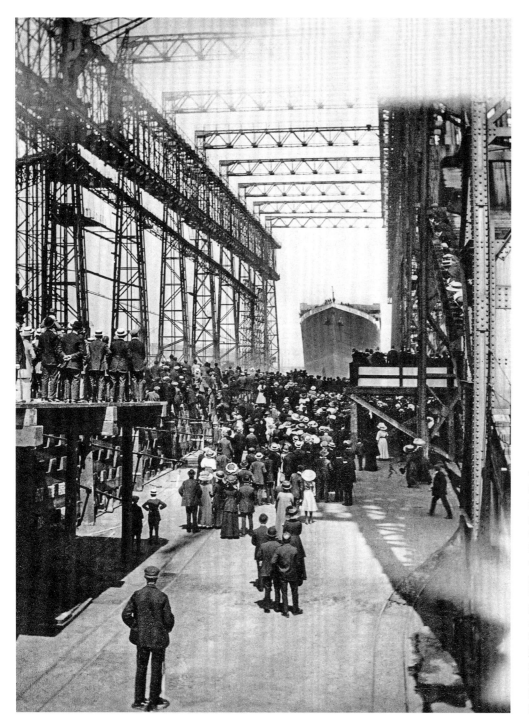

'"Gone'": Approximately fifty seconds have gone by, and *Titanic*'s bronze tailshafts have reached the water, while most of the throng stands stock still, watching transfixed. Many are crowded in a position of extreme risk, while one woman to the left of centre has finally gained height – probably hauled up by her boyfriend, who seems to have a protective left arm around her waist. Another woman, right, has gone up the steep Arrol gantry access slope to join onlookers who are ranked higher still. Despite press claims of 'hats flying high' in celebration, nobody appears to have doffed their headgear to hail the baptism by this evidence.

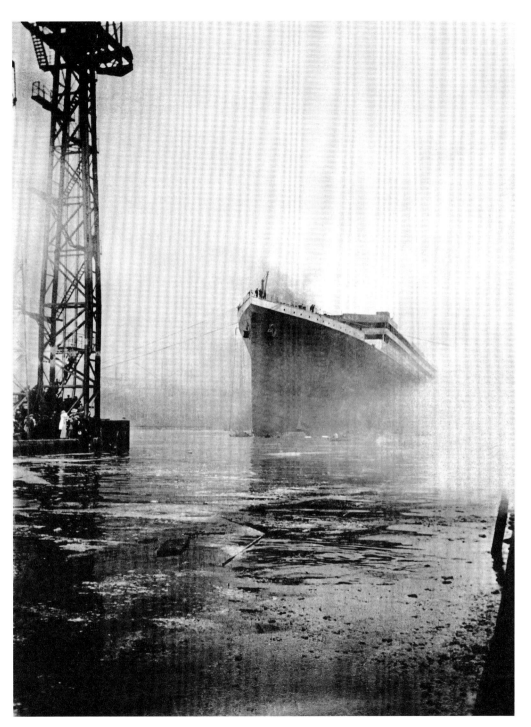

'In the water': Just outside the gantry, the vessel has been pulled up, with her wooden poppets still attached at the base of the prow. Visible alongside is one of the rowboats whose tasks included detaching the arrest hawsers hooked to eyeplates in the hull and even recovering valuable pieces of timber. It is said that 100,000 people witnessed the launch, and there were deep drifts of spectators on the opposite shore of the Lagan, on Albert Quay and at West Twin Island, even at the rival Workman Clark yard.

High on the port side of the bare superstructure, a sole figure leans out from what will become the boat deck – although there is a yawning gap in a forward location where a quartet of lifeboats will ultimately be lined.

The *Olympic* and *Titanic* are not only the largest vessels in the world, they represent the highest attainments in naval architecture and marine engineering; they stand for the pre-eminence of the Anglo-Saxon race on the ocean, for the 'command of the seas' is fast changing from a naval to a mercantile idea, and the strength of a maritime race is represented more by its instruments of commerce and less by its weapons of destruction than was formerly supposed. Consequently, these two leviathans add enormously to the potential prosperity and progress of the race, and the White Star Line have well deserved the encomiums that have been showered upon them for their enterprise and foresight in the production of such magnificent vessels.

It is safe to predict that the *Olympic* and *Titanic* will enhance the great reputation already enjoyed by the Line; they are without a peer on the ocean; though so large, they are beautiful, alike in their appearance and in the simplicity of the working arrangements. Everything on board has been well – in many cases brilliantly – conceived and admirably carried out, and passengers will find comfort, luxury, recreation and health in the palatial apartments, the splendid promenades, the gymnasium, the squash racquet court, the Turkish baths, the swimming pond, palm court verandah, etc. Moreover, the staterooms, in their situation, spaciousness and appointments, will be perfect havens of retreat, where many pleasant hours are spent, and where the time given to slumber and rest will be free from noise or other disturbances. Comfort, elegance, security – these are qualities that appeal to passengers, and in the *Olympic* and *Titanic* they abound.

The horse has been described as the noblest work of the Creator; a ship may be said to be one of the finest of man's creations, and certainly the *Olympic* and *Titanic* deserve special recognition as the product of man's genius and enterprise. A ship – if the Ark can be so designated – played an important part in the early stage of man's development. To-day ships are amongst the greatest living agencies of the age, and the White Star liners *Olympic* and *Titanic* – eloquent testimonies to the progress of mankind, as shown in the conquest of mind over matter – will rank high in the achievements of the 20th century.

(*Cork Examiner*, Thursday 1 June 1911, p.8)

The London *Times* reported the next day:

> Underwriters were glad to note that the new White Star liner *Titanic* had been successfully floated at Belfast. With the possible exception of the insurances on the *Mauretania* and *Lusitania*, the amounts to be covered on the *Olympic* and *Titanic*, when the vessels take up their service, are the largest that have ever been placed in the market.

That same day, 1 June, shipwright James Dobbin, 43, was working a cross-cut saw on a ribband used in the *Titanic* launch when one of its supports fell on him, pinning him to the ground. Taken to hospital, he died next day from shock and haemorrhage. Dobbin left a widow, Rachel, and a son, James Jr, 17.

There would be further accidents and deaths, 254 incidents in all, just in fitting out the vessel.

—·—

The launch of the new White Star liner *Titanic*, following upon that if the *Olympic* last Autumn, has shown the world once again that in those great industries to which she has devoted herself, Belfast is second to no city on the face of the globe.

Not only residents of this great commercial centre, but Irishmen wherever they are situated, whether in Arctic or tropical regions, on mountain, plain or wave-beaten island, thrilled with pride at the news of this memorable achievement.

(*Belfast Evening Telegraph*)

6

OLYMPIC MAIDEN

The *Olympic*'s preparations did not begin well. On the day of *Titanic*'s launch, 100 firemen aboard her sister went on strike, 'owing to some difference with the owners over their terms of engagement. The abruptness with which the strike occurred looked like making matters rather awkward having regard to the plans which had been made for the departure of the vessel', said the Belfast *Newsletter*. 'But other men were soon found to take the place of the disaffected, and in this way the situation was saved.'

The *Olympic* sailed for Liverpool, where she was opened for public inspection for a day. That city's *Daily Post* declared: 'Her stately proportions were much admired and seen to the greatest advantage. The arrival of the magnificent vessel was greeted with salvoes of applause.'

She arrived in Southampton on 3 June, and was soon facing new labour troubles, this time to do with coal. The maiden voyager would eventually be bunkered by labourers from the North of England under police protection in the midst of a strike by local colliers. When the scab workers arrived by train there was 'some jeering but no real disturbances'.

The *Belfast Evening Telegraph* eventually reported:

Olympic's Maiden Voyage

Southampton, Wednesday – The White Star liner *Olympic*, which has been making ready for sea at Southampton, in face of unexampled difficulties occasioned by labour troubles, sailed on her maiden voyage shortly after noon today, being drawn out of the new dock only a few moments after the advertised time.

Her departure was witnessed by huge crowds, within and without the docks, and a band on the pier adjacent played popular airs.

The coaling, considerable delayed by the strike of coal porters, was completed in time, though it was only yesterday that the *Olympic*'s departure was certain.

The Kempster daughters, Sheila, left, and Margaret, amidships on the port side of the *Olympic*. 'The use this compass isolation stand was put to', reads the original album caption.

'Becoming too popular as a gymnasium, all games on it were stopped.' With the weather cloth erected, the attractions of the compass platform as a treehouse are obvious.

Elsewhere this memorable day, Wednesday 14 June 1911, the same paper disclosed:

Robert James Murphy, of 6 Hillman Street, Belfast, was the victim of a fatal accident at the Queen's Island on Tuesday, shortly before the horn had signalled a cessation of work for the day.

It would appear that the deceased was engaged as a counter, which is a branch of the riveting trade, on the leviathan White Star liner *Titanic*, and that when crossing a plank gangway the boards suddenly parted and caved in.

The unfortunate man was precipitated to the tank top, a distance of 50 feet, and alighted on a number of iron bars, one of which entered his head and another penetrating his arm.

His workmates at once had the injured man carried to the store pending the arrival of the ambulance, in which Murphy was conveyed to the Royal Victoria Hospital, where all that human aid could devise was done by the resident surgical staff to alleviate the poor man's sufferings.

From the first it was seen the case was hopeless, and death took place a few hours later.

A particularly sad coincidence of the accident was that Mr Murphy's son Robert met with an untimely end six months' previously in a similar manner when working on the *Olympic*, sister-ship of the vessel on which his father was killed.

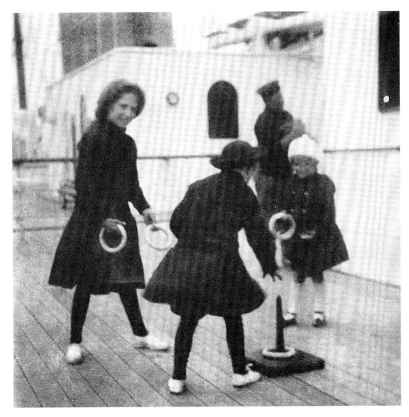

'Margaret, Sheila and Pat playing quoits.' This is aft on the starboard side, near the barrier and gate separating second class from first. A sailor is engaged in touch-up work in the background, and the group is located opposite Lifeboat 11.

First-class children in a pillow fight on an elevated beam erected along the promenade deck. Each sits on a saddle blanket marked 'White Star Line'. These pillowcases are understood to be in a red check pattern. The adults will have to look lively in catching any tumbling child, otherwise ship's surgeon William Francis Norman O'Loughlin could be called into service. He had transferred from the *Adriatic*, and would die on *Titanic*.

Adults get in on the act – officially listed as 'Pillow Spar Contest – Gentlemen'. This energetic swipe was captured in shadow on the teak window on A Deck, which gives onto a corridor between the first-class entrance and the reading and writing room and the lounge. The bout was part of a programme of organised deck sports, known colloquially as the *Olympic* games. Other pursuits included chalking the pig's eye, tug of war, a cigarette race, and even a whistling competition. Entrance fees paid for prizes, with any balance given to seamen's charities.

From April 1911 till August 1914, all went well on the *Olympic*, and we were like a happy family together, at work and at play. She was a great ship, very popular with all classes of travellers, and not less so with the crew, whose quarters were roomy, well-ventilated, conveniently arranged, and altogether comfortable.

Ship's surgeon Dr J.C.H. Beaumont

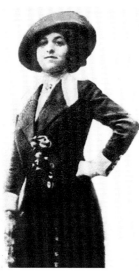

The ladies' egg and spoon race on A Deck. The officer in the background, although indistinct, appears to be Second Purser Claude Lancaster (Hugh McElroy, destined to be on *Titanic*, was his senior). The hunched competitor has dropped her egg, promoting mirth from onlookers, seen right.

But it was no laughing matter when ladies were hobbled by their Edwardian garb from being loaded at the windows here when an emergency arose on *Titanic*: 'I couldn't walk, I was in a potato sack, this tight skirt, absolutely useless,' said first-class survivor Edith Russell, a fashion writer (*inset* in the suit she wore to go aboard *Titanic*). She told sailors: 'I'm a prisoner in my own skirt, I can't get up to that railing, much less jump across into a lifeboat. I'm not an acrobat!' They threw her 'head foremost, through space'.

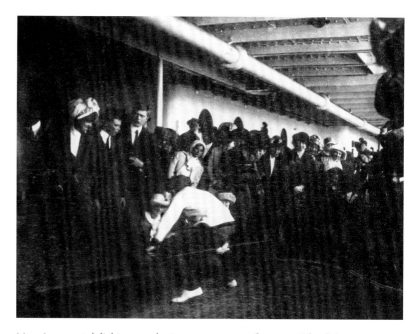

More innocent delight as an elastic young man performs a trick of the rope, which may have helped open some doors towards shipboard romance. The light-coloured shoes, however, must be deplored, even at this remove in time.

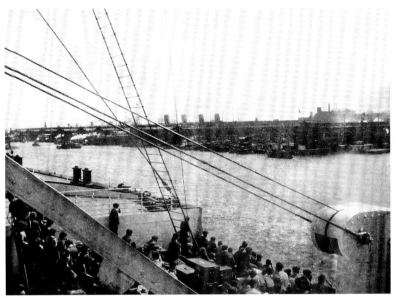

Officers supervise as sailors scramble about the stem head to prepare the *Olympic* for arrival as the tip of southern Manhattan hoves into view with the shape of the Singer building faintly discernible. The starboard companion is roped off at the top, and a sign just beyond warns that passengers are not permitted beyond this point. Huge cast-iron bitts for mooring ropes can be seen on the forecastle, with some from the *Titanic* now unmistakable in her debris field. It is Wednesday 21 June 1911.

Olympic nearing Cunard Pier 54, where the stern of the *Lusitania* projects into the North River, indicated by the smoke billowing from the nearest tug. Kempster, in error, labelled her the *Mauretania*. There was some press controversy over the fact that *Lusitania* failed to sound her whistle or otherwise acknowledge the arrival of the latest four-funnel liner on the block. It is notable that luggage has already been brought up from the cargo holds in readiness for landing, with handlers still hauling crates (to the left of the crane girder).

'I lift my lamp beside the golden door': The Statue of Liberty welcomes the *Olympic* to New York, a sight never witnessed by maiden voyagers on the stricken sister ship. Third-class passengers climbed the cargo cranes from the forward well deck in desperation to gain upper-level lifeboat opportunity as the *Titanic* sank.

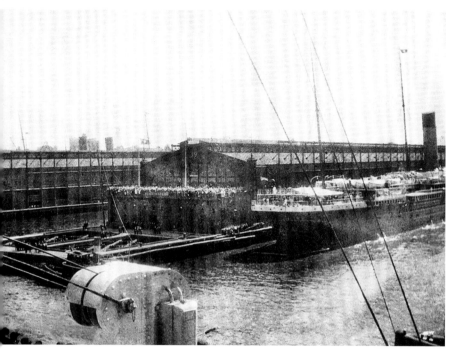

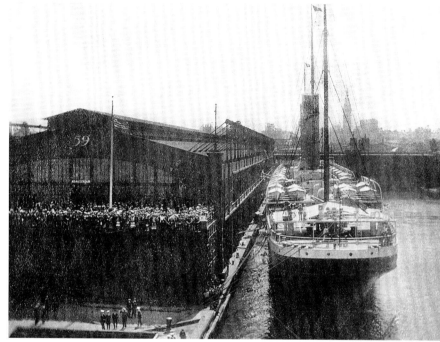

'Passing *Oceanic*, just before entering our dock, which can be seen': The White Star piers were just upriver from those of Cunard. Charles Herbert Lightoller, destined to be senior surviving officer of the *Titanic*, was first officer of the *Oceanic* at this time.

Relatives, well-wishers and bright sunshine greeting the RMS *Olympic* at Pier 59, where a sign on the thronged balcony faintly proclaims 'White Star Line'. A man on the docking bridge, at the stern of the *Oceanic*, appears to be operating a tripod camera, whereas a man alongside takes a still photograph. The vessel has boom logs deployed.

WHITE STAR LINE.

TRIPLE-SCREW R.M.S. "OLYMPIC."
46,359 TONS.
THE LARGEST BRITISH STEAMER,
AT NEW YORK.

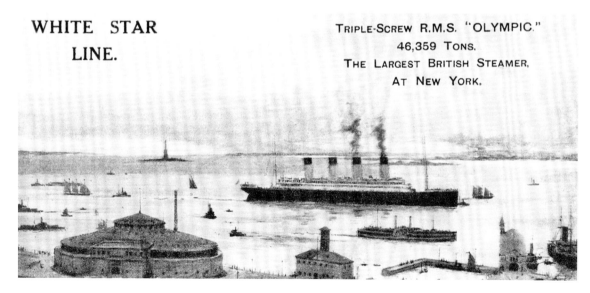

Biggest Ship Arrives

Olympic Welcomed by Crowds Along River Front

Trip Without Accident

Ten Tugs Help Haul Largest Vessel to Her Pier – One Slightly Damaged

The largest ship in the world came to these waters yesterday on her first run across the Atlantic from Southampton. She is called the *Olympic*, and was built at Belfast for the White Star Line at a cost coming close to the $7,000,000 mark.

The *Olympic* is big and broad and rides high out of the water, but she does not always show her greatness to its fullest extent. The observer must see the vessel under favourable circumstances, with ample objects in view with which to compare her, before he can get an idea of her real gigantic dimensions.

There were plenty of these about yesterday when the *Olympic* came into the harbour, and some of the crowds that lined the waterfront and the rails of ferryboats were able to see the great vessel at her best.

A fleet of fair-sized merchantmen lay at Quarantine when the *Olympic* weighed anchor, and they looked like little coasters by comparison. Two small black objects standing upright appeared on the last of her four funnels. They aroused some curiosity on board the revenue cutter when some three hundred yards away, but as the cutter came closer the tiny black objects moved and it was seen that they were men. The liner could have carried a small army on her funnel tops.

She arrived off Sandy Hook at 3am, was released from Quarantine at 6.50am and started up the bay at a trifle more than half speed. The ferryboat *Bronx*, black with folk from Staten Island, overhauled her and saluted, and when the whistle of the liner responded the crowd on the *Bronx* cheered loudly.

Passing craft saluted, but Captain Smith was too busy on the bridge to answer every salutation. The Battery had a fair crowd, and the piers along both sides of the North River were fringed with sightseers.

Captain Smith came up slowly on the east side of the river against a stiff ebb tide and stopped when his bow was opposite Pier 59. Then began the great task of warping 45,000 tons of steel, 882 feet long, into a comparatively narrow dock. The *Olympic* vibrated as her propellers raced astern, and for some fifty minutes, while the manoeuvring continued, great currents of mud were sent out in all directions.

A tug was caught in the powerful vortex and carried under the great overhang [stern]. The smaller craft's pole was snapped off and she careened. Her rudder was put out of commission and the crew, prepared to jump overboard, climbed ashore when the damaged craft was pulled out of harm's way.

Just as the *Olympic*'s stern cleared the Cunard pier, the *Lusitania* backed out into the stream and headed for Liverpool.

Even after the *Olympic* was in the dock with her stern some twelve feet inside the pier extension, her bow was some sixty feet away from the side of the pier. Fearing to nudge the monster an inch further into the mud toward the bulkhead lest something give way ashore, Captain Smith spent a half hour coaxing his big charge to move in properly. It was a splendid piece of difficult jockeying, and the skipper was congratulated on his fine work by officials of the line.

The ten tugs used in docking the *Olympic* were kept busy for almost two hours. Captain Smith said he could not bestow too much praise on the vessel he had just brought over.

'She is splendid! splendid!' he declared. 'She could not have behaved better.' He had been up all night bringing the *Olympic* to port, and after docking her he took breakfast and went to bed.

The big vessel brought over 1,316 passengers, 489 of whom were in the first cabin. Among these were four Japanese engineers who had come over to observe the behaviour of the vessel. Also on board were representatives of many steamship lines who travelled in a similar capacity.

As soon as the *Olympic* docked, Captain Ruser of the Hamburg-American liner *Kaiserin Auguste Victoria*, went aboard and spent the day looking into every cranny of the biggest

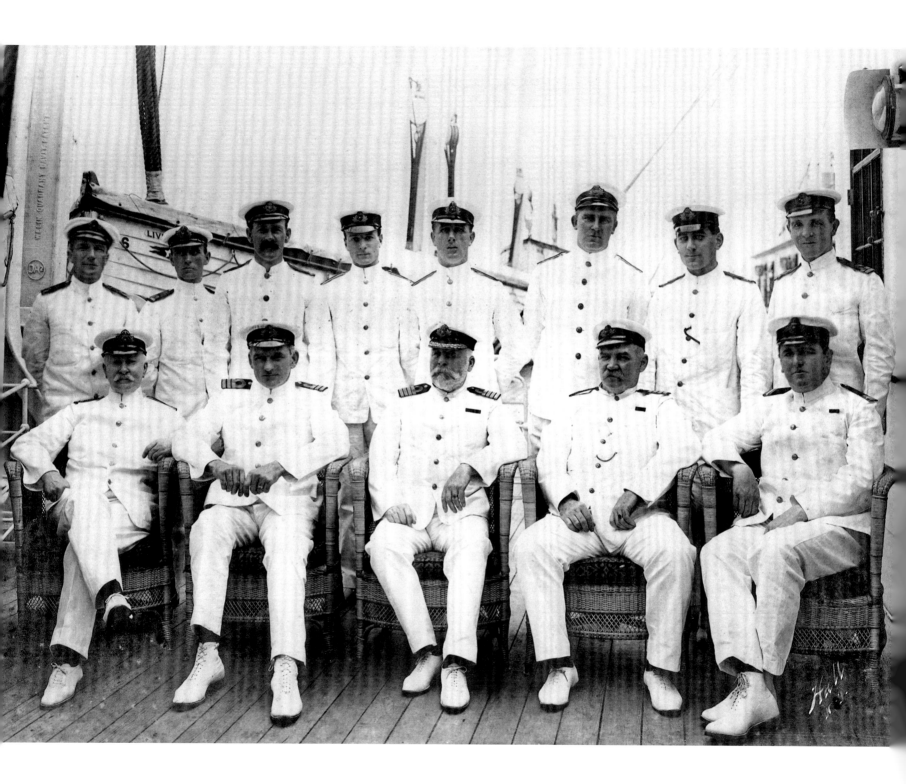

ship afloat. The liner even tempted Commissioner Waldo from Police Headquarters, and he spent almost an hour inspecting the vessel.

The ship's officers, who were enthusiastic over the voyage, were willing to show every courtesy to visitors, but preserved a sphinx-like silence on the subject of coal consumption. The *Olympic*'s boilers took on 6,000 tons of coal at Southampton and she had not a great deal left on arrival. It was said aboard unofficially that she consumed between 775 and 825 tons of coal a day.

J. Bruce Ismay, president of the International Mercantile Marine Company, to which the White Star Line belongs, was a passenger. Concerning the ship he said:

'I think this ship is going to be hard to beat. She worked splendidly all the way over with a minimum of vibration. She was never put to her full speed, yet she is here on schedule time. We will never try to bring the *Olympic* up on Tuesday night, for she is a Wednesday boat. There are one or two minor details on her that will be corrected on the *Titanic*, her sister ship.'

Because of her size and great passenger capacity, the business of the *Olympic* is transacted by two pursers, C.B. Lancaster, formerly of the *Oceanic*, and H.W. McElroy, who was on the *Adriatic*. In their daily tours of inspection the pursers cover five and a half miles.

(*New York Tribune*, Thursday 22 June 1911)

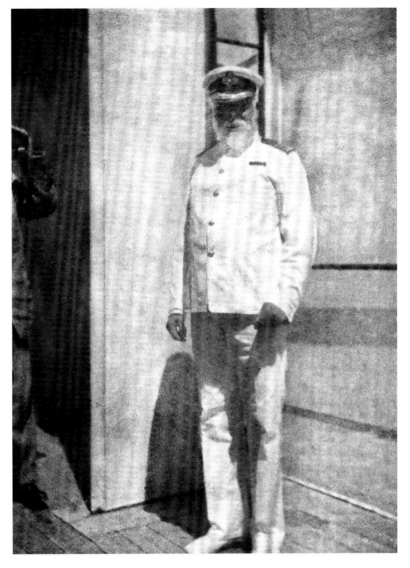

Officers on the port side of the *Olympic* in New York after her maiden arrival, looking forward from Lifeboat 6. The chairs have been borrowed from first class. Back row, from left to right: Harold Holehouse, Alphonse Tulloch, Robert Hume, Dr Ryder Nash, David Alexander, Henry Cater, Claude Lancaster, William Murdoch. Front row: Dr William O'Loughlin, Henry Wilde, Captain Edward J. Smith, Robert Fleming, Hugh McElroy.

Captain Smith in his summer whites at the conclusion of *Olympic*'s maiden voyage. This poor-quality shot was likely made during Kempster's crossing on *Olympic* with Smith. The *Titanic*'s captain had also commanded the *Adriatic* in 1907 when Kempster first crossed the western ocean.

Captain Smith's Prediction

Mr Kempster, one of the directors of Messrs Harland and Wolff, speaking in Belfast on Saturday said it seemed only the other day that he was speaking to Captain Smith, and asked him if the old British pluck remained in the seamen of today. Captain Smith was seated at the time, and he got up and raised his hand, declaring that if any disaster such as the loss of the *Birkenhead* occurred again, the seamen would go down as those men went down. He had lived to prove his words.

(*The Times*, Monday 22 April 1912, p.11)

Captain Smith had the utmost confidence in the safety of the ocean giants that were now being constructed. In 1907, when he came to New York in command of the *Adriatic*, on her maiden trip, he said:

Shipbuilding is such a perfect art nowadays that absolute disaster, involving the passengers, is inconceivable. Whatever happens, there will be time enough before the vessel sinks to save the life of every person on board. I will go a bit further. I will say that I cannot imagine any condition that would cause the vessel to founder. Modern shipbuilding has gone beyond that.

(*Washington Times*, Wednesday 17 April 1912)

Captain Smith's Foreboding

That Captain Smith, of the *Titanic*, believed the steamer was not properly equipped with lifeboats and other life-saving apparatus was the statement made by Mr Glenn Marston, a friend of the Captain, today. Mr Marston said that while returning from Europe on the *Olympic*, in company with Captain Smith, he remarked on the small number of lifeboats. It was then, according to Mr Marston, that Captain Smith spoke of the life-preserving equipment of the *Titanic*, then under construction. 'I noticed the small number of boats and rafts aboard for the heavy passenger carrying capacity of the ship, and remarked on it to Captain Smith,' said Mr Marston. 'Yes,' he replied, 'If the ship should strike a submerged derelict or iceberg, that would cut through into several of the watertight compartments, we have not enough boats or rafts aboard to take care of more than one-third of the passengers. The *Titanic*, too, is no better equipped. She ought to carry at least double the number of boats and rafts that she does to afford any real protection to passengers. Besides, there is the danger of some of the boats becoming damaged or being swept away before they can be manned.'

Mr Marston further quoted Captain Smith as saying that he thought the lack of equipment for saving lives was not due to the desire of the steamship line owners to save money, but rather because they believe their ships are completely safe.

(*Daily Telegraph*, Thursday 18 April 1912, p.14)

Mauretania interlude

Despite the fact that Harland & Wolff was associated predominantly with the White Star Line, there was no discouragement of its executives from travelling on Cunard and seeking to pick up tips. For example, White Star chiefs J. Bruce Ismay and Harold Sanderson took the *Mauretania* to New York in February 1910 – during which voyage a fierce gale off Roche's Point prevented the dropping of the Queenstown pilot and he was taken on to New York. The harbour pilot only succeeded in getting aboard the vessel through a 'magnificent feat of pluck'. The seas were too rough for Thomas Martin to be subsequently put off, so he was carried on the crossing. The passage took five days, nine hours and fifty-nine minutes, at an average speed of 22.23 knots, which must have been impressive to the White Star executives, who had *Titanic* and *Olympic* under construction at Belfast (Ismay returned from America aboard his own company's *Laurentic*).

'John, Sheila and Margaret on the *Mauretania*. Goodbye to New York – August 6, 1911.'

A poor-quality snap of J.W. Kempster *en famille* on the promenade deck of the *Mauretania*. It is August, so there is no need for steamer rugs.

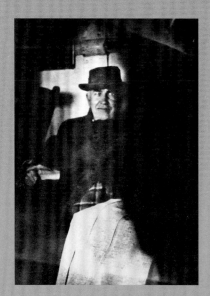

Thomas Alva Edison (1847–1931). Kempster's caption reads, 'All that came out of Mr Edison, Aug. 7th, 1911.' Meeting Edison, the arch-pioneer in the development of electricity, would have been a privilege and inspiration to Kempster, who was head of the electrical department at Harland & Wolff. We can imagine their in-depth conversations, although Edison, seen in a deckchair under a steamer rug, was trying to leave his work behind.

A moment from the family holiday in New York. The touring car is going aboard the ferry *Nonawantuc* at Port Jefferson to cross the Long Island Sound to Bridgeport, Connecticut.

The *Titanic* famously had an automobile aboard on her maiden voyage. William Ernest Carter of Pennsylvania embarked a Renault CB towncar, which was in a crate in the cargo hold and remains at the bottom of the Atlantic. Carter escaped in Collapsible C with Bruce Ismay and reached the *Carpathia* ahead of his family, who left in Lifeboat 4. His wife Lucile divorced him two years later.

After taking a holiday in New York State, including Niagara Falls, the Kempster family returned by the *Mauretania*.

The *Edison Phonograph Monthly* reported to its subscribers:

Department heads from the factory, and many other of the 'old man's' friends gathered on the Cunard line pier in New York on the morning of August 2nd to wish him bon voyage on the first real vacation trip he has had in twenty-two years. Just before the monster *Mauretania*, on which he was to sail, drew away from the pier, Mr Edison amused the reporters who had gathered by saying: 'I am going away to worry. I've been too busy right along to worry, but now I can have a good time at it'.

It is a fact that his days and nights have been taken up of late years with the perfection of talking pictures, improvements to the Phonograph, storage battery experiments and the multitudinous other things that only a brain like his can originate and direct. While he has always worked about twice as long each day as the most ambitious subordinate in his laboratory and factory, he has exceeded himself in the last year, and was persuaded by Mrs Edison to take a few weeks of rest.

His son, Charles, accompanied him on the *Mauretania*, which was met by Mrs Edison and their daughter. They intend to spend about two months touring England and the Continent.

The Oregon Railroad and Navigation Company's steamer *Columbia* became Edison's first commercial application of the incandescent lightbulb.

'In the magical days to come there is no reason why our great liners should not be of solid gold from stem to stern,' wrote Edison in one of his predictions for the year 2011, in an article for the *Miami Metropolis* newspaper of 20 June 1911. Modern cruise ships have come close to fulfilling his vision.

7

MEDIC ON DUTY

The *Medic* is an important component of the *Titanic* story. Two shipmates from this pioneer of the Australian run, the first of White Star's Jubilee class of liners, would go on to serve together aboard the ill-starred maiden voyager in April 1912.

First Officer William McMaster Murdoch and Second Officer Charles Lightoller had become friends as junior officers on the *Medic* shortly after the turn of the century. Serving alongside them was a colleague named James McGiffin, who became White Star Line marine superintendent at Queenstown. McGiffin, a bosom pal of Murdoch, saw both men at the *Titanic*'s last port of call on 11 April 1912.

When Lightoller next saw McGiffin, he reportedly told him that Murdoch, their colleague from the *Medic*, victim of the *Titanic* sinking, had been 'forced to shoot a crewman who led a rush on one of the lifeboats, pushing aside women and children. The bullet struck the man's jaw.'

Such an incident was described by passenger survivor Vera Dick, in the *Washington Post* of 19 April 1912: 'The guards shot the jaw off an immigrant who tried to crowd into one of the boats, brushing the women aside.'

Fireman John Thompson corroborated to New York's *Sun* newspaper of 23 April that a member of crew had been shot: 'I was close to him [Murdoch] for half an hour or more. I saw him shoot a steward through the jaw for trying to crowd into a boat full of women.'

On returning to Britain, a saloon steward (possibly James Johnson) said at Plymouth: 'The only panic was among the Dagoes, one of

The *Medic* is seen here tied up at Railway Jetty in Albany, Western Australia, on 10 June 1911.

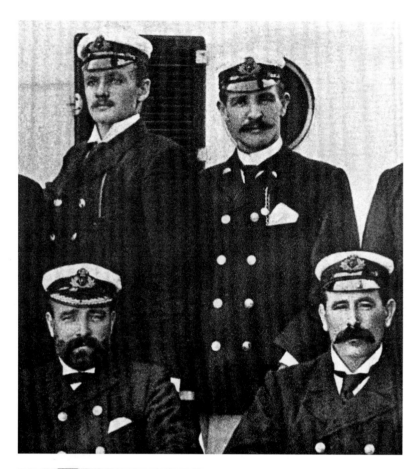

A *Medic* quartet in 1900. Top: Charles Herbert Lightoller, left; William McMaster Murdoch, right. Bottom: Captain Joseph Barlow Ranson, left; James McGiffin, right. (Courtesy of Maureen Landreth)

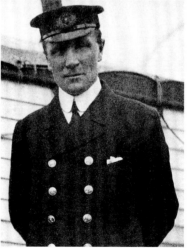

Fourth Officer Sidney Wilkinson beside a lifeboat on the boat deck of the *Medic* at Melbourne on 9 July 1911. By coincidence, this officer also resigned from White Star shortly after the *Titanic* disaster, in September 1912, having only joined the company in May of the previous year, two months before this photograph was taken.

whom I did see shot through the chin.' Another said of crowding males: 'One had his chin blown off.' This informant told the *Western Daily Mercury* of 29 April that seven men had been shot down in the final throes.

Said by his son to have been 'a broken man' after the loss of *Titanic* and Lightoller's candid account of the trauma, McGiffin resigned from White Star in August 1912.

A notable number of personnel left the company rolls that grim year – yet remained at sea with other lines, indicating that at least some could have felt their responsibilities too acutely, especially since White Star operated a punishing system of watches, or periods of duty, around the clock. Rival lines offered longer on-board rest periods for their navigators, eventually forcing concessions from the White Star Line in order to retain staff.

Just short of the first anniversary of the disaster, White Star announced improved conditions for its officer class:

The Imperial Merchant Service Guild is officially informed by the White Star Line of substantial improvements in the pay and general conditions of the officers of the fleet, which will take effect in the case of all steamers leaving on and after May 1. All the officers will then be granted increased pay, in many cases to the extent of £3 to £4 per month.

A special system of annual leave for all the commanders and officers is to be arranged as soon as possible, and officers will be given an annual holiday extending to three weeks, two of which will be made continuous, whenever circumstances will admit of it. Officers' Royal Navy Reserve drill will not be counted as holidays.

The officers will not, as hitherto, be required to undergo the sight tests at the Board of Trade, but will be examined by the company's own doctor.

Considerable improvements are to be inaugurated as regards watch-keeping, and as soon as the company can arrange it, all officers throughout the company will be put on three watches, and in a large number of ships an additional officer will be carried in order that this may be done. This eventually will lead to the entire abolition of the two-watch system in the White Star Line.

Improved conditions are also to be instituted in connection with the messing of the officers, who in the first-class passenger steamers will fare according to the first-class menu, the daily messing in this way to be arranged by one officer of each ship deputed by his brother officers for the purpose. In the second- and third-class passenger vessels and cargo steamers an improved scheme is to come into force providing for special fare in the case of commanders and officers.

(*The Times*, 4 April 1913, p.20)

Medic was 12,222 tons, inaugurating White Star's Australian service in August 1899 with a maiden voyage carrying just eighty-five passengers.

On putting into Plymouth on Saturday 15 April 1911, exactly one year before the *Titanic* sinking, the *Medic* landed seven crew members from the wrecked steamer *Tottenham*, which had gone ashore on a reef off the island of Juan de Nova when bound for Calcutta in February.

Picked up by cruiser *Forte* as the *Tottenham* began to break up, the *Medic* carried the men home after they had been landed at Durban.

An exceptional rare image showing a helmsman at the wheel of the *Medic* while Fourth Officer Wilkinson supervises. This picture was taken en route from Western Australia to Durban, Natal, on 30 July 1911. The scene evokes the *Titanic* just prior to the iceberg being spotted by the lookouts, when Sixth Officer James Moody was in the wheelhouse with Quartermaster Robert Hichens keeping a steady course at high speed. They were in complete darkness when a bell sounded thrice from the crow's nest ahead, followed by the ringing of the telephone.

A deck scene on the *Medic*, from London to Australia via the Cape, 21 May 1911, ten days before the launch of the *Titanic* at Belfast. Some passengers shade themselves from the fierce sun with umbrellas.

Hugh Hollingsworth, first officer, in splendid isolation on the top deck of the *Medic*, beneath the flying bridge, at Melbourne.

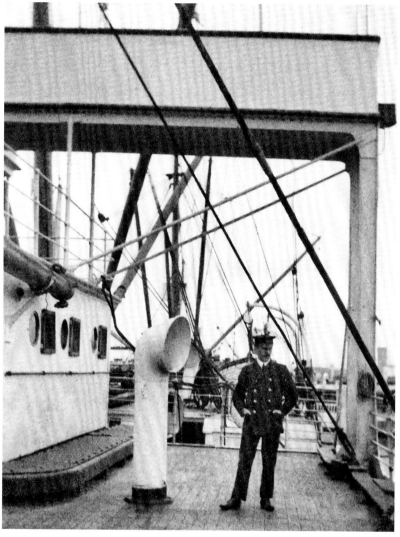

Hollingsworth won a King's Commendation for his courage in July 1918 when the giant White Star liner *Justicia* was torpedoed in daylight off Malin Head.

Hollingsworth stayed aboard the crippled liner for the long night thereafter, when there were fears that a wolf pack would close in for the kill – as subsequently achieved. Virtually all crew had been taken off, but the chief officer and a handful of others stood guard to prepare a planned towing operation at first light.

It was undoubtedly a brave act for a married man with a young son. Hollingsworth had also been aboard the *Titanic*'s sister ship, *Britannic*, but left before she was sunk by a mine in the Kea Channel in 1916.

The 32,500-ton *Justicia*, named in respone to the *Lusitania* sinking, was commandeered while on the stocks at Harland & Wolff as the intended *Statendam* of the Holland America Line.

Hollingsworth was wounded when she was struck by further torpedoes, but all men aboard were withdrawn before *Justicia* sank. He subsequently recovered in a shore role at Liverpool before returning to sea six weeks later. In the mid 1920s he resigned and immigrated to Sydney, taking up a job as cargo supervisor with Messrs Dalgety & Co.

He died there, aged 66, on 10 June 1939, just before the outbreak of the Second World War.

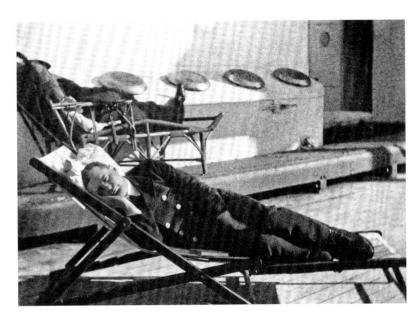

Surgeon Dr Frank Edwards takes a nap at sea from Albany to Melbourne in late July 1911. Purser J.T. Dean is crumpled in sleep in the background. Although Officer Bell has captioned this highly unusual scene as a 'siesta', it must not be supposed that senior crew are lazing.

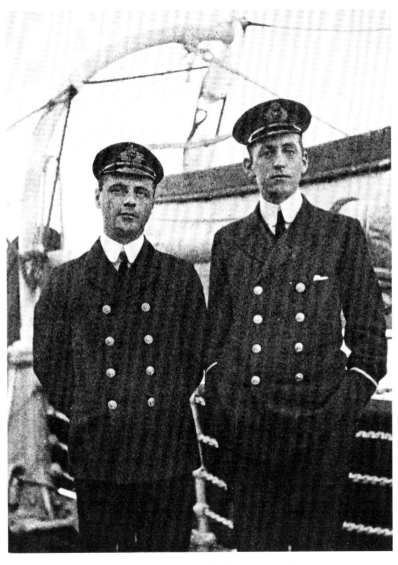

Dr Frank Edwards, left, and Purser Dean, right, when up and about.

As already noted, the equal on/off stints of duty in force at the time, both day and night, left many officers permanently tired and may even have affected their functionality in extreme cases. Fifth Officer Harold Lowe told the American *Titanic* Inquiry the following spring: 'You must remember that we do not have any too much sleep, and therefore when we sleep, we die.'

He was explaining why he was not awakened by Fourth Officer Boxhall bursting into his room and yelling out that he should rouse himself as the ship had struck an iceberg.

Lowe joined the *Medic* as his first ship after the sinking, in August 1912. Having come through the disaster unscathed, he then broke his leg aboard.

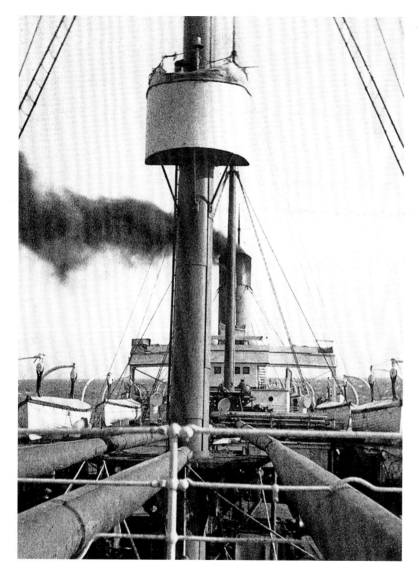

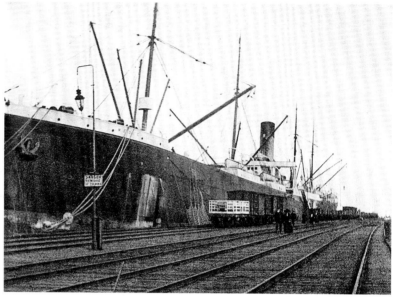

Medic at Railway Jetty, Albany, on 18 June 1911. The sign close to the tracks says 'Danger. Beware of trains.'

A lookout on duty in the crow's nest of the *Medic* as a stiff breeze blows at sea on 18 July 1911. Of note is the horizontal rope rigged to the weather cloth that acts at a bell-pull close at hand. One strike indicated an object to port, with two meaning it lay to starboard. This nest has a tricky external ladder, whereas *Titanic* had one inside the foremast itself, with an opening onto the cage beneath the crucial bell.

Infamously, the three strikes sounded by Fred Fleet on the *Titanic* meant an object dead ahead. It was the duty thereafter of the officer of the watch to determine the distance and nature of what had been seen, and to decide if any change of course was necessary. Lookouts were specifically told that the identification of an object was none of their concern, a mindset that contributed to the non-provision of binoculars in many cases. Even in the more modern ships where crow's nest telephones were provided, the purpose was to transmit instructions from the bridge to the lookouts. Fleet's desperate follow-up phone call to the bridge of the *Titanic* was something of an impertinence.

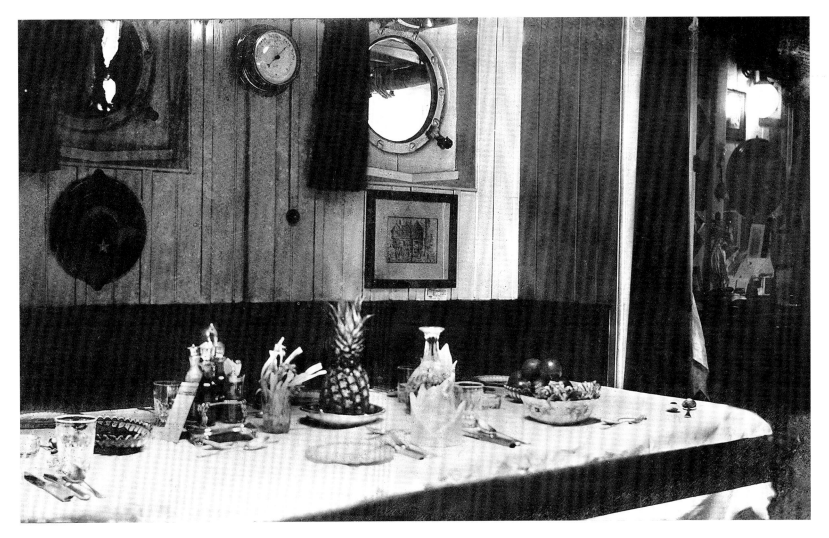

A linen tablecloth laid with White Star Line bespoke cutlery, glass, dishes and napery, all now highly prized by collectors. This is believed to be an officers' mess of the *Medic*, captured on an unknown occasion. The barometer is set to 'fair', yet the date on the menu propped against the cruet set is cruelly unreadable.

A White Star emblem is prominent on the deadlight set against the bulkhead, and the company burgee is visibly cut into the glassware, while also being displayed in its red colour on the side of the china serving dish. It would have featured too on the decanter, alongside the pineapple centrepiece, although it cannot be readily discerned here.

This seaborne still life (with apples), although somehow conjuring the embroidered tale of the *Mary Celeste*, is adjudged by experts as the finest realisation in photographs of the luxury of the much vaunted White Star dining experience.

The *Medic* mounted an apparent threat of its own to Australia when Lightoller was aboard with Murdoch and McGiffin in 1900. Sailing into Sydney, an Officer Watson, looking at Fort Denison in the harbour, noticed a huge projecting muzzle. 'What a lark to fire that gun some night. Wouldn't it shake 'em up?' he remarked.

Lightoller needed little further prompting: 'We slowly collected powder, fuse, and masses of white cotton waste ... What really topped off the crazy joke, and gave it a real artistic finish, was the idea of hoisting the Boer colours on the flag staff of the fort,' he recalled in his memoirs, referring to the conflict raging in South Africa.

A *Medic* raiding party stealthily assaulted the Martello tower of the fort by night. 'Striking the match, I lit the end of the fuse ... The flag was now gaily fluttering in the breeze, as I dashed for the lightning conductor ...'

'We waited and waited. Then it came, and no mistake indeed. There was a crash like thunder, we could feel the concussion even where we stood. How we chuckled during the remainder of our stay in Sydney. The noise, the uproar, the jeers and recriminations.'

One of Lightoller's shipmates later gave him away to his employers. It 'caused me to realise the immediate necessity of writing my resignation before I was asked, and so nearly ended my brief career in the White Star Line. Nearly, but not quite so.'

Carpeted at Liverpool by marine superintendent Henry Hewitt, Lightoller's resignation letter was torn up after the administration of a severe dressing down:

> I was taken out of the Australian Line as it was not thought advisable for me to go back until things had simmered down a bit. As a matter of fact, in effect I got slight promotion, being transferred to the Atlantic.

A *Medic* contrast. The forecastle and bows in daylight on the run from Liverpool to Australia via the Cape in May 1911. An officer can just be glimpsed at the port companion in the forward well deck.

Four months later, from the same perspective, Bell snaps the *Medic* in moonlight on the Great Australian Bight during the leg from Albany to Melbourne. With the lowering of the crow's nest weather cloth, the silhouette of a lookout can be seen. Famously there was no moon the night the *Titanic* struck.

8

OLYMPIC COLLISION

These pictures were taken by Los Angeles corporate lawyer John William Kemp on a marathon trip to Europe with his wife Georgia and 13-year-old son, Thatcher. They are provided courtesy of the Swiss *Titanic* researcher Günter Bäbler.

On 8 April 1911 the family boarded the White Star liner *Canopic* in Boston, bound for the Mediterranean. Making landfall on the other side, they spent weeks touring the Continent, arriving in England in July.

This was followed by a tour of Scotland, before a crossing to Belfast, where *Titanic* was fitting out. The Kemps took three photos of the new leviathan in early September 1911, sticking them onto a page of their album captioned only as 'Belfast'. After a tour of southern Ireland, taking in Dublin and Killarney, they returned to Britain.

The bow of the RMS *Titanic*, with three workmen in the forward well deck bestowing a sense of proportion. She has gained a forward mast with crow's nest and rigging, and deck cranes have been installed, but otherwise little appears changed since her launch just over three months before. Toilet sheds are on the forecastle.

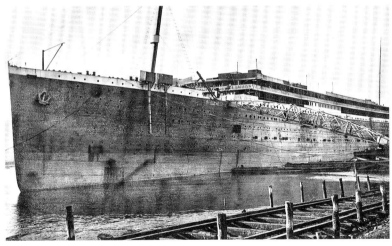

A longer view shows the *Titanic*'s mainmast also now in place, and the window screen on B Deck is taking shape – an additional screen on A Deck being ultimately what would most distinguish her from her sister. The open bow door on E Deck has a haunting quality – Officer Lightoller sent Bosun Alfred 'Big Nick' Nichols and six men to open this door on the night of the sinking, intending to send lifeboats to the opening to be filled with more passengers. 'He [Nichols] merely said "Aye, aye, sir," and went off,' the officer testified. None of the men was ever seen again.

Titanic appears skeletal in this broadside shot, as if already lying on the bottom, although she did not sink intact as the British Inquiry earnestly insisted in its final report. The aft docking bridge, present at the time of launch, has been dismantled to allow for deck installations and will soon be reinstated. There is some suggestion these pictures were taken on a Sunday because of their quality of stillness.

On 20 September 1911, after further trips to the Isle of Man and even the Isle of Wight, the Kemps were due to quit England and bid goodbye at last to their long European adventure.

It was a fateful date in the history of the Olympic-class liners. Going aboard the grand White Star liner at Southampton, they little dreamt their homeward sailing would soon be aborted because of a collision in the Solent with the Royal Navy cruiser *Hawke*.

The damage caused in this famous incident caused the return of the *Olympic* to Belfast and delayed the completion of the *Titanic*, ultimately pushing back the maiden voyage to April 1912.

Olympic has been in service for only three months and was due to cross to New York for the fifth time. An hour after departure she was struck in her starboard quarter. The incident occurred in the Solent. off the Bramble Bank, while the liner was under compulsory pilotage. The voyage was cancelled and the next morning she returned to Southampton under her own steam.

The *Daily News* Portsmouth correspondent says:– Bluejackets who witnessed the collision state that the two vessels were on parallel courses, making for Spithead. The *Olympic* was steaming slowly, and the *Hawke* overtaking her, when the cruiser suddenly swerved to port and the collision occurred. Only those on the navigation bridge know the cause of the collision, but it is possible there was a temporary

failure of the steering gear, as the cruiser was on running trials, having been in dockyard hands at Portsmouth. Yachtsmen fail to understand why the *Hawke* should have turned towards the liner, which was on her proper course, unless she failed to act on a port helm.

The Press Association's special correspondent at Southampton telegraphs:– The liner *Olympic*, the pride of the British Transatlantic service, which left Southampton yesterday morning in all her majesty to make a voyage to America, came slowly and painfully back this morning assisted by a cluster of helpful tugs and berthed in the deep water basin.

The collision occurred with such suddenness that those on deck had but a momentary presentiment of what was about to happen, but the utmost coolness and perfect discipline prevailed on board, and every order was promptly carried out. The first intimation of the accident [aboard *Hawke*] was the telegraph signal to the engines to stop and reverse. This was carried out within thirty seconds. The check to the cruiser's momentum was insufficient to prevent the collision. Every man below was shaken off his feet, but they stuck to their posts though no-one knew whether the *Hawke* was doomed. Every instruction was carried out with absolute coolness.

The Press Association's Portsmouth correspondent telegraph interviews with naval men who were aboard the *Hawke* at the time of the collision with the *Olympic* throw very little light upon the cause of the mishap. The liner had spent the night riding quietly at anchor on the calm waters of the Solent, whilst aboard passengers slept as peacefully as they would have done ashore. At 8.30 this morning the vessel left under her own steam, attended by half a dozen tugs for Southampton, making leisurely the journey along the beautiful waterway to the docks, where a large crowd of officials and passengers' friends awaited her arrival.

At ten o'clock the *Olympic* was seen coming up from Netley, and over half an hour elapsed ere she entered the basin and was warped alongside the quay. She was much deeper in the water than usual, drawing 35 and a half feet at the stern and 33 feet forward, while amidships the Plimsoll line was submerged, but there was no appreciable list, for the water had been pumped out as much as possible to lighten the ship. The decks were crowded with passengers, eagerly looking over the rails, whilst all the port holes on the starboard side framed

eager faces. The attention of the waiting crowd on the quay was soon diverted from the towering bulk of the ship to the damaged portion aft in the starboard quarter. Ninety feet from the rudder was a gaping wound in the hull, where the bow of the *Hawke* had struck the liner. The hole was a slanting one, fully twenty feet in height and ten feet across at the top. Such was the force of the impact that the iron plating was driven inwards to a depth of five or six feet, revealing a mass of twisted ironwork and exposing to view several berths. In this aperture stood some stewards gazing at the busy scene on the quay below. On the waterline itself there was a smaller hole, as if pierced by the ram, whilst the waves concealed the damage lower down. As soon as the gangways were in position some passengers came ashore to examine for themselves the effects of the collision, which they had been unable to do from the ship. Then the mails were landed and placed in a special train for London.

(*Cork Examiner*, 22 September 1911, p.5)

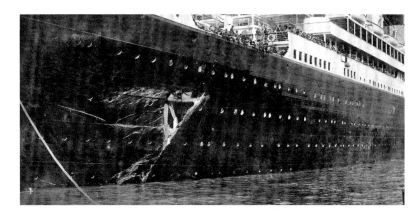

A real photo postcard by Silk of Southampton, showing the gash. The newspapers lauded the structural integrity of the vessel, suggesting that 'up to 3,000' lives of passengers and crew had been saved.

Loading baggage on the day of the collision. The forecastle faces towards Southampton and the Southwestern Hotel is seen. In the middle background are rail carriages, with the boat train from Waterloo station in London able to arrive parallel to the Ocean Dock. Note the dockside figures beneath the baggage hoist.

Inspecting the damage. The rupture was eventually boarded up with wood before a trip to Belfast for repairs. The Kemps had meanwhile returned home aboard the *St Louis* of the American Line. Other passengers were accommodated over the next ten days on the *Adriatic*, *Minnetonka*, *Canada*, *Arabic*, *Majestic*, *Cedric*, *Megantic* and *New York*.

Back at Southampton, a crewman peers from the ripped side in a photo taken by the Kemps after they disembarked. Some of the onlookers are likely to be disappointed fellow passengers.

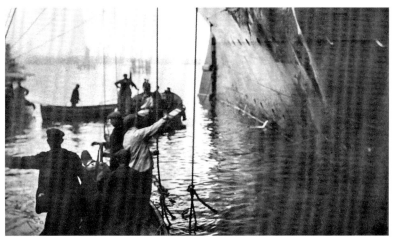

9

RUNIC DOWN UNDER

Perhaps something of an ugly duckling in her design, the *Runic* took beautifully to water. She was a steadily productive cargo and passenger vessel until eclipsed in size and elegance by the White Star Line's new *Ceramic*, which was half as large again at 18,000 tons. (Launched at the end of 1912, *Ceramic* was the first vessel after the *Titanic* disaster to be completed by Harland & Wolff, and on board for her sea trials would be John Westbeech Kempster.)

By 1911 White Star operated five ships on the Australian run, comprising *Suevic*, *Runic*, *Medic*, *Persic* and *Afric*, each marginally larger than the next, known as the Colonial class. *Runic* and *Suevic* had their bridge and officer deckhouse far forward of the funnel, with two well decks in between.

Runic's unblemished career record was finally besmirched as the *Lusitania* left New York on her fatal final voyage, on 1 May 1915. Off Beachy Head that same day, the *Runic* rammed the British freighter *Horst Martini* in a fog. The victim sank, but without loss of life.

At the end of her service in 1930, and because of her extensive refrigeration holds (which could hold 100,000 mutton carcases), *Runic*

was sold off to the whaling trade. Renamed *New Sevilla*, she was torpedoed off Malin Head, Co. Donegal, by U-138 on 20 October 1940. More than 400 crew were saved, although two died, the stout ex-*Runic* staying afloat for twenty hours until she finally succumbed.

Passenger anxiety could take its toll on the officer class. Early in 1911 the *Runic* had run into the tail end of a typhoon when approaching Durban, bound for London. The waves were said to run 'mountains high' for three or four days:

> Some of the lady passengers, fearing another *Waratah* disaster, did not undress for two nights. On being laughed at later, and asked what difference it would make if such a catastrophe occurred, one of them gravely replied, 'Oh, it would have been so cold to go down undressed.'

The Blue Anchor liner *Waratah* left Durban, bound for Cape Town and then London, in July 1909. She promptly disappeared with 211 passengers and crew, and her wreck has never been found.

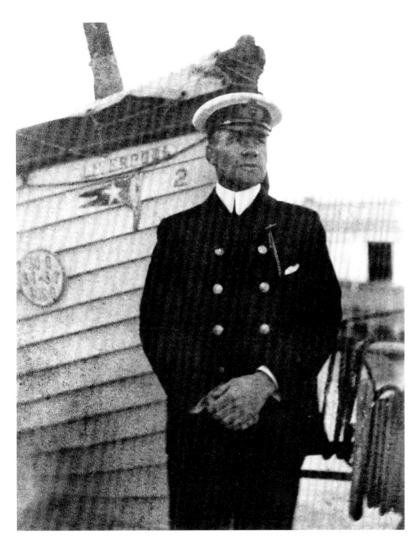

March 1912 – one month before monumental misadventure. First officer of the *Runic* Harry Raby, seen here at Hobart, has himself less than three and a half years to live. Raby was to be killed through enemy action while commanding the patrol vessel HMS *Ramsey*, sunk in the North Sea on 8 August 1915.

A third of a century after First Officer Raby's death (at the early age of 39) came a poignant sequel. It was reported in the *Dundee Courier* of Thursday 29 January 1948:

A cabin cruiser put out from Kirkwall, Orkney, yesterday, to carry out the instructions in a woman's will that her remains should be cremated and her ashes scattered on the sea.

She asked that during the final ceremony the hymn, 'For Those in Peril on the Sea,' should be sung.

In those waters in World War 1, a young naval officer to whom she was engaged lost his life. Afterwards the woman married.

She was Mrs Elizabeth Maryland Maxson Trier, of Fairfield, Oakleigh Park North, London, who died last November aged 60.

Her sister, Mrs Ruth M. Millar, with whom she lived, told a reporter: 'It was while coming back to Britain from Australia, before the First World War, that Bessie met Harry Raby, who was one of the ship's officers.

'They became engaged. With the outbreak of war, Harry joined the Royal Navy. They hoped to marry soon after the voyage from which Harry never returned.

'Bessie was heartbroken, and when she died she left instructions that her ashes were to be scattered as near as possible to the spot where Harry's ship was lost.'

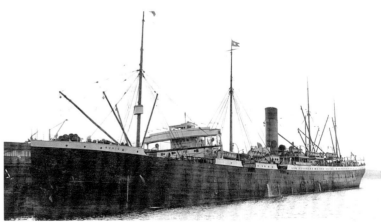

Runic.

In November 1911, news broke back in Belfast:

Shot on the *Olympic*

A startling shooting affair occurred on Saturday on board the White Star liner *Olympic*, which is at present lying at the new deep-water wharf in Belfast Harbour.

(*Belfast Evening Telegraph*, Monday 20 November 1911)

The vessel had been returned to the city for repairs following her collision. Boilermaker Edward John Wilson, 45, fired three shots in the engine room, hitting foreman Joseph Sharpe, 30, in both legs after being denied overtime. Overpowered, he begged to have his brains blown out with his own revolver. The two men later reconciled, allowing remorseful Wilson, a father of ten whose cancer-stricken wife had since died, to escape a prison term. Months later, a broken leg in the *Titanic* stokehold condemned engineer Jonathan Shepherd to death by drowning.

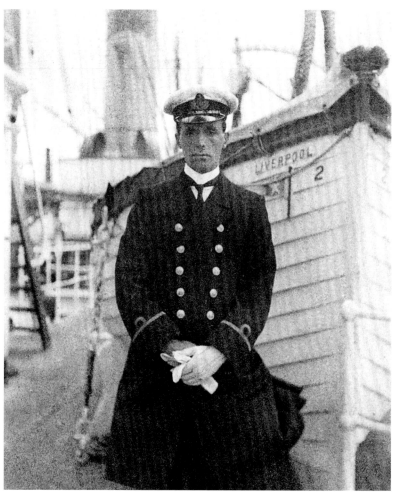

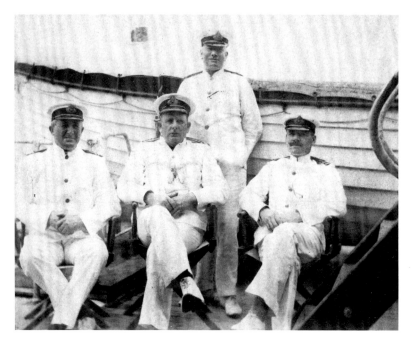

The chief officer of the *Runic*, 45-year-old Llewellyn Morgan Davies of Swansea looks glum and weary beside Lifeboat 2 on Saturday 30 September 1911. He seems to have become sated with the sea, and before Christmas 1912 was announced as White Star's new assistant wharf superintendent at Liverpool, where he would finish a shore career twenty-eight years later. This picture was taken ten days after the *Olympic* collided with HMS *Hawke* in the Solent.

Captain Kearney, centre, commander of the *Runic*, with senior officers. From left: Chief Officer John Brown Bulman, Second Officer W.H. Yates (standing) and First Officer Harry Raby. Sunday 4 February 1912.

Captain Kearney was captain of the *Adriatic* when he retired at age 60 in December 1930. he was master of fourteen White Star Line vessels in a lengthy career; they included *Bovic*, *Victorian*, *Persic*, *Canopic*, *Bardic*, *Medic*, *Calgaric*, *Doric*, *Megantic*, *Vedic*, *Cedric* and *Baltic*.

WHITE STAR—AMERICAN LINE
SOUTHAMPTON—NEW YORK SERVICE

THE ROYAL MAIL TRIPLE-SCREW STEAMER

"TITANIC"

WILL BE DESPATCHED FROM

SOUTHAMPTON TO NEW YORK

ON HER MAIDEN VOYAGE

On WEDNESDAY, April 10th, 1912, at noon

(Calling at Cherbourg and Queenstown)

LOADING BERTH—WHITE STAR DOCK

DISCHARGING BERTH—NEW YORK CITY

RATES OF FREIGHT BY SPECIAL AGREEMENT

Goods are only received subject to the exceptions and restrictions of liability contained in the usual Bill of Lading of the Company. Merchandise on quay awaiting shipment is at Shippers' risk of loss or damage by fire and/or flood. All risk of Lighterage to be borne by Shippers

Goods taken at through Rates to
WESTERN POINTS IN THE UNITED STATES AND CANADA.

APPLY TO THE WHITE STAR LINE,

38, Leadenhall Street	Tel. No. 4300 London Wall	LONDON
1, Cockspur Street	" " 3534 Gerrard	
30, James Street	" " 933 Central	LIVERPOOL
Canute Road	" " 1381 "	SOUTHAMPTON

Exteriors of the Bell album, left, and the Kempster album.

An exceptionally rare example of a notice sent to freight forwarders in March 1912, believed to be the only piece of White Star Line artwork specifying the maiden voyage of the new Royal Mail triple-screw steamer *Titanic*. It portentously warns that unstowed cargo is at the owners' risk of flood.

How the *Titanic* looked at her wharf in Belfast on 1 April 1912, as high winds delayed her sailing. A study in oils.

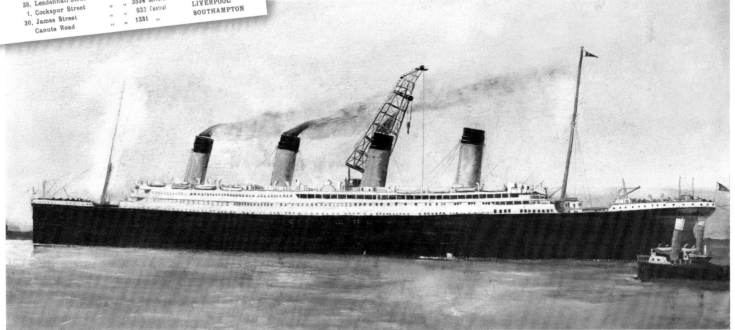

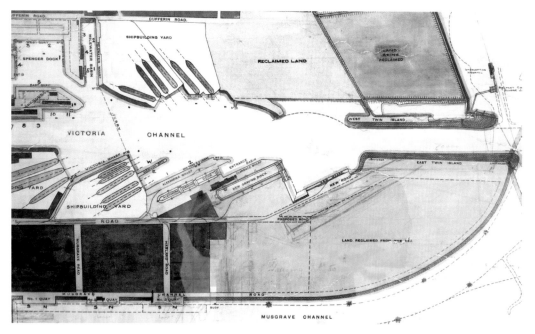

Clockwise from top left: Detail of Belfast harbour map by engineer W. Redfern Kelly, 1912, showing the *Olympic* and *Titanic* slips at extreme left, and the 'new graving dock,' middle, and the 'new wharf', where outfitting took place, to the right. The channel between West and East Twin Islands is less than 600ft wide, meaning the new vessels could not afford to be caught broadside.

A box with seventeen remaining *Titanic* socket signals in the debris field, some with visible lanyards. Quartermaster Arthur Bright said he and Quartermaster George Rowe each took a box of rockets from the stern to the bridge, where Officer Boxhall had previously sent up pyrotechnics. 'When we got up there we were told to fire them.'

In 1955, Rowe estimated twelve rockets to a box, but this shows capacity for twenty-eight. The boxes were 'metal and fairly heavy', and he was told to bring 'as many as I could'.

A myth espoused by the British Inquiry that *Titanic* fired only eight distress rockets still has zealous adherents. (NOAA, 2004)

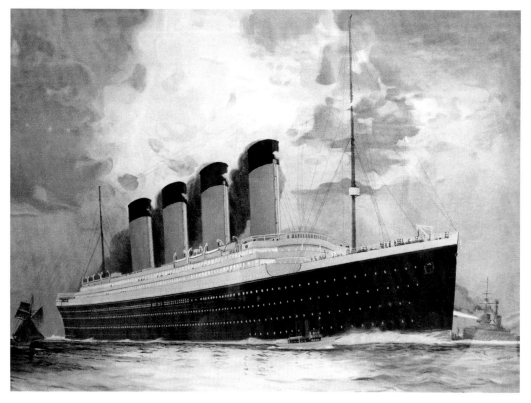

An agent's poster image of the *Titanic* by artist James S. Mann. Commissioned before her completion, it shows a rounded bridge she would not in fact possess. A second light is shown on her fore-rigging, but she displayed only one masthead light. A cruiser beaming a searchlight at the bow seems ironic, as the disaster raised questions about whether such a device could have helped detect the iceberg in time for its avoidance.

An angel of sacrifice on stylised waves on the collectible Royal Opera House programme for a *Titanic* memorial matinee performance on Tuesday 14 May 1912.

The London Hippodrome staged a similar fundraising concert for the bereaved on Tuesday 30 April. This cover image of the *Titanic* steaming at night was by famed marine artist Charles Dixon.

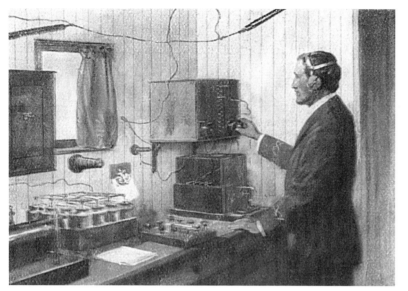

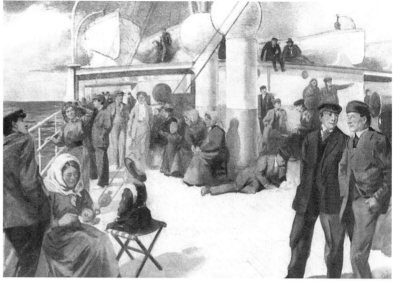

Clockwise from top left: Wireless was seen as a wonder of the age and a guarantee against loss of life on the ocean passage. Young men vied for positions working the wireless, but few ships had an installation and none operated all hours.

The long voyage. Lifeboats were only for lounging against, it seemed. These illustrations are from a Canadian Pacific Line brochure.

A twenty-four-page steerage brochure. An example was auctioned for £7,000 ($11,200) by Henry Aldridge & Son in 2011.

Steerage parties were an exciting and uninhibited feature of shipboard life.

A corner of the galley, behind the scenes. Even small vessels needed extensive victualling.

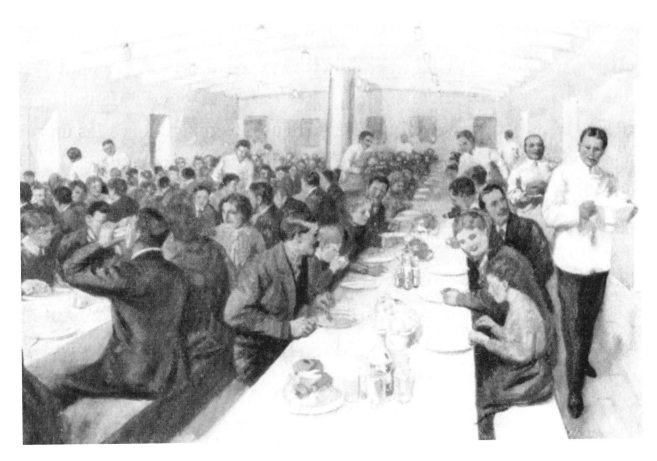

Where stewards earned their corn. Third-class fare was wholesome and plentiful.

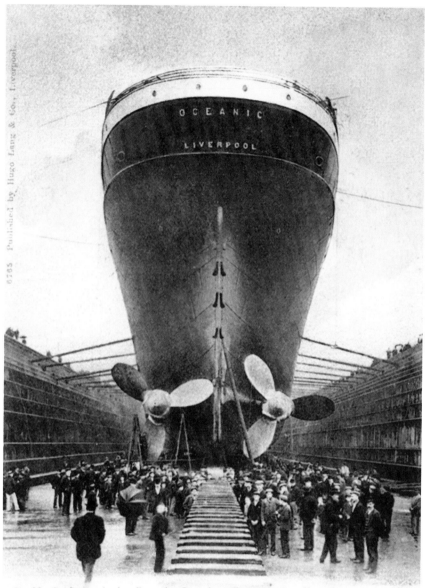

R. M. S. Oceanic in Canada Graving Dock. 17274 Tons. 704 ft long. 68 ft broad. Liverpool.

The stern of the *Oceanic* in dry dock in Liverpool. Compare to the photograph on p. 12.

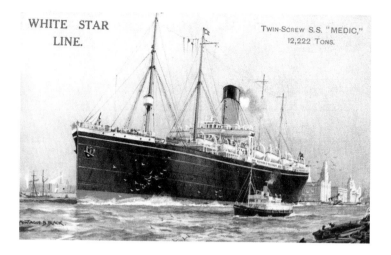

WHITE STAR LINE.

TWIN-SCREW S.S. "MEDIC," 12,222 TONS.

The *Medic*, outward bound from Liverpool. The service to the Antipodes provided vital revenue. The original Pilkington & Wilson White Star Line serviced the Australian gold rush of the nineteenth century. The line suffered its first maiden voyage disaster with the loss of the *Tayleur* and 360 lives in 1854, enabling T.H. Ismay to snap up the company.

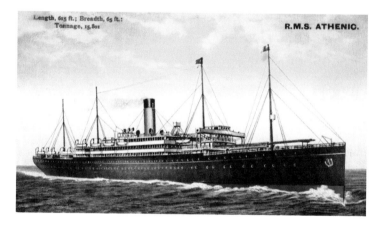

Length, 615 ft.; Breadth, 63 ft.; Tonnage, 15,801.

R.M.S. ATHENIC.

Athenic was the perfect passenger vessel for White Star – prosaic and predictable, yet highly profitable.

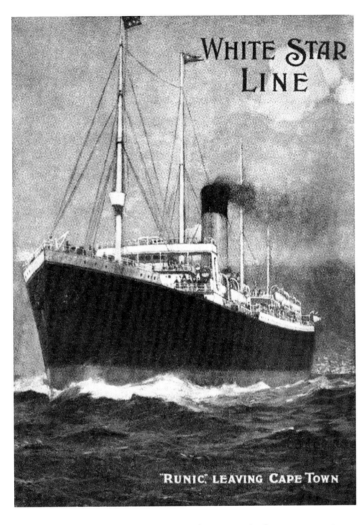

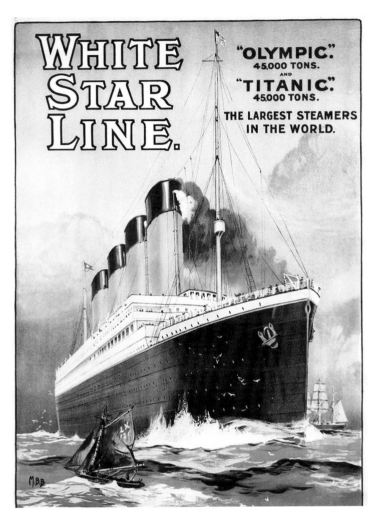

The reliable and routine *Runic* leaving the Cape, which was a waypoint and watering stop on the long-haul London–Sydney route.

A classic poster by Montague Birrel Black (1884–1964), which was promptly withdrawn after the sinking.

Nameplate above from a *Titanic* lifeboat which sold for £22,500 in April 2014.

Above right: Badge obtained by Arthur Shore, barber on the *Olympic*, from the barber's shop on *Titanic* prior to sailing.

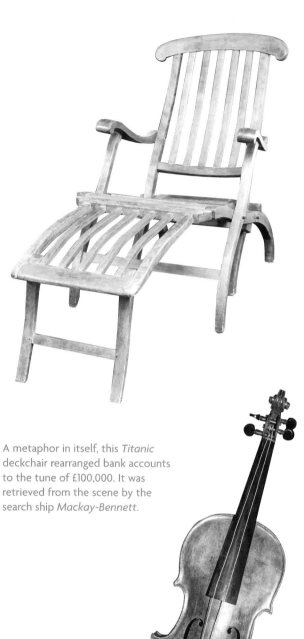

A metaphor in itself, this *Titanic* deckchair rearranged bank accounts to the tune of £100,000. It was retrieved from the scene by the search ship *Mackay-Bennett*.

The most expensive *Titanic* artefact in the world. A violin presented to bandmaster Wallace Hartley by his fiancée Maria Robinson was sold at auction for £1.1 million.

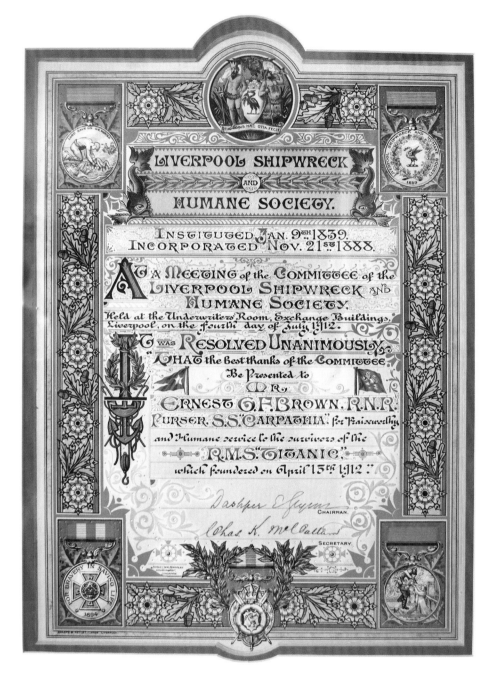

A tribute scroll to *Carpathia* purser Ernest Brown from the Liverpool Shipwreck & Humane Society, illuminated by James Orr Marples.

Runic alongside Dalgety Wharf at Miller's Point, Sydney, New South Wales. It is Guy Fawkes' Day 1911, a Sunday, and Third Officer Bell has climbed into the crow's nest to take a photograph astern.

Note the chutes from Dalgety's Wool Stores, at the left of picture, for ease of transferring merino bales to the wharf. When she left for London on 11 November 1911 (at midday) *Runic* carried 4,500 bales of wool, not to mention 1,000 hides, 30 casks pelts, 75 bales fur and skins, 20 bales sheepskins, 102 bales of leathers, 38,000 carcases of mutton and lamb, 4,800 crates of rabbits, and 7,500 boxes of butter, along with 1,535 tons of wheat (a mill is seen in the background of this photo).

Other cargo included 200 tons of lead, 190 of copper, 200 of timber, 600 of copra and 558 of tallow, along with meat, jam and sundries.

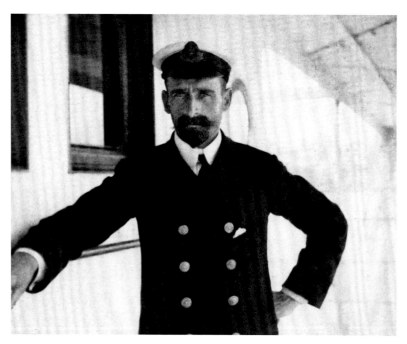

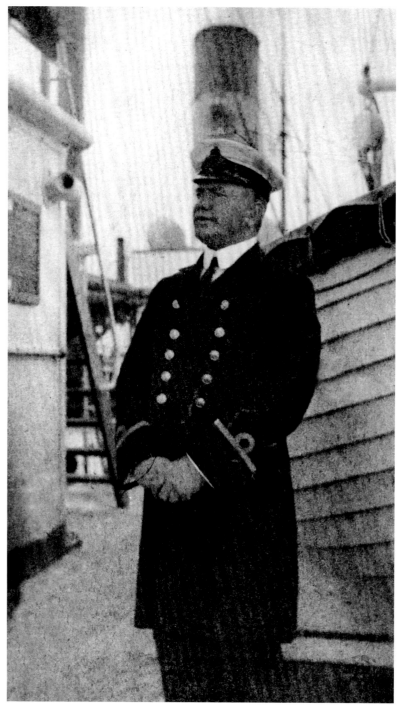

William Burnaby Starr, second officer of the *Runic*, at Sydney, 5 November 1911. Born in Mhow, Madhya Pradesh, India, where his father was in the 108th Regiment of Foot, he spoke fluent Urdu as well as English. He is seen two days before his 35th birthday.

Starr had a long career with White Star, interrupted by naval service in the Great War, finally retiring in 1934. Five years later he was captain of the merchant vessel *Tairoa* when she was intercepted and sunk by the German pocket battleship *Admiral Graf Spee* on 3 December 1939.

Initially taken prisoner, Starr was transferred to the *Altmark* with his crew, just a few days before the *Graf Spee* herself was destroyed at the Battle of the River Plate. The *Altmark* in turn was trapped by HMS *Cossack*, and Starr was thereby rescued from captivity on 16 February 1940. He died in Liverpool on 15 July 1952, aged 75.

Taken on the very day *Titanic* struck her iceberg, Sunday 14 April 1912. This time William Henry Yates is the second officer of the *Runic* and she is in the Indian Ocean, a vast distance from where Captain E.J. Smith has cancelled the lifeboat drill this same morning because of high winds.

It is easy to visualise a *Titanic* officer in a pose similar to Yates saying, 'This way, if you please, ladies,' later that night. If this scene were to be transposed, it would be Chief Officer Henry Wilde since this is Lifeboat 2, whose loading he oversaw, although it was sent away in the charge of Fourth Officer Boxhall.

Yates died in Liverpool on St Patrick's Day 1925, aged only 49. *Titanic* officer survivors Harold Lowe and Herbert Pitman would both serve briefly aboard the *Runic* in 1921, the latter as purser, having been found to be colourblind in 1913.

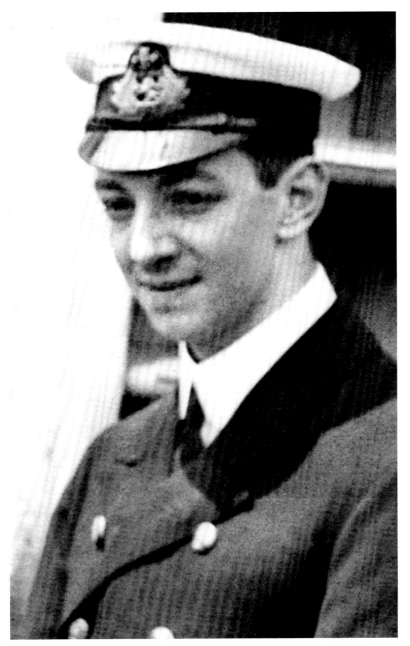

Carpathia purser Ernest Brown. He soon left the sea, settlng in the United States.

Letter from à la carte restaurant controller Will Jeffery complaining about the high winds delaying *Titanic*'s departure from Belfast. The 28-year-old died in the sinking. There is good evidence the restaurant staff were deliberately denied access to the boat deck.

Titanic launch ticket.

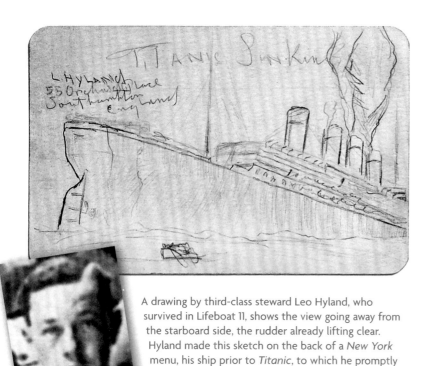

A drawing by third-class steward Leo Hyland, who survived in Lifeboat 11, shows the view going away from the starboard side, the rudder already lifting clear. Hyland made this sketch on the back of a *New York* menu, his ship prior to *Titanic*, to which he promptly returned after the sinking. Hyland made another sketch years later for author Walter Lord, which has been carried in all editions of the book *A Night to Remember* since 1956.

A *Titanic* menu from the Belfast–Southampton delivery trip. Only one passenger was aboard, US citizen Wyckoff Vanderhoef, but standards still had to be maintained.

R.M.S. "TITANIC."

APRIL 3, 1912.

HORS D'ŒUVRE VARIÉS

CONSOMMÉ PAYSANNE
TOMATO

HALIBUT, HOLLANDAISE

SUPRÊME OF CHICKEN À LA STANLEY
FILETS MIGNONS & MUSHROOMS

ROAST DUCKLING, APPLE SAUCE
SADDLE OF MUTTON, CURRANT JELLY

FRENCH BEANS ARTICHOKES
GARFIELD & BOILED POTATOES

QUAIL ON TOAST & CRESS
SALAD

PUDDING DUCHESSE
RHUBARB TART
PASTRY

DESSERT COFFEE

Sailing-day letter from 16-year-old Georgette Madill of St Louis, a first-class passenger. She writes: 'The *Oceanic* & *New York* were moored beyond us and just after we had left the dock the *New York* broke her cables & drifted into our stern – it was most exciting!'

Rescued in Lifeboat 2, Georgette was one of the first aboard the *Carpathia*, suffering a relatively short ordeal. The daughter of a judge, she defended Bruce Ismay, saying she had seen him enter a boat at the request of Captain Smith.

Georgette died in London in 1974, just prior to her 78th birthday.

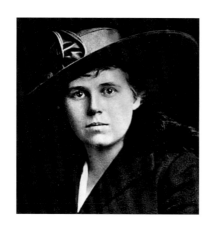

WHITE STAR LINE.

R M.S. "TITANIC." APRIL 14, 1912.

THIRD CLASS.

BREAKFAST.

OATMEAL PORRIDGE & MILK
SMOKED HERRINGS, JACKET POTATOES
HAM & EGGS
FRESH BREAD & BUTTER
MARMALADE SWEDISH BREAD
TEA COFFEE

DINNER.

RICE SOUP
FRESH BREAD CABIN BISCUITS
ROAST BEEF, BROWN GRAVY
SWEET CORN BOILED POTATOES
PLUM PUDDING, SWEET SAUCE
FRUIT

TEA.

COLD MEAT
CHEESE PICKLES
FRESH BREAD & BUTTER
STEWED FIGS & RICE
TEA

SUPPER.

GRUEL CABIN BISCUITS CHEESE

Any complaint respecting the Food supplied, want of attention
or incivility, should be at once reported to the Purser or Chief
Steward. For purposes of identification, each Steward wears a
numbered badge on the arm.

The last meals ever served on *Titanic*. Steerage passenger Sarah Roth, a child in Whitechapel during the Jack the Ripper terror, found this 14 April menu in her handbag when rescued by *Carpathia* – having previously been prevented by an officer from climbing to the boat deck of the stricken maiden voyager.

She married Daniel Iles a week after the sinking on Monday 22 April, in St Vincent's Hospital, her bridesmaid being Emily Badman, a fellow survivor from Collapsible C.

The *New York Sun* said: 'The whole hospital knew about this romance. The large room was prettily decorated with flowers. Miss Roth wore a gown of blue silk and a straw hat trimmed with blue velvet. Mr Iles wore a black cutaway suit.

'While Father [Anthony] Grogan was reading the service, the corridor as well as the parlour was filled with survivors of the *Titanic* and with convalescent patients.'

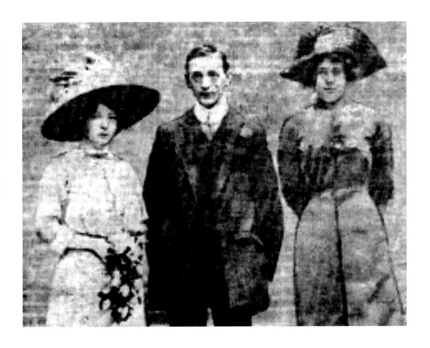

White Star Line head Bruce Ismay in Connemara in the 1930s. His survival in a lifeboat (when so many of his customers died) led to a local pun on his name in Gaelic: *Brú sios mé* (phonetically Broo sheesh may), meaning 'shove me down'. Ismay was nonetheless a respected employer in Casla, Co. Galway.

£9,500 CLAIM.

Burning of Costello Lodge Recalled.

TREES UPROOTED.

At Galway Circuit Court on Tuesday, before Judge Wyse Power, B.L., Mr. J. Bruce Ismay, 15 Hill-street, Berkley-square, London, claimed £9,500 for the destruction by burning of Costello Lodge, Costello, on the night of September 5, 1922.—By consent, a sum of £6,865 was awarded for the house, out-offices, boat-house and boats.

There was a further claim for £400 for the uprooting and destruction of the shrubs and trees in the garden.

Judge Power awarded a decree for £300.

The total award was £7,215, with a reinstatement clause for £5,700, and £12 witnesses' expenses.

Mr. Tyrrell, B.L. (instructed by Messrs. Blake and Kenny) appeared for the applicant, and Mr. R. J. Kelly, State Solicitor, opposed on behalf of the Minister of Finance.

Patrick Gavin, Clynagh, Costello, claimed £100 damages for the seduction of his daughter, Annie Gavin, by Patrick Coyne, motor driver, 3 Corrib Terrace, Galway, on March 24, 1924.

Ismay shows his torment on the way to the *Titanic* inquiry in Washington DC. He resigned in 1913 and thereafter spent much time at his Lutyens-designed Irish retreat on the edge of the Atlantic. Ismay ordered a new building after the first was burned by the IRA in 1922, for which he duly claimed compensation – despite the fact that his company had resisted doing the same for four Irish passengers who died on *Titanic*; their families ultimately succeeded in proving negligent navigation. He wrote, 'I never want to see a ship again, and I loved them so.'

The company's offices in London, Liverpool, New York, Southampton and Queenstown were besieged in the wake of the sinking.

Relatives running the news gauntlet on leaving the White Star offices in Cockspur Street. (*Illustrated London News*)

A pass to inspect the *Titanic* on sailing day, Wednesday 10 April 1912.

Parting note from *Titanic* bandmaster Wallace Hartley: 'This is a fine ship and there ought to be plenty of money on her', referring to anticipated tips. He also writes: 'We have a fine band and the boys seem very nice.' It was later sold at auction by Henry Aldridge & Son for £93,000. Hartley's funeral in Colne attracted a crowd of 30,000.

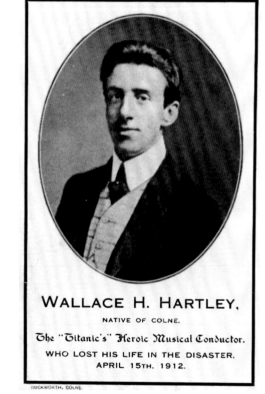

WALLACE H. HARTLEY,

NATIVE OF COLNE.

The "Titanic's" Heroic Musical Conductor.

WHO LOST HIS LIFE IN THE DISASTER.
APRIL 15TH. 1912.

DUCKWORTH. COLNE.

On board R·M·S·"TITANIC."

Sunday afternoon

My Dear ones all,

As you see it is Sunday afternoon & we are resting in the Library after Luncheon I was very bad all day yesterday Could not eat or drink, & sick all the while, but today I have got over it, This Morning Eva & I went to church & she was so pleased they sang . Oh God our help in ages past, that is her Hymn she Sang so nicely, so she Sang out loud, She is very bonny. she has had a nice Ball & a box of Toffee

Seven-year-old Eva Hart between her parents Benjamin and Esther in 1912. The latter's on-board letter, dated Sunday afternoon – a few hours before the collision – says Eva was delighted to have the chance to sing the hymn 'O God, Our Help in Ages Past'. It also reads in part: 'The sailors say we have had a wonderful passage up to now. There has been no tempest, but God knows what it must be when there is one.' Mother and daughter survived the sinking, but Mr Hart was lost. The letter sold at auction for £121,000.

Eva Hart became a magistrate in later life. She died in 1996, aged 91.

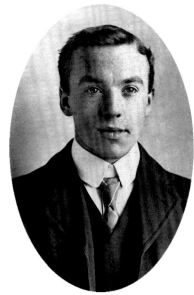

Arthur Paintin, Captain E.J. Smith's 'tiger', or personal steward; he was lost in the sinking. Arthur was aged 29 and had only been married a few months. His bride later gave birth to his son, named after him. Surviving steward F. Dent Ray said he last saw Paintin 'standing on the bridge, next to the captain'.

Paintin's last letter to his parents:

'We have now commenced the quick voyages all the summer (bar accidents). I say that because the Olympic's bad luck seems to have followed us, for as we came out of dock this morning we passed quite close to the Oceanic and New York, which were tied up in the Adriatic's old berth, and whether it was suction or what it was I don't know, but the New York's ropes snapped like a piece of cotton and she drifted against us. There was great excitement for some time, but I don't think there was any damage done.'

This letter sold at auction with the original envelope for £39,000.

10

BELFAST BALLET

The two Olympic-class superliners were brought together for a final time in March 1912 through a mishap whereby the elder sister lost a propeller blade during an eastbound crossing from New York.

New York's *Sun* reported:

> She lost one blade of her port propeller at 4.30pm on 24 February. The shock was felt throughout the ship, but it occasioned no serious alarm.
>
> The Duke of Newcastle, who was one of the passengers, said the big ship swerved like a train rounding a curve.

The *Olympic*'s speed was cut from 23 knots to 21 (excessively, claimed the *Sun*) and she lost about twelve hours altogether. Captain Smith wirelessed the line that a call at Belfast, which possessed the only repair dock large enough to accommodate her, would be necessary. Then began a complex choreography:

Titanic, left, her hull half-painted, and *Olympic*, right, in extraordinarily close proximity, with barely a couple of tugs between them. The graving dock is empty (except of water) because the repaired *Olympic* has just exited. She must be backed away before the *Titanic* can take her place. The pump house to left still exists, as does the dock, but the chimney has gone.

This amazingly detailed picture was taken on Wednesday 6 March 1912. A cropped version of this scene, but of very poor reproduction, was printed in the *Belfast Evening Telegraph* the next day, captioned: 'Unique Photograph of Two Leviathans'. It referred to *Olympic* and *Titanic*, 'the former leaving the world's largest graving dock, and the latter about to enter it'. (see p.7)

Olympic dry-docked

Liner expected to be ready for sailing today

The White Star liner *Olympic*, which lost a blade of her port propeller on her voyage across the Atlantic last week, and which appeared at Belfast Lough on Friday morning too late to catch the tide and be docked for repairs, was since dry-docked on Saturday morning [2 March].

A very strong wind was blowing almost straight against the side of the *Olympic* from the Co. Down quarter, but in order to prevent her 'slewing' a couple of powerful tugs got to the leeward of her and kept her on the straight way into the dock.

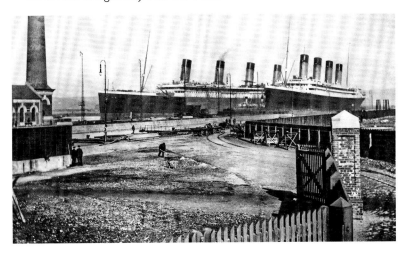

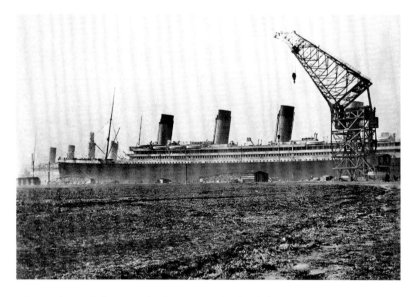

Olympic has withdrawn to the fitting-out wharf and the *Titanic* in the background is now entering the graving dock, being about two-thirds way through insertion, with the dock chimney appearing to extend from her third funnel.

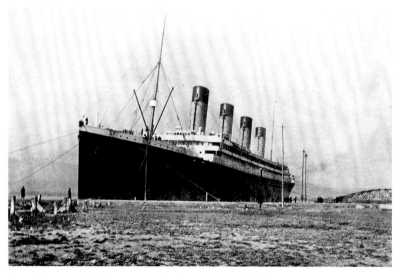

The *Olympic* at the fitting-out wharf. Some sort of collision mat appears to be over her prow. The forecastle is clustered with sailors, and crew also look out from her forward well deck. She was berthed overnight at the fitting out wharf due to continuing high winds. She will now have to be turned for the open sea the next morning, Thursday 7 March, in order to return to station at Southampton.

The operations were carried through successfully by a big staff of men, and after the liner was made secure the dock was closed up and the work of pumping out the dock, which took two hours, was commenced.

The repairs were started during the afternoon [of Saturday]. The *Olympic* will, it is expected, leave Belfast to-day for Southampton, where she is to resume her sailings on Thursday.

(*Irish News*, Monday 4 March 1912, p.4)

Olympic Delayed

Boisterous Weather Compels Re-docking of Liner

The half gale prevailing on the Lough, which interfered with the docking of the *Olympic* on Saturday continued unabated yesterday morning at high tide, when the operation of undocking the vessel was performed.

Five tugs were employed to tow the liner out of the new graving dock, the work of replacing the lost propeller having been completed on the previous night [Sunday 3 March]. The public were not admitted to the immediate vicinity of the graving dock.

When out of the dock the *Olympic* was taken [stern first] down the Channel as far as No. 3 Buoy, at the [East] Twin Island, but it was soon found that the stiff south-westerly breeze was going to give considerable trouble in the difficult and delicate task of clearing the big ship. Once well into the Channel, the wind caught her immense broadside, and the five powerful tugs had their work cut out in keeping her from slewing. It was stated at first that an accident had occurred, but we learn on enquiry that there was no more serious mishap than the snapping of one of the big mooring ropes when the vessel was being undocked.

Under the circumstances, and in view of the fact that there was no sign of the stiff breeze and heavy sea moderating, it was decided not to risk bringing the liner any further along the narrow and exposed Channel.

As the fitting out wharf is occupied by the *Titanic*, the only course open was to bring her back into the graving dock, which had not been emptied. The re-docking was carried out safely and quickly, there being sufficient water in the dock to float the vessel. She will be kept in the graving dock until the weather moderates.

(*Irish News*, Tuesday 5 March 1912, p.6)

The *Olympic*

Weather Conditions Prevent Mammoth Liner from Sailing

Owing to the unfavourable weather condition prevailing in the Lough during the past few days, the White Star liner *Olympic*, which has undergone repairs at the large graving dock, could not be removed from her present position yesterday.

During the early hours of yesterday morning several tugs were requisitioned for the purpose of towing her out to the outer wharf.

Water was taken into the dock to float her, but the winds became so adverse that it was considered necessary to suspend operations.

The weather moderated considerably during the evening, and hopes are entertained for a further mildness in order to allow of the mammoth liner taking advantage of a high tide this morning. It is expected that as soon as the *Olympic* is removed the *Titanic* will be transferred to the graving dock and the former will then be towed to the latter's old berth. It is intended to turn her bow towards the lough so as to facilitate matters as much as possible. There is at present on board only a part crew, but she will take on her full complement at Southampton.

(*Irish News*, Wednesday 6 March 1912 p.5)

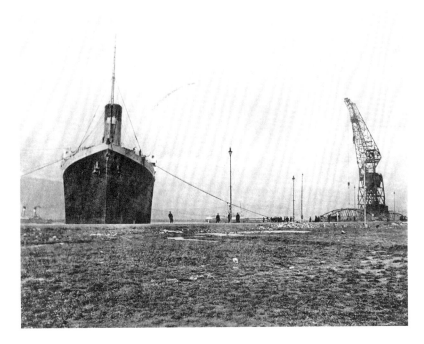

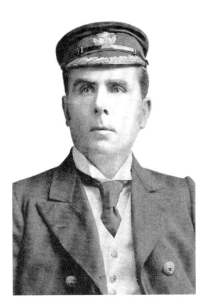

Right: Herbert James Haddock, first captain of the *Titanic* when she was at Belfast. (Titanic Historical Society)

Left: The turning of *Olympic* gets underway, with tugs to left and right. She is under the command of Captain Edward John 'Ted' Smith.

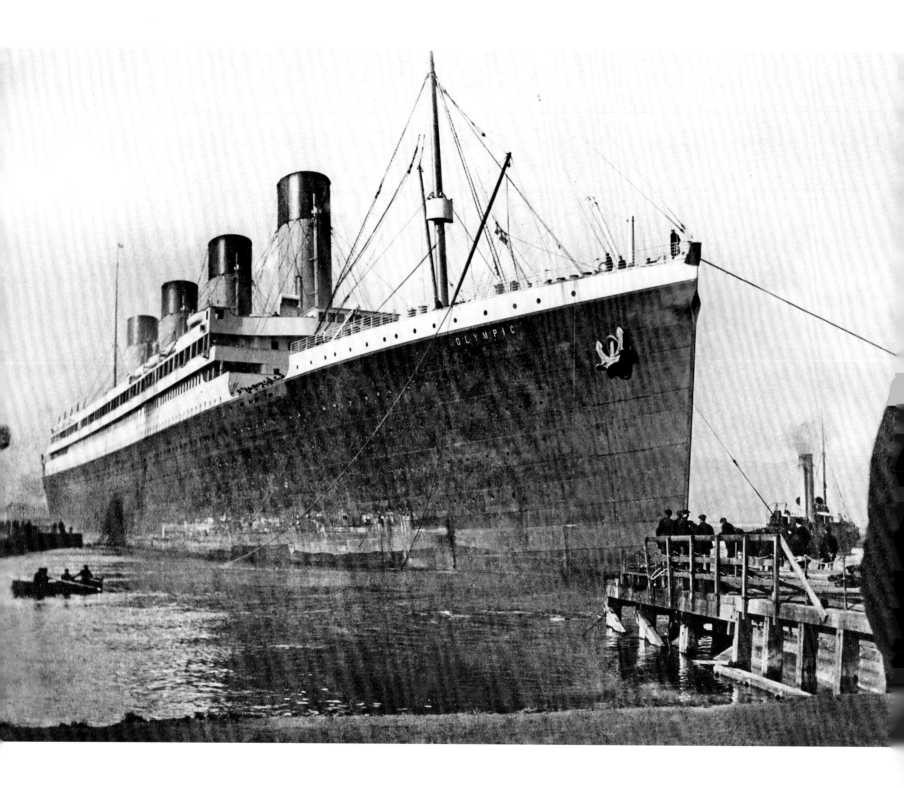

Danger averted, the *Olympic* moves away from the dock wall, on top of which is a crowd of onlookers with the stern of *Titanic* for shade. The gulls have livened up proceedings, a woman wears a fur coat on the jetty, and a man close to camera, right, hopes his children will remember the thrill of witnessing this day.

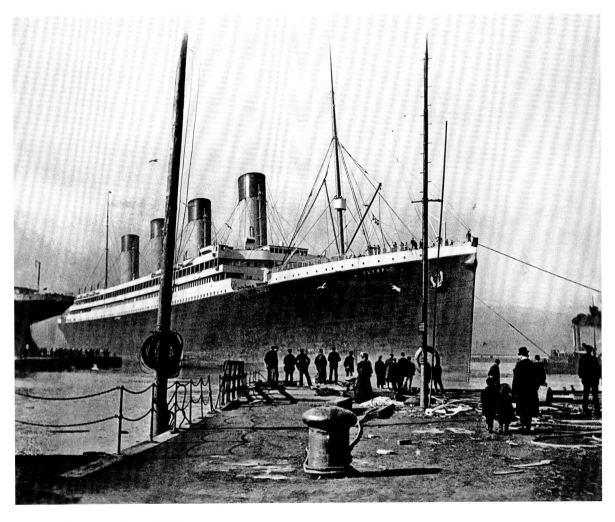

Opposite: Olympic is turned, but her side is dangerously near to the wall of the graving dock, where the stern of the newly installed *Titanic* is seen to extreme left. 'The power of the tugs was utilised through stout hawsers to keep the liner clear of the dockside towards which she had a tendency owing to the force and direction of the breeze. The direction of the operations required the greatest skill and care.' *Olympic* crew line the forward well deck, and above them an officer appears at the angle of A Deck. Above him, between the starboard wing bridge and the bridge, appears to be Captain Smith. There are men in the crow's nest and on the forecastle, while puny matting still hangs over the prow.

It was nineteen days later, on 25 March, that 57-year-old Herbert James Haddock, who was four years younger than his fellow commander, became the first man to ink his name on a *Titanic* crew agreement, having led over a boarding party that had sailed from Liverpool to take charge of the ship until the arrival of a further working complement.

He did not long remain at the helm, with Smith arriving to take charge of the sea trials. Haddock faced an *Olympic* mutiny shortly after *Titanic* sank.

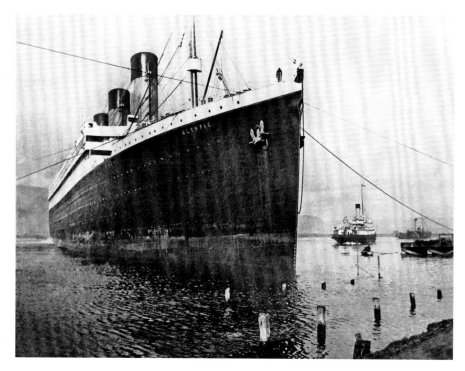

'It is intended to turn her bow towards the Lough so as to facilitate matters as much as possible,' said the *Irish News* of *Olympic*. 'There is at present on board only a part crew, but she will take on her full complement at Southampton.' She was 'bow on' for the mouth of the Lagan by midday, 'the water having meanwhile moderated sufficiently to make her clearance from the harbour quite safe'.

The paper added the next day: 'The operation of changing the positions of the two leviathans was a big and delicate task; but it was most successfully carried out under the supervision of Mr [Thomas] Andrews and Mr Charles Payne of Harland & Wolff, and Captain [Charles] Bartlett, marine superintendent, White Star Line.'

Thomas Andrews died on the *Titanic*.

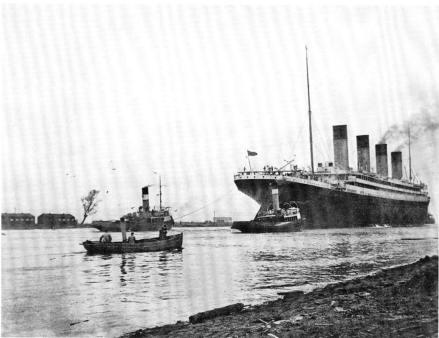

This sumptuous picture shows the vessel pursued by a steamboat. The original caption says it is J.W. Kempster therein (seen handling a camera), along with someone identified only as 'G.P'. In the background is West Twin Island.

Departure of the *Olympic*

The mammoth White Star liner *Olympic*, which arrived in Belfast Lough on the 1st inst. for repairs on connection with her mishap in mid-Atlantic, where she lost a blade of her propeller and sustained some slight damage to the shafting, left the deep-water wharf yesterday, and having been swung in the river, proceeded to Southampton, being taken some distance down the channel by the powerful tugs which had escorted her to the Queen's Island.

The difficult operation of swinging the leviathan was carried out without a hitch, and was witnessed by a large crowd of interested spectators, who were, however, kept at a safe distance by a force of harbour police on duty in the vicinity.

If the weather to-day is favourable the *Titanic* will be towed on the first tide from the new graving dock, where she was temporarily accommodated to facilitate the manoeuvring of her sister ship, and will be berthed again at the fitting-out wharf.

(Belfast *Newsletter*, Friday 8 March 1912, p.7)

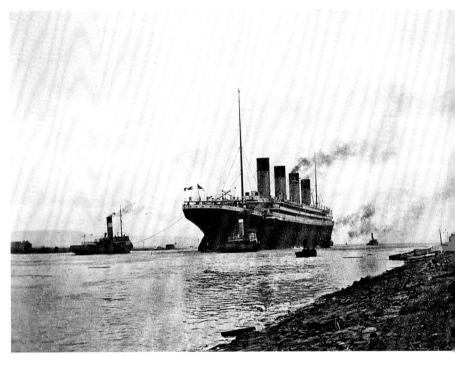

The building on the left, on West Twin Island, belongs to the Intercepting Hospital for Contagious Diseases.

Just after noon she passed slowly down the channel, attended by quite a flotilla of tugs, and emerged into the Lough, presenting a glorious spectacle in the brilliant Spring sunshine.

On getting into good water the liner was put under her own steam, and was soon lost to the view of the many who gathered at various vantage points to watch her departure.

(*Irish News*, Friday 8 March 1912, p.4)

Two days before, on 6 March, an inquest had been reported by the same newspaper featuring a heartbroken sailor who was soon to embark the RMS *Titanic*:

Robert Hopkins, 31 Belmont Street, identified the body as that of his wife, Annie Hopkins. She was 42 years of age. Witness said he had been at sea since the 28th January last, and, his voyage ended, he had returned home about one' o'clock on Monday morning [4 March]. His wife came downstairs, opened the door, and let him in. She appeared to be then in her usual health, though he thought her strange looking ... deceased had been twice confined in the observation ward of the Union Hospital, Belfast, and once in Liverpool.

Later he dressed and went down to the shipping office for his pay. His errand over, witnessed returned home ... he could not see his wife in the kitchen and went upstairs, but she was not there either. Witness then went to put some coal on the fire, and was opening the scullery door when to his horror he saw his wife suspended above him by a rope from the bannister. He sent for a doctor, but he could already see that his wife was dead.

(*Irish News*, Wednesday 6 March 1912)

On *Titanic,* Hopkins registered his marital status as 'widowed'. He survived the sinking, and stayed in the United States, dying in 1943, aged 77.

113

In other news this day:

Motor Ambulance's First Trip

Yesterday the new motor ambulance was requisitioned for the first time, when a call was received to the SS. *Titanic*. It appears that a young man of twenty-two years of age, named George Stewart, residing at Mountcollyer Road, was working on a crane when he was crushed in the machinery.

The ambulance immediately conveyed the unfortunate man to the Royal Victoria Hospital, where he was detained. The time taken by the new motor for the whole journey from headquarters to the hospital was under a quarter of an hour.

(*Irish News*, Friday 8 March 1912, p.4)

The 1911 census shows the victim as a shipwright. Perhaps his injuries, from which he recovered, saved him from a delivery trip to Southampton and the danger of being re-engaged for the maiden voyage.

This was not the first casualty involving the completed *Titanic*, quite apart from well-chronicled deaths and injuries in her construction. A painter who worked on her hull was found drowned in the River Foyle after a night's drinking on a trip to Derry made after he was paid off. John Fox, 28, of Bridge Street, Belfast, originally from Glasgow, had gone missing on 30 March 1912. Two watches found on Fox's watery corpse, when it was finally recovered on 24 April, had both stopped at 11.30 p.m.

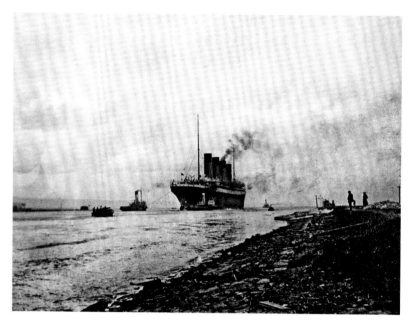

The Kempster boat has moved from astern to the *Olympic*'s port side. Now coming up quickly behind is another vessel, possibly populated by postcard photographers, of which the most famous was Walton of Belfast.

The *Olympic* has reached the open water of Belfast Lough.

11

TITANIC SAILS

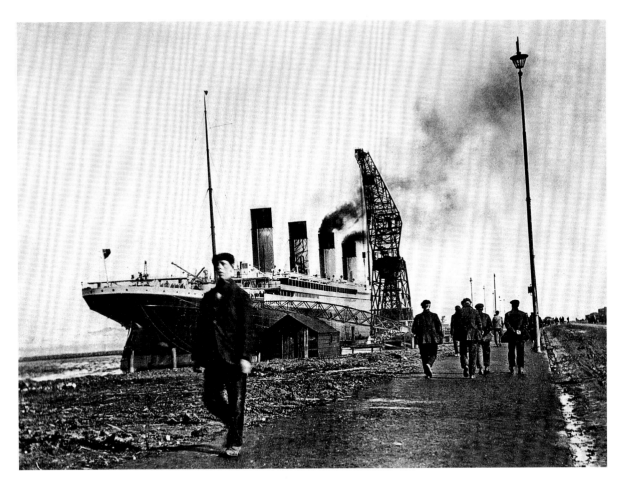

The *Titanic* on April Fool's Day 1912, a blustery Monday.

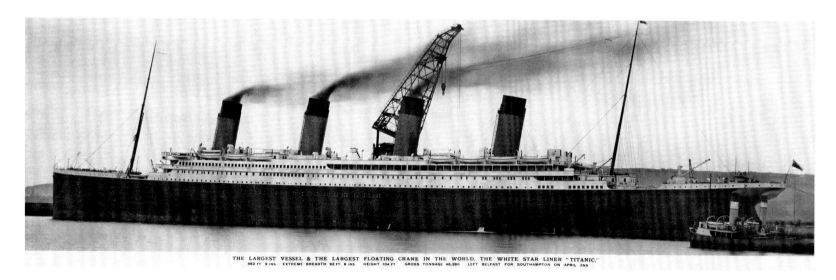

THE LARGEST VESSEL & THE LARGEST FLOATING CRANE IN THE WORLD, THE WHITE STAR LINER "TITANIC."
882 FT. 9 INS. EXTREME BREADTH 92 FT. 6 INS. HEIGHT 104 FT. GROSS TONNAGE 46,380. LEFT BELFAST FOR SOUTHAMPTON ON APRIL 2ND

A Hurst & Co. (Belfast) postcard of *Titanic*, thought to have been taken on the morning of 1 April, indicating the power of the wind in folding back thick columns of smoke upon themselves.

She was due to sail to Southampton on 1 April but was held up by high winds after her sea trials had been successfully completed – which even then had run into squalls of sleet and snow in Belfast Lough.

The weather in the city had become 'very inclement' the previous day, 31 March, while the temperature dropped appreciably towards evening. Downpours of icy rain were 'succeeded by heavy showers of snow and sleet from nine till ten o'clock'.

The following day, intended sailing day 1 April, the local forecast was for 'strong wind, a gale in places, squally; showery; hail, sleet or snow in several localities; temperature low'. Captain Smith, in consultation, decided to await developments.

But the wind force reached Beaufort scale 8, a gale, at the re-fixed evening hour when *Titanic* had been due to depart. The photograph on the previous page appears to have been taken in the morning, judging by the shadows, yet the smoke from the first funnel is already blowing horizontally, consistent with the forecast chill wind out of the north-west. The mainmast and stern flags are ripping gloriously.

On this day, a 28-year-old on-board staffer of the à la carte restaurant, Will Jeffery, pens a letter to his mother, datelined SS *Titanic* at Belfast, 1 April 1912.

He writes:

Thanks very much for letter, which I received this afternoon, and I am going to try and catch a mail with this. I have just heard that we are not going to sail tonight, although we were originally due to sail @ 9 o'c this morning, then it was postponed till tonight, as it was so windy, and now till the morning.

We are doing very little here except worry around trying to get various necessary jobs done, and until the workmen are out of the way we can't touch anything.

You must excuse any more now as I must hurry – give my love to all. Your loving son, Will.

By the following morning, 2 April 1912, the wind had moderated and backed more favourably to the south-west, although it was still fresh. High water at Belfast was at 10.55 a.m., and the *Titanic* seized her opportunity.

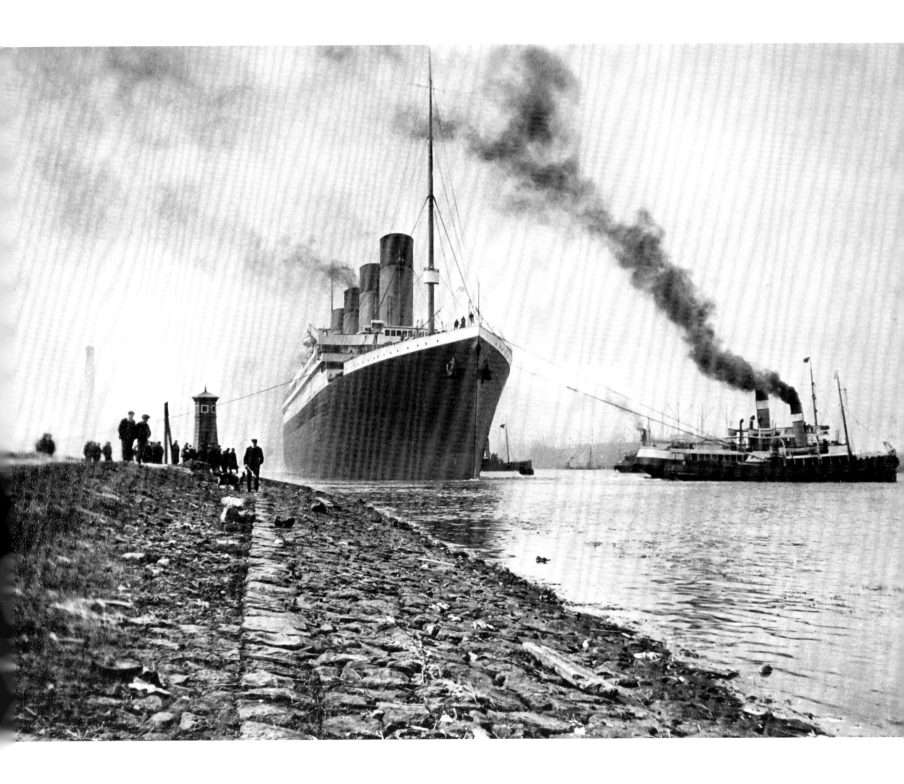

Departure of the *Titanic*

The World's Largest Vessel

The new Royal Mail triple-screw steamer *Titanic*, which has been built by Messrs. Harland & Wolff, Ltd., for the White Star Line, left the deep-water wharf shortly before ten o'clock yesterday morning for Southampton, whence she will sail on her maiden voyage to New York on the 10th inst.

The usual scenes of bustle and animation attending the departure of a great liner were witnessed from an early hour in the morning, and as the hawsers were cast off the *Titanic* – the largest vessel in the world – floated proudly on the water, a monument to the enterprise of her owners and the ingenuity and skill of the eminent firm who built her.

She was at once taken in tow by the powerful tugs which were in attendance, and the crowds of spectators who had assembled on both sides of the river raised hearty cheers as she was towed into the channel.

(Belfast *Newsletter*, Wednesday 3 April 1912, p.7)

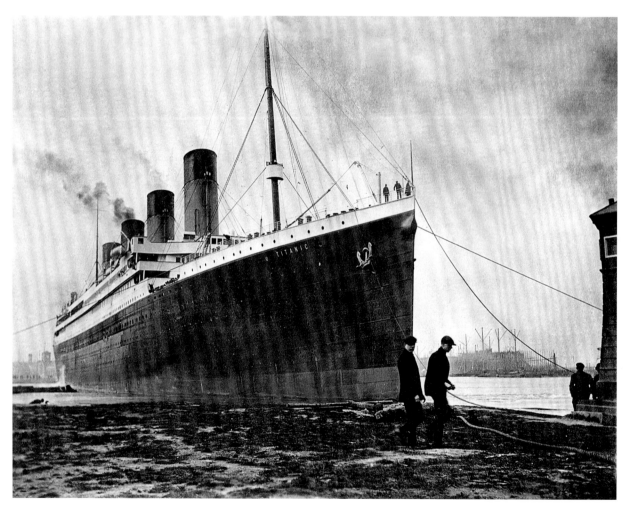

Opposite: The Workman Clark shipyard is seen across the Lagan as the *Titanic* makes ready. One of the figures at the stem post, likely the middle one, is William McMaster Murdoch, whose express duty as chief officer under White Star Line regulations is to be on the forecastle when casting off.

The *Titanic* arrived in the Solent very late on Wednesday night, 3 April. By the next day, Murdoch would be supplanted as chief by Henry Tingle Wilde, and would drop down to first officer.

Lookout Fred Fleet, fated to first spot the iceberg, has signed ship's articles and may already be in the crow's nest.

Poised by the East Twin Island light tower, the *Titanic*'s run for the open sea is about to begin.

Both these pictures show a dark diagonal on the starboard side, below the well deck. While a coal-bunker fire was already merrily blazing, expert opinion suggests the mark is a causeway reflection.

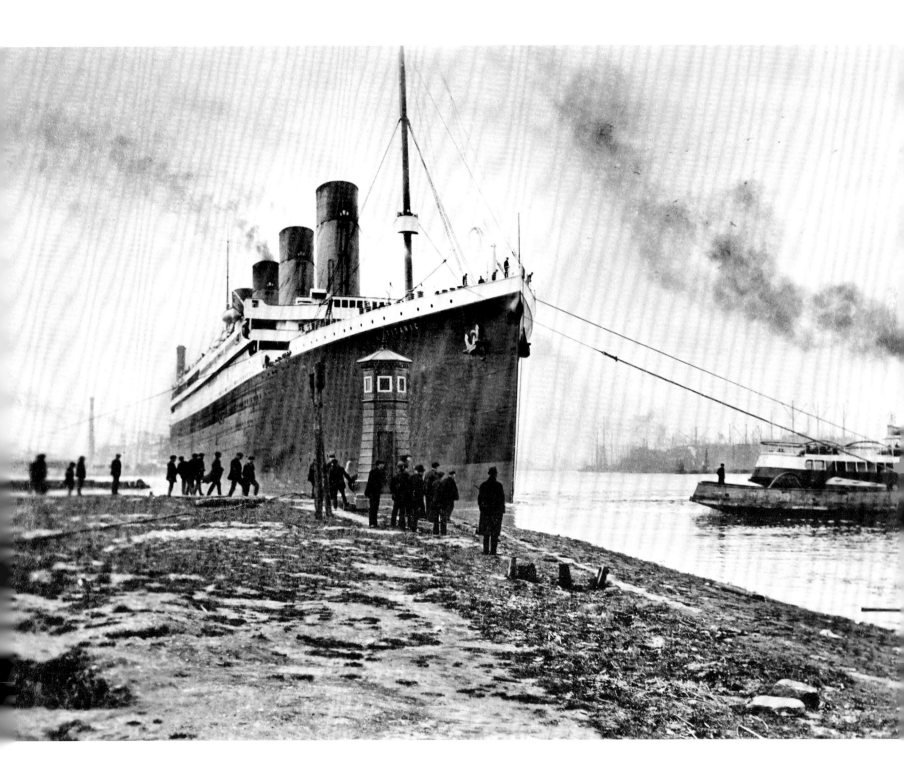

The mammoth vessel presented an impressive and picturesque spectacle, looking perfect from keel to truck, while the weather conditions were happily of a favourable character.

(Belfast *Newsletter*, Wednesday 3 April 1912, p.7)

Five tugs husbanded *Titanic* as she left. *Hercules*, *Herald* and *Hornby* were deployed forward, with *Huskisson* and *Herculaneum* astern, from port to starboard respectively.

The delay of a day in putting to sea may have put paid to an intention for the *Titanic* to make a courtesy call to Liverpool, the home port emblazoned on her stern, as the *Olympic* had done on her

Opposite: By a quirk of cartography, the *Titanic* is now substantially in Co. Antrim, while her sternmost tug is in Co. Down. The Victoria Channel was divided, the northern water being in Antrim, southern in Down. But the Down boundary ended diagonally just before the lighthouse keeper's house seen at land's end to right. At the far side of this house was a fixed red lighthouse (obscured). 'When the tugs were left behind the compasses were adjusted, after which a satisfactory speed run took place, and 'the latest triumph of the shipbuilder's art then left for Southampton, carrying with her the best wishes of the citizens of Belfast.'

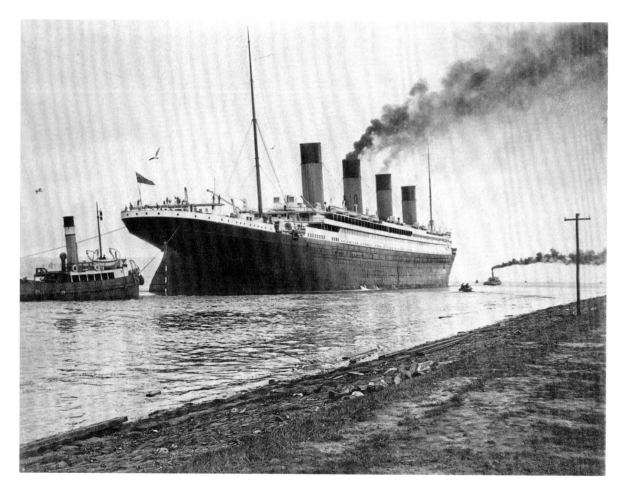

The *Titanic* about to enter the Victoria Channel, and upon that tide in the affairs of men that leads to flood and misfortune. No one is paying attention to the report in this day's newspaper of 'An Atlantic Experience' in the case of the Furness liner *Athenian*, of a mere 1,467 tons.

Arriving in Leith (Edinburgh, Scotland) from Philadelphia, the *Belfast Telegraph* reported: 'For ten days the steamer was surrounded by pack ice and considerable difficulty was experienced in cutting a way through, in consequence of which a number of her plates were dented and about forty rivets broken.'

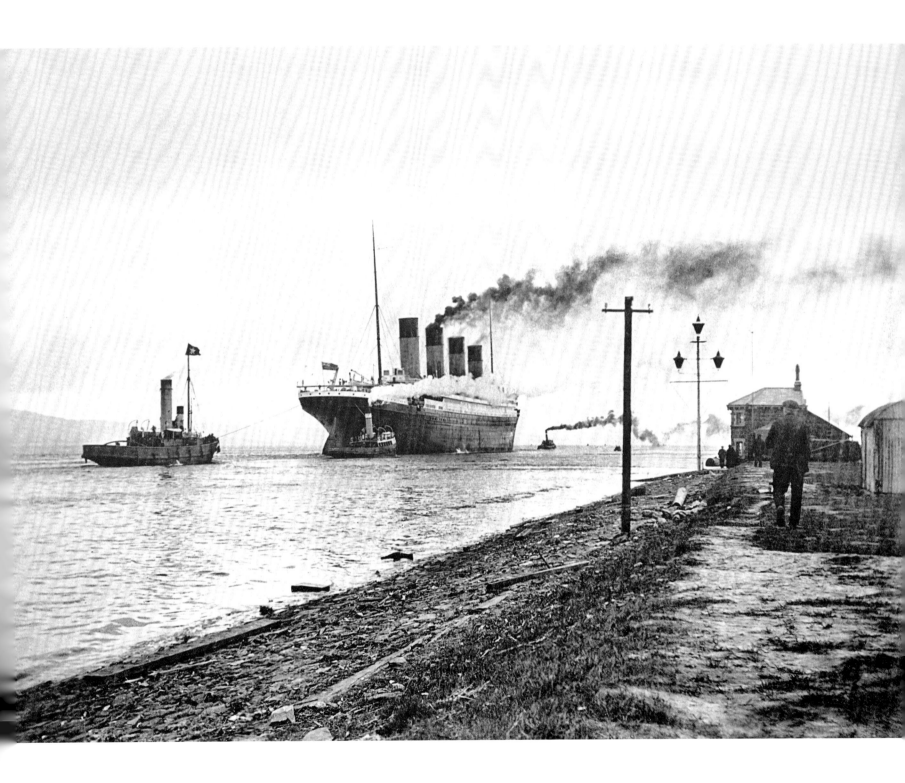

delivery voyage, meaning she would never see the port where she was officially registered.

Charles Lightoller, first officer while leaving Belfast, is one of the figures on the aft docking bridge in these pictures, as was his duty.

Considerable interest was aroused in Penzance on Wednesday in a remarkably fine steamer which was observed crossing the Bay. She proved to be the White Star liner *Titanic*, on her way from Belfast to Southampton.

The *Titanic* shaped a course considerably nearer the land than that usually taken by liners, and as the day was fine a good view of her was observed.

(*Cornishman*, Thursday 11 April 1912)

Titanic is operating under a port helm to avoid a sandbank (the ancient Gaelic name for Belfast, *Béal Feirste*, means 'mouth of the sandbank') with buoys marking the navigable channel, conical buoy No. 10 to right.

An icon bids adieu to her cradle city for the first and last time. In twelve days' time her last and desperate port manoeuvre will not be enough to avoid catastrophe.

The Victoria Channel between the West and East Twin Islands, though neither is an island any longer. To lower left is the Thompson graving dock, with the outfitting basin described as the 'new wharf'. The light tower is seen nearby (lower centre), the causeway leading to a larger lighthouse at its extremity. To the right lies Belfast Lough, while the Musgrave Channel lies lower right.

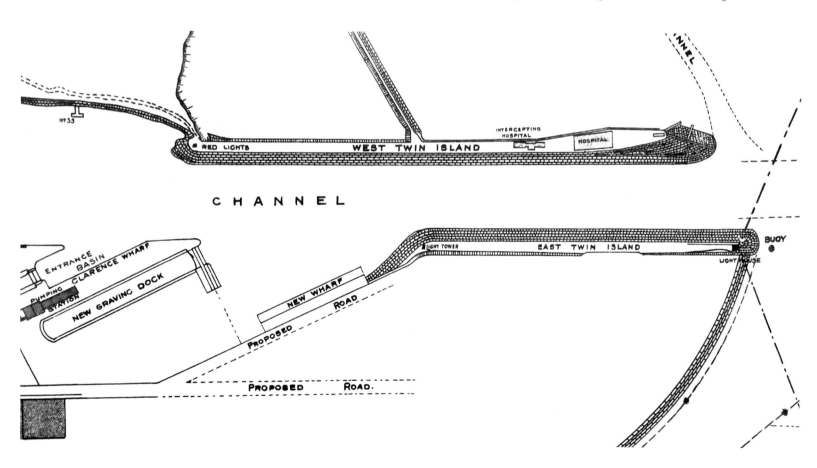

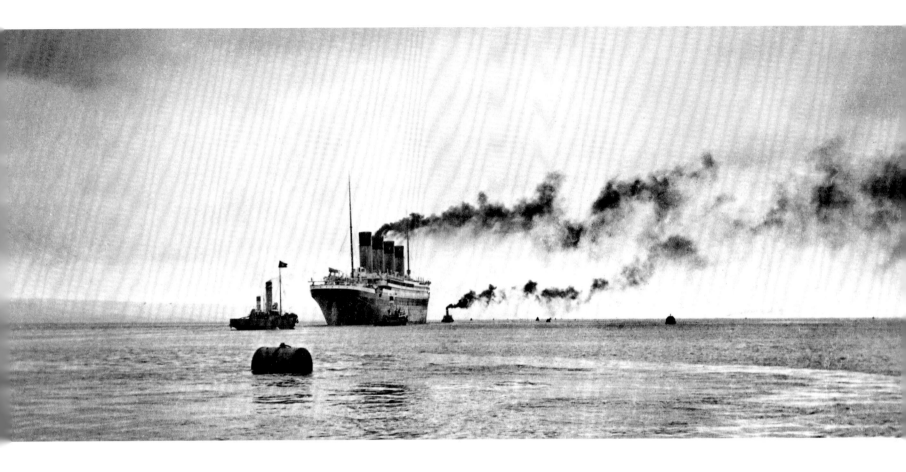

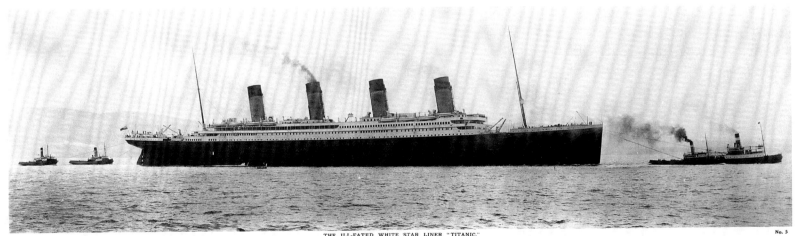

No. 5

THE ILL-FATED WHITE STAR LINER "TITANIC."
LEAVING ON HER FIRST AND LAST VOYAGE. SUNK BY COLLISION WITH AN ICEBERG APRIL 15th, 1912, WITH
A LOSS OF 1,500 SOULS. THE GREATEST MARITIME DISASTER IN HISTORY.

12

EVE OF THE UNTHINKABLE

Titanic arrived in the Solent late on the night of Wednesday night, 3 April. Testimony was later given that she had made an average of 18 knots on the voyage through the Irish Sea, with the watertight doors being tested daily.

Joe Mulholland was the second-last man to sign on for the delivery trip, joining the *Titanic* on 2 April. He gave an outline of the trip to Southampton to the Dublin *Sunday Independent* on 15 April 1962:

There was plenty of drama on the journey down the Irish Sea as the great ship – the pride of the Belfast shipyard – headed for Southampton to take on board its complement of passengers, a cross-section of the social registers of England and America. In Belfast in those days it was hard to get an experienced stokehold staff. Joe Mulholland said they scoured the Salvation Army hostel, the dockside, and eventually got together a scratch team ranging from 'milkmen to dockers': 'I had to mind six stokeholds, and the chief engineer told me to get the men to break up the big clinkers. I told them, but they must have lifted up the covers and kicked the clinkers down and affected the hydraulic pumps because the seas came back and we were soon standing up to our thighs in water. A young whipper-snapper of an engineer came galloping up and he gave off something shocking. We got the water away, but I did not fancy that young fellow.'

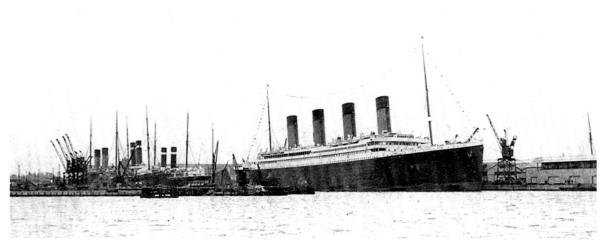

Joe recalls a meeting in the engine room with Thomas Andrews, the designer of the ship, director of Harland & Wolff, and a member of the noted Comber (Co. Down) family:

I knew Mr Andrews because I often stoked ships on their trials after they were launched at Belfast. He came down to me and pointed to some of the insulting slogans about the Pope which had been chalked up on the smoke-box. Some of them were filthy and I had already heard about similar slogans which had been painted on the hull before the *Titanic* was launched.

Mr Andrews said, 'Do you know anything about these slogans?'

I did not, so he said, 'They are disgusting' and went off and returned with some sailors and had them removed.

Mulholland was 79 at the time of this interview. He said, 'There was something about that ship I did not like, and I was glad to lift my old bag and bid goodbye to my shipmates, like Hughie Fitzpatrick and Pancake Baker, when she arrived at Southampton.'

He claimed that before *Titanic* left Belfast he had taken pity on a stray cat which was about to have kittens, bringing it aboard and putting her in wooden box down in the stokehold. (*Titanic* stewardess Violet Jessop also mentioned this feline in her memoirs.)

But at Southampton, when ruminating whether to take an offered cushy job as storekeeper on the maiden voyage or to sign off, another seaman called him over and said, 'Look Big Joe. There's your cat taking its kittens down the gangplank.'

Joe said, 'That settled it. I went and got my bag and that's the last I saw of the *Titanic*'.

—·—

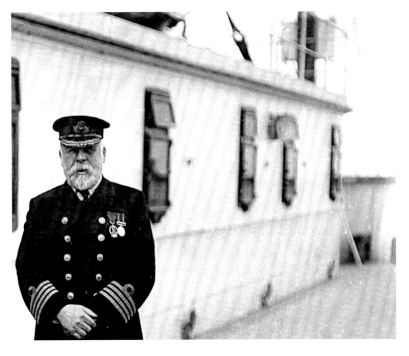

Captain Smith at Queenstown on 11 April 1912. This picture was issued cropped, but detail from the glass plate negative shows Collapsible A on the roof of the officers' quarters above his head. This lifeboat was later swamped in the sinking. The crow's nest is visible on the foremast. In less than three and a half days a desperate alarm will sound from here.

The crew agreement for the delivery voyage was lodged on 4 April with the Board of Trade in Southampton. An eagle-eyed civil servant named N.O. Dodd noticed that nobody had signed off the document as the master of the ship before it was deposited with him. He sent word to the ship, then tied up at berth 44, where coaling was the uppermost consideration, given the recent pit strike. But E.J. Smith did not turn up to furnish his signature.

A crimson inscription by Dodd can be seen on the front of the document to this day: 'Capt. Smith was informed that he had not signed [the] agreement. He sent a message that if he could not call before he sailed, he would do so on the return of the ship.'

The master of the *Titanic* thus promised to return her to Southampton.

—·—

Opposite: Left: *Titanic* at Southampton on Good Friday, 5 April 1912. The other liners, left to right, are the *Majestic*, *Philedelphia* and *St Louis*, all *c*. 10,000 tons; right: Joseph Mulholland, 1919. (Southampton City Archives)

Chief Officer Henry Tingle Wilde. (*Daily Mirror*)

On board R·M·S·"TITA[...]

7th April

My dear Koral & Edie

Thanks for your letter received this morning which I was glad to have & to know that you were allright I would have written to you but have been so busy & so uncertain what I was going to do I am now in the 'Titanic' but am not sure that I am sailing in her yet, I tried to get to Liverpool yesterday but could

(Henry Aldridge)

On Sunday 7 April, *Titanic* chief officer Henry Wilde writes to his nieces:

I am now on the *Titanic* but I am not sure I am sailing on her yet. I tried to get to Liverpool yesterday but could not manage it, but I am not quite sure of going yet. I am wondering whether Mother has had the business settled yet. Will you ask her to let me know.

If I go on this ship we sail on Wednesday & will be back in 17 days & I will try & come up then.

I have been kept very busy on board all day on Good Friday & again today Sunday with the crew getting the ship ready. She is very far behind to sail on Wednesday. Working on her night & day. She is an improvement on the *Olympic* in many respects & is a wonderful ship, the latest thing in shipbuilding.

As if to prove Wilde's point, an unseen detail of the *Titanic* at Southampton on Good Friday, 5 April. A party of workmen have lowered themselves down the port side (between the white of the superstructure and the black of the hull) and are touching up the plating. Far above them hang escape craft. Some passengers, nine days later, would clamber down the lifeboat falls in a desperate bid to reach those already launched.

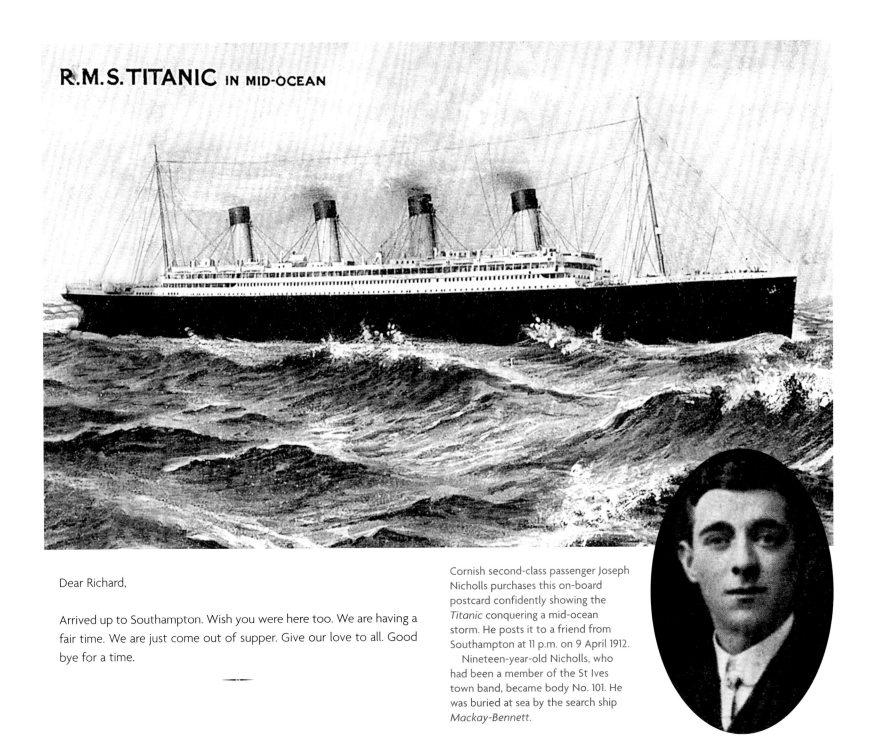

R.M.S. TITANIC IN MID-OCEAN

Dear Richard,

Arrived up to Southampton. Wish you were here too. We are having a fair time. We are just come out of supper. Give our love to all. Good bye for a time.

Cornish second-class passenger Joseph Nicholls purchases this on-board postcard confidently showing the *Titanic* conquering a mid-ocean storm. He posts it to a friend from Southampton at 11 p.m. on 9 April 1912.

Nineteen-year-old Nicholls, who had been a member of the St Ives town band, became body No. 101. He was buried at sea by the search ship *Mackay-Bennett*.

CHERBOURG. — L'Arrivée d'un Train Transatlant

White Star's Special Corridor Train left the Gare Saint-Lazare in Paris at 8.55 a.m. and was at the White Star pier before 3.30 p.m., taking in Évreux, Lisieux, Caen and Lison. Tickets were obtainable from the line's offices at 9 rue Scribe.

First-class passenger Edith Russell, a fashion buyer travelling as Rosenbaum, wrote:

As the train was about to pull out, Laurent, the head tailor of Paquin, the famous couturier of the Rue de la Paix, accompanied by the head tailors, rushed up and thrust through the compartment window two huge white boxes tied with tapes, carrying heavy lead seals. These boxes contained clothes I had ordered, but which had not been finished in time, hence this late delivery. The boxes were never unpacked and went down with the ship just as they were delivered.

Russell recalled in 1956:

The train-run from Paris to Cherbourg was quite pleasant. I chatted with some Swedish and American ladies in the compartment and with a Mexican gentleman [Manuel Ramirez Uruchurtu] ... We formed a very merry little party. The fact that we were all sailing on this exceptional vessel on her maiden voyage seemed to draw us together. Everybody was looking forward to seeing the monster ship. But on arriving in Cherbourg I had a most disagreeable premonition of trouble ahead.

CHERBOURG — Embarquement des Voyageurs à bord du " Nomadic"

Collection Mercier, Cherbourg

The *Nomadic* ferried first-class passengers to the *Titanic*. Now dry-docked in Belfast, she is the last surviving vessel of the White Star fleet.

A Saloon Passenger's Impressions

Interesting Notes

'Look how that ship is rolling, I never thought it was so rough'. The voice was a lady's, and the place was the sun deck of the *Titanic*. We had just got well clear of the eastern end of the Isle of Wight, and were shaping our course down the English Channel towards Cherbourg.

The ship that had elicited the remark was a large three-masted sailing vessel, which rolled and pitched so heavily that over her bows the seas were constantly breaking. But up where we were – some 60ft above the water line – there was no indication of the strength of the tossing swell below. This indeed, is the one great impression I received from my first trip in the *Titanic* – and everyone with whom I spoke shared it – her wonderful steadiness. Were it not for the brisk breeze blowing along the decks, one would have scarcely imagined that every hour found us some 20 knots further upon our course. And then this morning, when the full Atlantic swell came upon our port side, so stately and measured was the roll of the mighty ship that one needed to compare the movement of the side with the steady line of the clear horizon.

After a windy night on the Irish Sea, when the sturdy packet boat tossed and tumbled to her heart's content – by the way, have ships a heart? – the lordly contempt of the *Titanic* for anything less than a hurricane seemed most marvellous and comforting.

But other things besides her steadiness filled us with wonder. Deck over deck and apartment after apartment lent their deceitful aid to persuade us that instead of being on the sea we were still on *terra firma*. It is useless for me to attempt a description of the wonders of the saloon – the smoking room with its inlaid mother-of-pearl, the lounge with its green velvet and dull polished oak, the reading room with its marble fireplace and deep soft chairs and rich carpet of old rose hue – all these things have been told over and over again and only lose in the telling.

So vast was it all that after several hours on board some of us were still uncertain of our way about, though we must state that, with commendable alacrity and accuracy, some 325 found their way to the great dining room at 7.32 p.m., when the bugle sounded the call to dinner. After dinner, as we sat in the beautiful lounge listening to the White Star orchestra playing the *Tales of Hoffman* and [a] *Cavalleria Rusticana* selection, more than once we heard the remark, 'You would never imagine you were on a ship'.

Still harder was it to believe that up on the top deck it was blowing a gale, but we had to go to bed, and this reminds me that on the *Titanic* the expression is literally accurate. Nowhere were the berths of other days seen, and everywhere comfortable oaken bedsteads gave place to furniture in the famous suites beloved by millionaires.

Then the morning plunge in the great swimming bath, where the ceaseless ripple of the tepid sea water was almost the only indication that somewhere in the distance 72,000 horses in the guise of steam engines fretted and strained under the skilful guidance of the engineers, and after the plunge a half-hour in the gymnasium helped to send one's blood coursing freely, and created a big appetite for the morning meal.

But if the saloon of the *Titanic* is wonderful, no less so is the second class, and in its degree the third class. A word from the genial purser acted as the 'Open Sesame' of the Arabian Nights, and secured us an English officer and his son, whose acquaintance I had made at lunch, and a free passage through all the floating wonder. Lifts and lounges and libraries are not generally associated in the public mind with second-class accommodation, yet in the *Titanic* all are found. It needed the assurance of our guide that we had left the saloon and were really in second class.

On the crowded third-class deck were hundreds of English, Dutch, Italian and French mingling in happy fellowship, and when we wandered down among them we found that for them too the *Titanic* was a wonder. No more general cabins, but hundreds of comfortable rooms, with two, four, or six berths, each beautifully covered in red and white coverlets. Here too are lounges and smoking rooms, less magnificent than those amidships to be sure, but none the less comfortable, and which, with the swivel chairs and separate tables in the dining rooms, struck me as not quite fitting in with my previous notion of steerage accommodation.

(Written anonymously by *Titanic* amateur photographer Fr Francis Browne, who disembarked at Queenstown. *Cork Constitution*, Saturday 13 April 1912, p.4.)

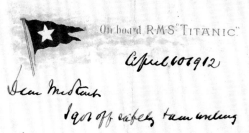

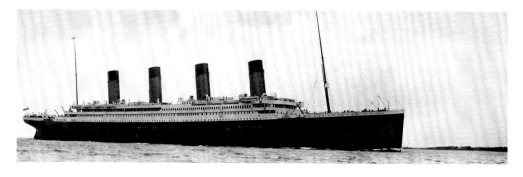

Exceptionally rare postcard by Silk of the *Titanic* on her way to France.

Titanic at Queenstown.

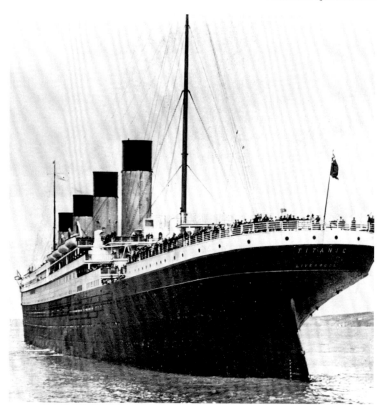

Sailing-day letter by the famed journalist William Thomas Stead to a colleague at his journal, the *Review of Reviews*: 'Dear Mr Stout, I got off safely & am writing in a room as comfortable as any in town.' Stead did not get off safely. A noted spiritualist who had predicted a mass drowning on an ocean liner through lack of lifeboat provision, he lost his life in the disaster.

The flag of the United States flies on the *Titanic* for the first time. The destination flag was hoisted at anchor in Queenstown at lunchtime on Thursday 11 April 1912, even if Old Glory's ascent was little noticed at the time.

Sailors normally had their port arrival details entered in their discharge books for each voyage. In replacement documents issued after the sinking, this crossing was entered 'Intended New York'.

Just after the disaster, the *Cork Examiner* reported:

> A young man named [John] Coffey had a lucky escape from being amongst those lost on the *Titanic*. Coffey joined the *Titanic* at Southampton and on the passage to Queenstown, decided to get out of her as he did not relish his job.
>
> Accordingly, at Queenstown, he stealthily got on board the tender which took the passengers out, and secreted himself on board and got clear at Queenstown successfully, and remained here until Sunday morning last when he joined the *Mauretania*.

Coffey was born in the port and had decided to use the *Titanic* as a taxicab home. His shipmate John Podesta later recalled:

> A fireman whom I knew very well, John Coffey – I was in the *Oceanic* and *Adriatic* with him – said to me, 'Jack, I'm going down to this tender to see my mother.' He asked me if anyone was looking, and I said 'No' and bade him good luck. A few seconds later he was gone!

The deserter lived until 1957, when he died in Hull, aged 68. The very last person off the vessel in her home waters was the Queenstown pilot, John Cotter.

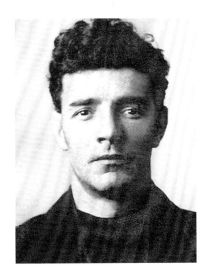

John Coffey.

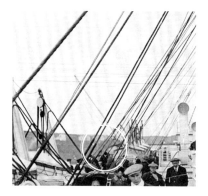

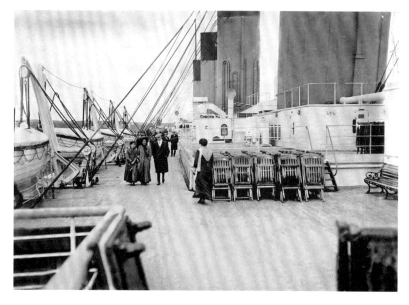

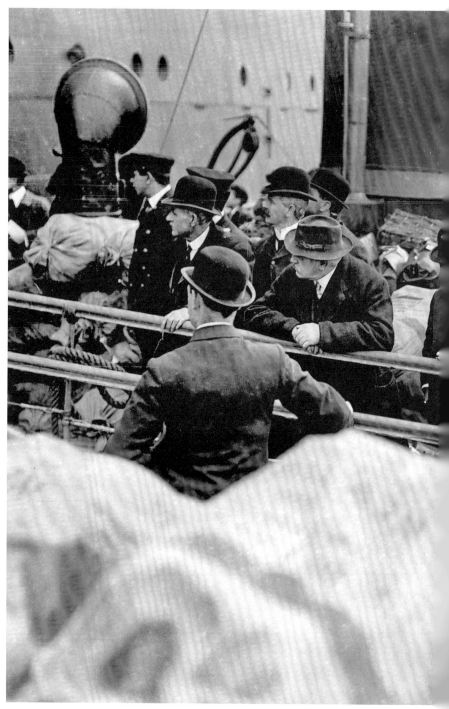

Top left: Previously hidden detail from a high-resolution reproduction of a glass plate negative shows the midship section of the boat deck port side at Queenstown, where officers and passengers have been peering overside at the tender *America* and her complement of Irish steerage emigrants.

Turning away from the scene is a bearded man in distinctive army uniform. This is Canadian Major Arthur Peuchen (*top right*) of the Queen's Own Rifles, aged 52, travelling alone in first class.

Peuchen will perform an amazing feat in this very location three nights later. Lifeboat 6, just forward of aftermost Lifeboat 8 (with visible White Star burgee), had just been lowered when its occupants cried out for more crew.

Lacking sailors, Officer Lightoller called out for experienced men among the crowd. Peuchen offered that he was a yachtsman, to be told that if seaman enough to climb down the lifeboat falls, he could go. The major daringly leapt to a dangling rope, descending to the boat below.

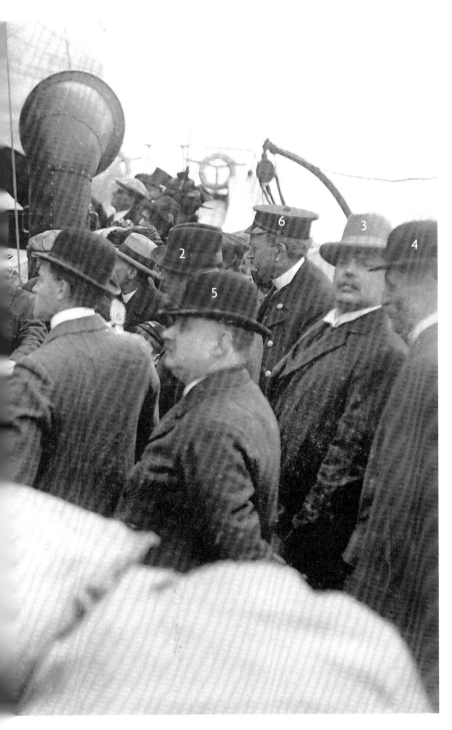

1. Thomas Myles

2. Eber Sharp

3. William McLean

4. James Scott

5. Charles Kirkland

6. James McGiffin

Saloon passengers, press and officials about to board *Titanic* by gangway from the tender *Ireland*. To the left is Thomas Myles (1) from Massachusetts, travelling second class, also above. He will lose his life. Next is Board of Trade surveyor Eber Sharp (2), who also appears above, wearing the same hat. To right, the man in pince-nez is William McLean (3), Board of Trade sanitary surveyor, and alongside is James Scott (4), wizened White Star agent at Queenstown. In front of him is second-class passenger Rev. Charles Leonard Kirkland (5), of Maine, destined to die in the sinking. His granddaughter identifies White Star marine superintendent James McGiffin (6) also going aboard. The woman top of picture seems likely to be second-class passenger Hilda Mary Slayter of Canada, who survived. Another woman's face, possibly that of survivor Nora Keane, appears under the chin of McGiffin. (*Titanic* at Queenstown embarked only four women in first and second class, which the *Ireland* carried.) Descending diagonally left produces a boy in a cap, face obscured, likely taken indulgently out of school by a local journalist father.

133

13

MAJESTIC 1912

The *Majestic* was the veritable ghost of the *Titanic* on the North Atlantic for the rest of 1912.

She had been taken out of service in November 1911 with the anticipated advent of the superlative second of the Olympic-class liners, the first having already supplanted the *Teutonic*, which was switched from Southampton–New York to Canadian routes.

The *Majestic* was designated a reserve ship and mothballed for a time at Birkenhead, Merseyside, while her future was mulled for months. Disaster to the *Titanic* intervened, and she had to be recalled to Atlantic undertakings to enable White Star to meet a weekly sailing schedule.

In autumn 1912 she was restored to her former pre-eminence when the *Olympic* abruptly left the Atlantic to be fitted with a new double bottom and added safety features as a result of her sister's demise. The *Majestic* and *Oceanic* maintained a winter run with the aid of the American Line's *St Paul*, *New York* and *St Louis*.

Her renaissance was short-lived; *Majestic*'s last crossing came in January 1914, after which she was sold for scrap. At just 10,000 tons, she had been feeling her age and long service.

Majestic debuted in 1890 and even briefly captured the fabled Blue Riband from the *City of Paris* the following year, reducing the Atlantic crossing to five days, eighteen hours and eight minutes. Unfortunately the achievement was surpassed a fortnight later by her sister ship *Teutonic*, which shaved a further ninety-eight minutes off the time.

Nonetheless *Majestic* served 500 voyages and more on the North Atlantic, achieving veteran status not without past days of glory.

Charles Lightoller wrote in his memoirs:

> I have seen a big modern liner push a plate in, where the old-time ship would have just bumped and bounced off without a scrap of damage. Three times in the old *Majestic* I have seen the look-out cage, situated half way up the foremast, and built of steel, flattened in against the mast, but little or no damage on deck.

He did not explain these enigmatic remarks, but elsewhere hinted that her past captain, E.J. Smith, had handled the vessel in a somewhat 'ram you, damn you' fashion.

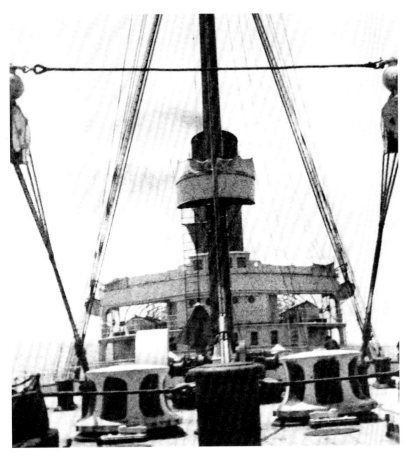

The *Majestic* at sea, bound from New York to Southampton on Friday 7 June 1912. Although the crow's nest looks empty at first glance, there is indeed a head there, to the lower left-hand edge of the dark funnel as we look.

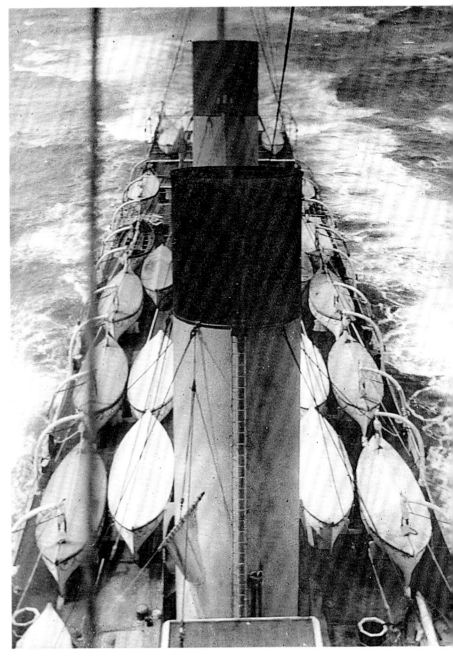

The somewhat ludicrous legacy of the *Titanic* disaster – massed lifeboats on the decks of the *Majestic* in August 1912.

White Star managing director J. Bruce Ismay announced on landfall in New York in April that henceforth his company's vessels would carry boats sufficient to carry all aboard.

It was pointed out, however, that *Titanic* sank in a calm sea over more than two and a half hours and barely managed to get sixteen standard lifeboats away in that time, thus a panoply of extra boats was no guarantee against major loss of life in another emergency.

In the House of Commons later in the year, Richard Holt, MP for Hexham, denounced the 'fetish of boats for all', calling it 'one of the most ridiculous proposals ever put forward'. Famed maritime sage Lord Charles Beresford spoke of the necessity of taking grave care lest providing too many lifeboats endangered a vessel by making her top-heavy.

The original fear of White Star Line principals with the Olympic-class liners was that providing more boats would 'clutter up the deck' and thereby inconvenience and even deter passengers.

The *Majestic* left New York on Saturday, two hours after the *St Paul*, overhauled her rival … and passed her at 10am on Wednesday. The two vessels were in sight of each other for 48 hours and were in wireless communication throughout the trip. There was much excitement among the passengers over the race, and considerable betting on the result.

The *Majestic* won to Plymouth, arriving there at 8.45 on Saturday night, two hours ahead of the *St Paul*.

(*New York Tribune*, Monday 2 September 1912, p.1)

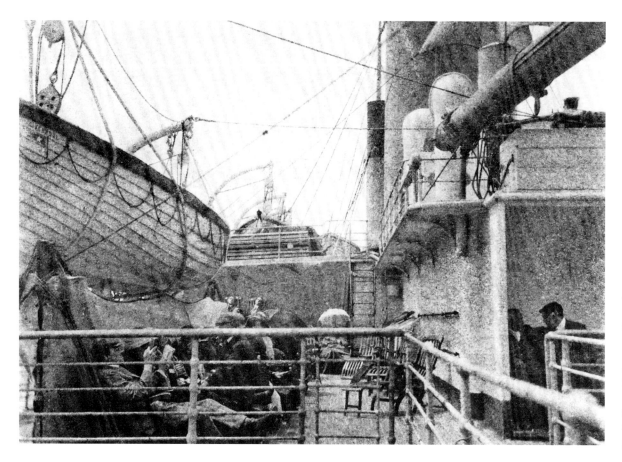

Passengers take their ease on the *Majestic* as she nears New York on Monday 19 August 1912. Five days later, she sailed from Pier 59 in the North River to complete her 500th round trip between New York and Southampton. She celebrated the occasion by beating the *St Paul* of the American Line in a race across the Atlantic, showing little had been learned from calamity. The triumph made the front page.

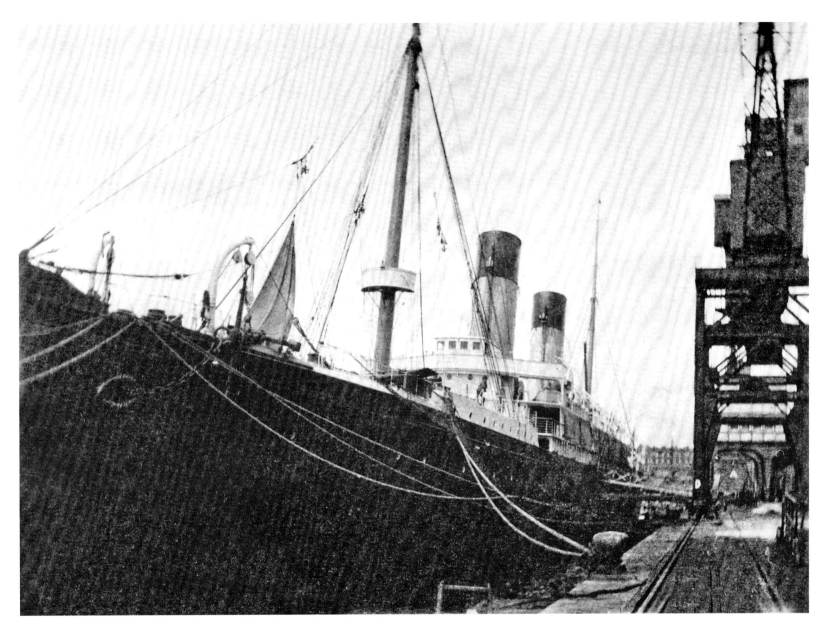

Majestic at Southampton, exactly two months after *Titanic*'s maiden departure. It is Monday 10 June 1912; the maiden voyager left from this selfsame berth 44 of the Ocean Dock on Wednesday 10 April, even being roped to the same bollard, which remains today.

The outline of the Southwestern Hotel, where many passengers stayed overnight before boarding the *Titanic*, can be glimpsed in the background. A sailor at the rail peers down at the photographer.

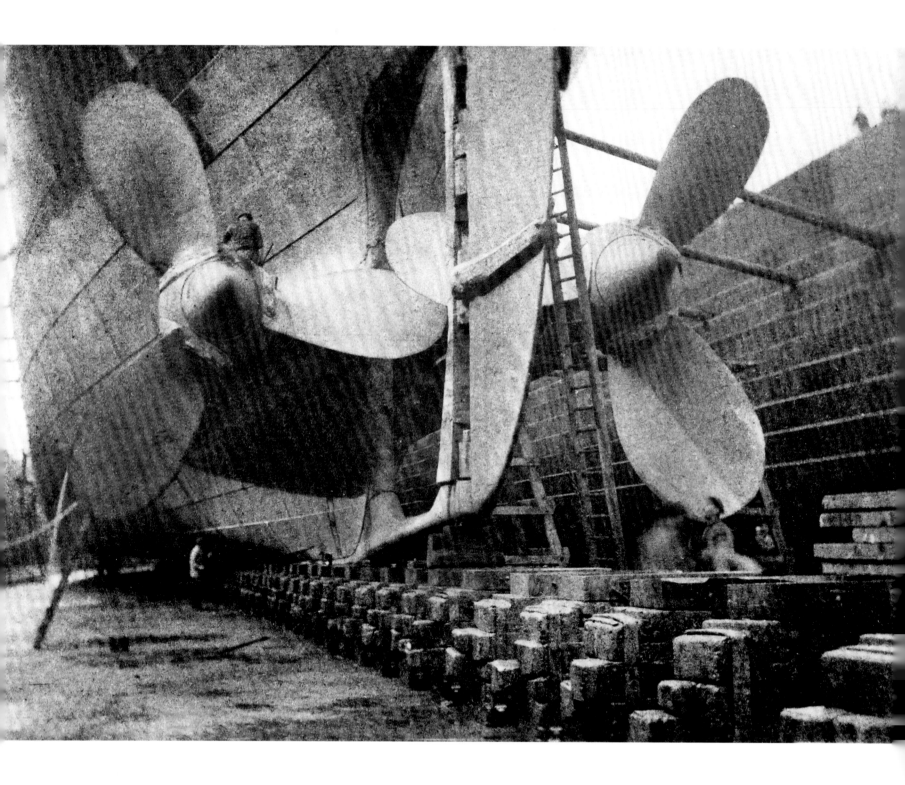

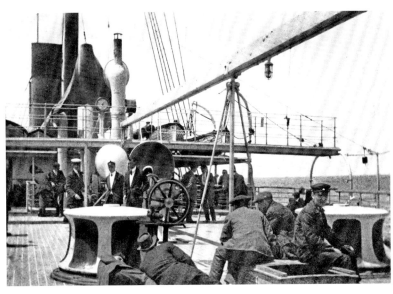

Members of the ship's orchestra, centre left, are among those taking the sun on the poop deck of the *Majestic* on Wednesday 29 May 1912. One bandsman has found a convenient hook for his hat. Lost *Titanic* violinist Jock Hume had performed on the *Majestic* in his day and there are many reports that the musicians were playing on deck as that vast vessel slowly sank, although whether they played 'Nearer My God to Thee' is heavily debated. In the top left of picture an officer and crewman appear to be checking an inboard starboard lifeboat, six weeks after the disaster. Other figures are a picture of indolence.

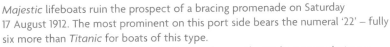

Majestic lifeboats ruin the prospect of a bracing promenade on Saturday 17 August 1912. The most prominent on this port side bears the numeral '22' – fully six more than *Titanic* for boats of this type.

These are cumbersome old-style davits, whereas the Welin patent davits on the sunken leviathan could have far more easily deployed even nested boats. One blueprint for the *Titanic* conceived a total of sixty-four standard lifeboats aboard.

Lightoller wrote:

I had been with him [E.J. Smith] many years, off and on, in the mail boats, *Majestic* mainly, and it was an education to see him con his ship up through the intricate channels, entering New York at full speed. One particularly bad corner, known as the South-West Spit, used to make us fairly flush with pride as he swung her round, judging his distances to a nicety; she heeling over to the helm with only a matter of feet to spare between each end of the ship and the banks.

Opposite: The *Majestic* has moved into Trafalgar dry dock in Southampton for an overhaul. A workman is standing on her port propeller, while another is looking at her keel further into the dock. High above, on the edge of the dock, a couple of figures gaze down towards her rudder. It is Friday 21 June 1912, and the British *Titanic* Inquiry is hearing from its last significant witness. He is Captain Arthur Henry Rostron of the Cunarder RMS *Carpathia*, which rescued more than 700 survivors from the lifeboats – some of whom had watched the *Titanic*'s giant bronze propellers rear horrifyingly out of the water as she foundered.

Telegraphs, a binnacle, and other equipment bristling on the bridge of the *Majestic*. Picture taken Sunday 18 August 1912.

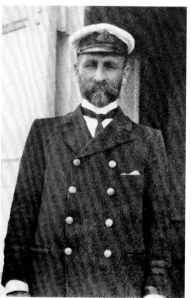

George Alcock of Aberdeen, first officer of the *Majestic*. It was Alcock who took over from Chief Officer Lightoller on the *Celtic* when the latter finally resigned from the White Star Line in February 1920. Lightoller was frustrated, in that he had faithfully applied the 'whitewash brush' for the company in two searching *Titanic* inquiries, only to be persistently denied ascent to his own command.

Alcock had trooping duties in the Great War, conveying soldiers to the carnage from Australia, New Zealand, Canada and the United States, while Lightoller finally achieved captaincy with the Royal Navy destroyer HMS *Garry*, and even managed to destroy a U-boat.

Retiring after twenty-five years with White Star to Melbourne, Alcock named his house 'Salamis' after his first vessel when a 15-year-old apprentice. He died sixteen years after this June 1912 picture, aged only 60. His son, R.A. Alcock, had by then also become a master mariner.

Blair was the second officer of the *Titanic* on her delivery trip from Belfast to Southampton and confidently looked forward to making the maiden voyage proper. However, he was transferred out of the officer cadre to make way for the introduction of Henry Wilde.

On 4 April, Blair had sent a postcard to his sister-in-law:

Arrived on *Titanic* from Belfast today. Am afraid I shall have to step out to make room for Chief Officer of the *Olympic* ... I hope eventually to get back to this ship ... This is a magnificent ship. I feel very disappointed I am not to make her first voyage.

When he left *Titanic*, Blair took the keys to a crow's nest locker that may have contained binoculars. A set of ship's keys from the Blair estate was sold at auction by Henry Aldridge & Son in September 2007 for £90,000.

Dyke is a significant personality who would later serve as assistant commander aboard the *Britannic*, sister ship to the *Titanic* and *Olympic*, when she was sunk by a mine in the Aegean in November 1916.

On that occasion Harry Dyke coolly lowered aft starboard lifeboats, even finding time to upbraid firemen who were fending for themselves. However, by early January 1917 he had resigned from White Star, citing personal reasons, and never returned to sea. He died ten years later, aged just 57.

Blair dived overboard from the *Majestic* in 1913 to rescue a suicidal fireman, earning a $250 purse from admiring passengers. In 1914 he was exonerated at court martial over the total loss of the *Oceanic* by grounding at Foula. He would eventually win the OBE, Royal Decoration, Royal Humane Society bronze medal and the Liverpool Shipwreck and Humane Society silver medal, plus the Légion d'honneur.

In 1920, he resigned from the line and became an explorer and adventurer, even prospecting for gold in Central America in 1935. He died in 1953, more than forty years after *Titanic* sank, aged 79.

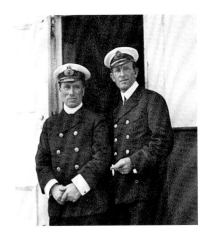

In the month after the *Titanic* sinking, one of her former officers appears sanguine, with a cigarette, at his narrow escape. David Blair stands alongside Chief Officer Harry William Dyke, left. Blair is second officer aboard the *Majestic* at sea on Wednesday 29 May 1912.

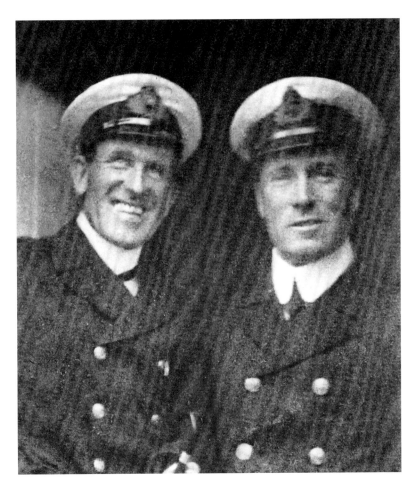

Another view of Blair and Dyke on *Majestic*, bound for New York in August 1912, and this time the *Titanic* escapee appears significantly happier, pipe in hand.

Considered by many the embodiment of courage, Lightoller commanded freezing men on an upturned collapsible in the hours of darkness after the maiden voyager had disappeared, leading them in the Lord's Prayer, and later using his officer's whistle to summon help from lifeboats at first light. Years later he risked his life to pluck soldiers from the beaches at Dunkirk.

He tartly corrected the chairman of the American *Titanic* Inquiry when asked what time he left the ship: 'I didn't leave it.' Senator William Alden Smith softened: 'Did the ship leave you?' Lightoller agreed such had been the case. He died in 1952, aged 78.

The strain of the grim *Titanic* ordeal etched indelibly on his countenance, Charles Herbert Lightoller puts on a brave front while at sea as first officer of the *Majestic* on Saturday 17 August 1912. He was still writing letters, on *Majestic* ship's stationery, to those bereaved and beset by the troubles that came in the wake of a monumental tragedy.

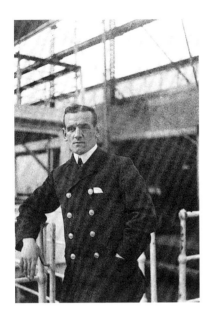

Alfred Brocklebank, second officer of the *Celtic*, at New York on Monday 7 October 1912. He is seen earlier in this book, bottle in hand, at a convivial session aboard the *Oceanic*.

Thompson was aboard the *Olympic* when she rammed and sank the German submarine U-103. He was also commander of the White Star transport *Afric*, which in turn was torpedoed and sunk off the Eddystone light in February 1917 by UC-66 with twenty-two lives lost. He spent twelve hours in an open boat before rescue.

For his war service Thompson won an OBE and later a CBE, becoming White Star marine superintendent at New York in 1921. He died in Queens in November 1944, aged 71.

Gottfried Pope was first officer aboard the *Cymric* when she was sunk in May 1916 by U-20, the same submarine that had claimed the *Lusitania* the year before. Pope was mentioned in despatches in December 1917 when his vessel *Belgic* avoided a submarine attack.

Alfred Brocklebank also served on the ill-fated *Britannic*, last of the Olympic class, and was second officer when she sank in 1916 in the livery of a hospital ship, the vessel never having begun her intended transatlantic role in the buff funnel colours of the White Star Line. He later became master of the *Gallic* and *Zealandic*.

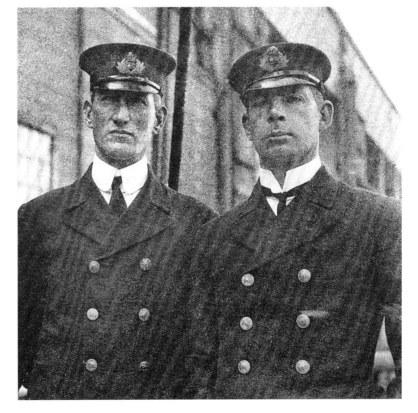

Philip Agathos Bell was assigned from the *Majestic* to the *Cymric* in September 1912, and this is one of his last pictures. Taken at Boston, it shows Chief Officer James Thompson, left, and Third Officer Gottfried Pope on 7 October that year.

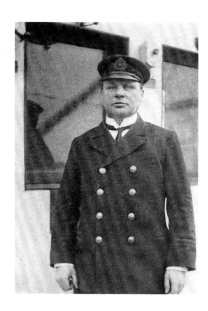

Bell's last image is of Sydenham Ernest Stubbs, chief officer of the *Zealandic*, at London Docks. It is 29 January 1915, and a war has broken out that will claim the lives of many among the merchant service – thankfully not that of Stubbs, who enjoyed a thirty-five-year White Star Line career.

Captain of the *Aurania* from 1935 after *Olympic* was scrapped, Stubbs retired in 1938, having won an OBE and Royal Decoration for war service. He died aged 84, on 18 June 1962 – half a century to the very day from when Guglielmo Marconi testified to the British *Titanic* Inquiry, followed by a surgeon from the *Oceanic* telling of the discovery of three bodies in a *Titanic* collapsible.

Stubbs is alpha and omega. He was aboard the *Republic* in January 1909 when sunk through collision with the *Florida*. And he was with the *Olympic* a generation later in 1934, when she ran down the Nantucket lightship, taking seven lives.

Assistant commander to Captain John W. Binks, Stubbs testified that his huge liner had 'practically stopped' when she rammed the beacon vessel.

Officers on the *Olympic*'s bridge first sighted the lightship a quarter of a mile away, dead ahead, he declared (in unconscious echo of the sister ship and her nemesis). 'The engines were ordered reversed. When we struck ... the weight of the *Olympic*, not its speed, cut the small boat in two,' Stubbs told the Inquiry. Captain Binks had ordered the watertight doors immediately closed.

Hail and farewell. It is ten years after the *Titanic* sank and John W. Kempster is in Cuxhaven to see the completed *Bismarck* taken out by a White Star crew that will paint out the name and replace it with *Majestic* – the second of that title – when safely out to sea. A war reparation dictated by the Treaty of Versailles, *Bismarck* leaves port watched by thousands of Germans, reportedly in silence. History marches determinedly on, even if sometimes stumbling in tragic circles.

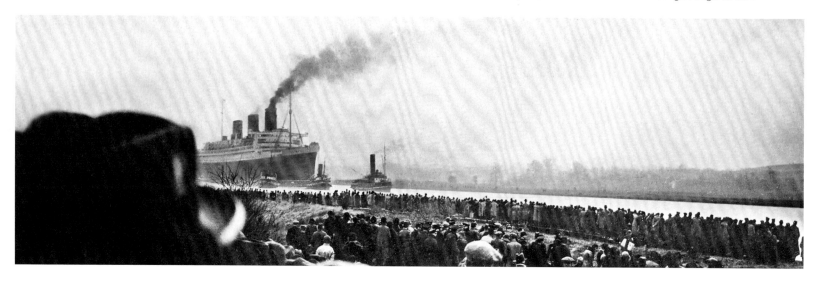

To order prints of Bell or Kempster photographs for private use see www.titanicphotographs.com
For licensing and commercial use please email: info@davisonphoto.com; tel. (353) 1 2950 799